MASTER DIGITAL COLOR

STYLES TOOLS TECHNIQUES

Brian & Kristy Miller

IMPACT
CINCINNATI, OHIO
www.impact-books.com

D1119459

Master Digital Color. Copyright © 2010 by Brian and Kristy Miller. Manufactured in China. All rights reserved. No part of this book may be reproduced in any form or by any electronic or mechanical means including information storage and retrieval systems without permission in writing from the publisher, except by a reviewer who may quote brief passages in a review. Published by IMPACT Books, an imprint of F+W Media, Inc., 4700 East Galbraith Road, Cincinnati, Ohio, 45236. (800) 289-0963. First Edition.

Other fine IMPACT Books are available from your local bookstore, art supply store or online suppliers. Visit our website at **www.fwmedia.com**.

14 13 12 11 10 5 4 3 2 1

Distributed in Canada by Fraser Direct
100 Armstrong Avenue
Georgetown, Ontario, Canada L7G 5S4
Tel: (905) 877-4411

Distributed in the U.K. and Europe by David & Charles
Brunel House, Newton Abbot, Devon, TQ12 4PU, England
Tel: (+44) 1626 323200, Fax: (+44) 1626 323319
Email: postmaster@davidandcharles.co.uk

Distributed in Australia by Capricorn Link
P.O. Box 704, S. Windsor NSW, 2756 Australia
Tel: (02) 4577-3555

Library of Congress Cataloging-in-Publication Data

Miller, Brian G. (Brian Glen), 1973-
 Master digital color : styles, tools, techniques / Brian and Kristy Miller. -- 1st ed.
 p. cm.
 Includes index.
 ISBN 978-1-60061-759-1 (pbk. : alk. paper)
 1. Color computer graphics. 2. Adobe Photoshop. 3. Comic books, strips, etc.-- Illustrations. I. Miller, Kristy. II. Title.
 T385.M5434 2010
 741.5'1--dc22
 2009037252

Acknowledgments

The authors would like to acknowledge the following people and companies who graciously contributed to this book: Don Bluth, David Bryant, Joe Corroney, Brian Denham, Shannon Eric Denton, Ray Dillon, Lee Ferguson, Christian Fernandez, Kevin Geiss, Gary Goldman, Amy Reeder Hadley, David Hahn, Jim Hanna, John-Paul Kamath, Jeff Mariotte, Jim McLauchlin, Terry Moore, Dan Neumann, Shawn Pryor, Brian Pulido, Mark Schultz, Nima Sorat, Val Staples, William Tucci, Rick Veitch, Martheus Wade, Eric White, Mike Worley, Dustin Yee.

The authors would also like to thank our friends at Dark Horse Comics; DC Comics; Devil's Due Publishing; Disney; DreamWorks/Titan Publishing; Graphic Universe; IDW Publishing; Image Comics; King Features Syndicate; London Horror Comic Ltd.; Lucasfilm Ltd.; Marvel Comics; Richard Starkings and Comicraft; TOKYOPOP; Top Cow Productions; United Media; WildStorm and Wizard Entertainment for your never-ending support.

Dedication

This book is dedicated to Kristy who does 90 percent of the work and receives 10 percent of the credit and recognition, and without whom I would be lost.

Designed by Jennifer Hoffman
Technical editing by Amy Jeynes
Production coordinated by Mark Griffin

Usage Guidelines for Practice Files

Many comic-industry professionals have graciously allowed their art to be included on the Bonus Disc for you to practice coloring. Please respect their copyrights by not redistributing the artwork in any form or at any online location except in the Hi-Fi user forum at www.HueDoo.com, where we invite you to post your practice images and receive feedback and assistance from the HueDoo user community.

Thanks for respecting the artists' ownership and copyrights!

Metric Conversion Chart

To convert	to	Multiply by
Inches	Centimeters	2.54
Centimeters	Inches	0.4
Feet	Centimeters	30.5
Centimeters	Feet	0.03
Yards	Meters	0.9
Meters	Yards	1.1

About the Authors

As a child, Brian Miller loved to color and paint. After earning straight smiley faces in preschool art, he tested into a grade-school gifted program known as Bright Ideas, where he quickly earned the nickname "Marker-Happy" because of his enthusiasm for that medium (and evidenced by the constant stains on his hands and clothing).

As a teenager, Brian discovered both Macintosh computers and comics, and experimented with coloring comic art. He picked up real-world design experience working part time for magazine publishers and printing companies while studying art at Southwest Missouri State University. There, he also met Kristy.

Kristy Miller has degrees in Antiquities and Secondary Education from Southwest Missouri State, as well as a Master's in Museum Studies from the University of Kansas. After working and living in various countries throughout the world, Kristy began teaching middle school history and Macintosh computers while Brian worked at an advertising agency. Brian continued to color comics on the side using various pen names until, in 1998, he walked away from his art director position to start Hi-Fi Colour Design with Kristy and a group of talented creators. After one too many harsh Missouri winters, Brian and Kristy moved Hi-Fi to Arizona. There, Kristy worked at a museum as Director of Education until she left her position in 2002 to help Brian run Hi-Fi Colour Design full time.

Kristy handles the day-to-day, nonartistic sides of Hi-Fi. For fun, she teaches anthropology and history at a community college. Brian enjoys coloring and creating fully painted covers and pinups for comics, books and magazine covers. In this book, *Master Digital Color*, Brian and Kristy will take you on a journey through various styles of coloring. They hope this is only the start of your great artistic adventure.

An Interview With Steve Oliff

Hi-Fi: What led you to become a colorist?

Steve Oliff: When *Fantastic Four* #13 came out in 1963, I was in the third grade. That same year, I discovered color theory from the bottom of a Play-Doh package. From then on, all I really wanted to do was comics.

When I was about thirteen, I started sending in scripts to Charlton Comics, 'cause by this time [Steve] Ditko was doing Blue Beetle and the Question. One day I got a seven-page handwritten letter from Ditko. He warned me that my stories were too violent for mainstream comics. Along with the letter, he sent me a script from *Creepy* magazine by Terry Bisson and Clark Dimond, a copy of Wally Wood's *Witzend* #4, a Charlton Question one-shot, and a tiny pamphlet by Ayn Rand called *Textbook of Americanism*.

HF: What sort of art training did you have, and what was your first published work?

SO: The art department in my high school was almost nonexistent, and I didn't last long enough in college to get any art training. What really helped me grow was going to conventions and seeing other artists. I went to my first San Diego Comic-Con in 1974 and made contacts that led to my first published work, a Neal Adams cover for *Venture* #5 around 1976. That got me work for Byron Preiss on the *Illustrated Roger Zelazny*, *Illustrated Harlan Ellison*, and finally, in 1978, *The Stars My Destination* where I worked with Howard Chaykin. I lived in Howard's mother's spare bedroom out in Queens for four months.

After that job, Howard took me up to DC, but they had no use for full color at the time. Marvel, though, needed someone exactly like me for their new *Hulk* magazine. They were working out a system of coloring onto two identical photostats, and I already had experience with that from the Neal Adams cover and the Zelazny and Ellison books. Plus, I used an airbrush, which was always an editor-pleaser. So my first job for Marvel was Bill Sienkiewicz's first *Moon Knight* backup story in *Hulk* #13. I colored on one stat and did effects work on the line-art stat.

HF: What other tools and techniques were you using at the time?

SO: That first job for Marvel was also the first time I became a color separator. I was painting out the letters on the color stats so the black letters would be clean and not have registration problems. I was also knocking out the line art on the black plate for color holds. And I used Zip-A-Tone to make some of the dark colors darker.

On the stats, I was using water-soluble felt pens blended with cotton swabs, Dr. Ph. Martin's Dyes for my airbrush, and Cel-Vinyl animation paint for flat areas and painting out captions. That system eventually led to the greyline system Pacific and then Eclipse used.

HF: Did you collaborate with any of your contemporaries?

SO: I was always working in isolation up here on the coast, but I was influenced by Richard Corben, Vaughn Bode, [Frank] Frazetta and Neal Adams.

HF: I recall seeing a comic based on *The Dark Crystal* and thinking the color was special. What was your role?

SO: That was a unique situation. I'd just flown to New York to work with Brent Anderson on the *X-Men* graphic novel *God Loves, Man Kills*. I stopped by Marvel on a Friday afternoon to check in with my editor, Weezie [Lousie] Simonson. She had gathered a group of colorists to bash out *The Dark Crystal* over the weekend. Since it was a movie adaptation, it was a full-color project. Most in the group weren't really familiar with doing full color on stats. I was the fastest and most experienced colorist there, so Weezie had me work over some of the other colorists' pages, and eventually I was given the title of color supervisor.

HF: Is there a favorite project or title you have colored?

SO: I have always been drawn to superhero comics, and I've been blessed to have worked on some pretty cool projects for all the major companies. Some of the biggies were *Spawn*, *The Maxx*, *Akira*, *Cosmic Odyssey*, *Blackhawk* and the first *Batman* movie adaptation.

SO: The first Epic comic I colored was Tom Yeates's *Timespirits*. Then I colored *Starstruck*, *The Bozz Chronicles*, *Coyote*, *Weird World*, and then *Akira*.

HF: Since you mentioned Akira, let's switch gears. It's 1988, and Akira has hit newsstands. To this day, I remember opening up an issue and seeing the digital colors, especially the gradients and color holds. It changed my concept of how a comic book could look. Did you know then that you were changing the industry forever?

SO: Actually, I did. Marvel wanted it colored because they didn't think the U.S. audience would respond well to it in black and white. There had not been an artistic color separator in the business since they started doing crappy separations on *Prince Valiant* in the Sunday funnies. The addition of gradients and the fact that a "color artist" was in control of the computer seemed like a fundamental break with the past, even then.

HF: Set the record straight for the comic historians. Is Akira the first comic colored digitally in the US?

SO: No. The very first comic story colored with a computer was a three-page backup in Michael Gilbert's *Mr. Monster*; I think it was issue #8 around 1986 or 1987.

Then there was the *Iron Man* [graphic] novel *Crash*. Mike Saenz was originally going to color it using PixelCraft's Tint-Prep software. There was a little blurb in *Computer Graphics World* that said they were going to demo the new software at the National Computer Graphics Association convention in Philadelphia. I went to that con and met Kenny Giordano, the owner of the software. A few months later, Mike dumped Kenny's software in favor of software by one of his buddies. Technically, *Crash* beat *Akira* to market by about a month, but the result was a pretty dismal experiment best forgotten.

Kenny didn't have a book to showcase PixelCraft's Tint-Prep. Once I got the job for *Akira*, Kenny gave me a computer loaded with Tint-Prep, and he got the film output job. Marvel would send him the artboards, then he would scan them and send the disks to me. I'd color them, send the disks back to Kenny, and he'd output the film. There were no proofs. That's how it really began.

HF: Spawn #1 was released in May 1992. What was the origin of that project?

SO: Todd [McFarlane] and I had talked years earlier about me coloring a book he was going to do. So when he started *Spawn*, he called me. He liked our test pages, and we were off and running. Everyone on the crew went over-the-top for *Spawn*. We had the feel of the book down. Todd rarely had any corrections.

HF: Were you aware of the impact your color was making?

SO: We were very aware of pushing the industry. We were aggressive about taking jobs from people we felt were doing inferior work. *The Savage Dragon* switched to us after issue #2 or 3, I think. And the Image line just kind of fell into our laps until they all started their own color separation divisions.

HF: Your efforts were rewarded with Eisner Awards in 1992, 1993 and 1994. Did that recognition change the people's receptiveness to digital color?

SO: Well, actually, we won four Harvey Awards, too, plus a smattering of CBG Awards, Wizard Fan Awards and some from Europe. Yes, it did change the way people thought of digital color. It became obvious that the old flat colors were on their way out.

One of my favorite moments in my career was in San Diego, in 1993 or 1994. Reuben Rude, Abel Mouton, Kiko Taganashi and I were walking from our hotel to the convention when Frank Miller stopped us and said, "You guys changed the look of comics." We were thrilled.

HF: You released Armature #1 in 1996. What was your inspiration?

SO: I published *Armature* because I wanted to write and draw a comic of my own for once. I now do a weekly black-and-white *Armature* strip for a local newspaper. I'm starting my seventh year, amazingly enough. I've been working on the story, improving my art, and trying to put it all together into a graphic novel. I'm working on a book about color, too. I'll be posting updates on that at Olyoptics.com.

HF: Do you have any advice for aspiring colorists?

SO: Above all else, respect deadlines. If you get a reputation as a deadline deadbeat, no matter how good you are, it can haunt you for years. If you respect deadlines, editors will love you.

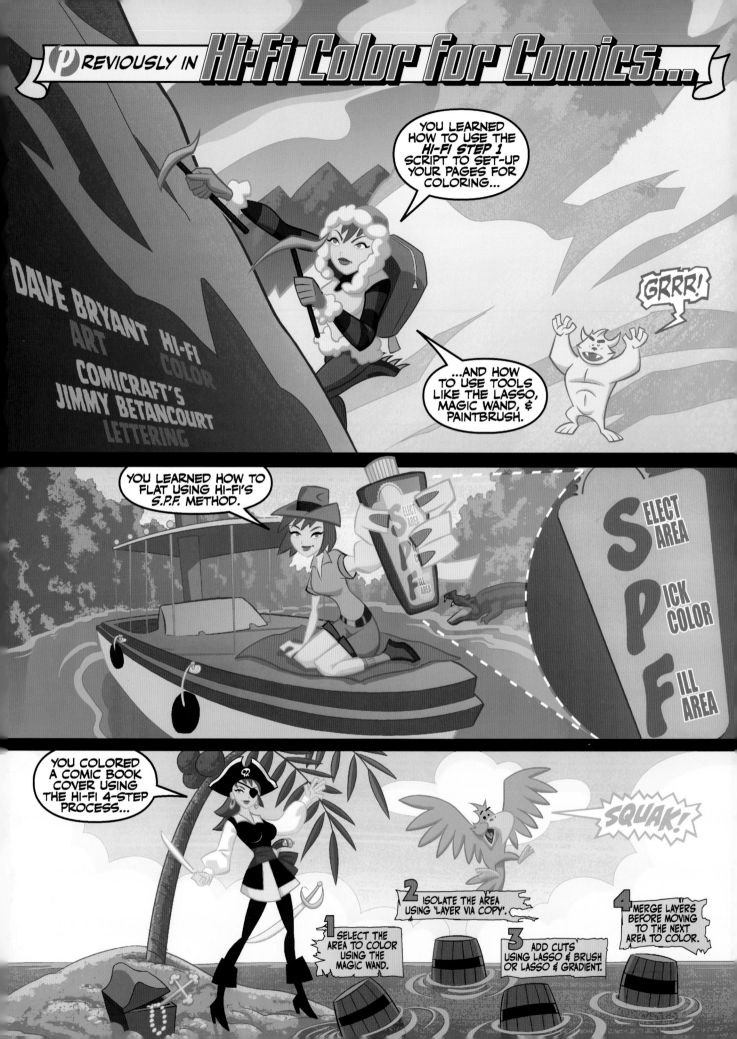

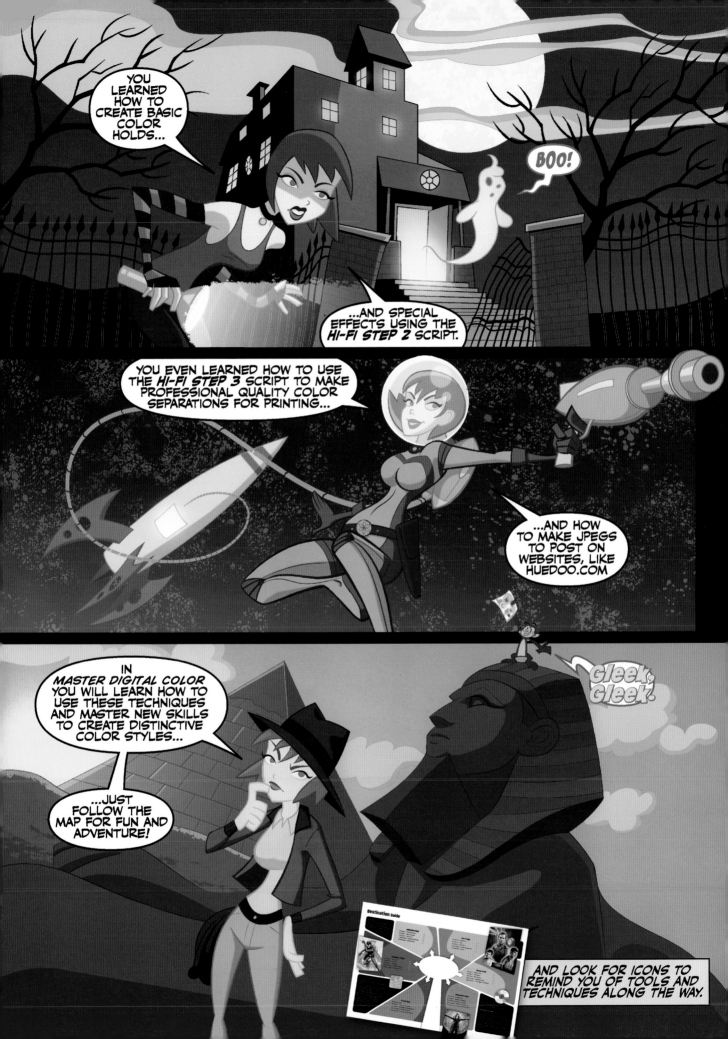

Destination Guide

All Roads Lead to Fun

Master Digital Color is divided into six coloring styles. Using the tools and techniques from *Hi-Fi Color for Comics*, you can color any project from any of the six color regions on the map.

About HueDoo.com

HueDoo.com is Hi-Fi's online community for colorists. At HueDoo, you can:

- Interact with other aspiring and professional colorists
- Build an online portfolio and find coloring jobs in the HueDoo classifieds
- Show off your latest creations to the world!

Each project in this book—as well as our first book, *Hi-Fi Color for Comics*—has a dedicated page on HueDoo.com where you can see what other readers are doing and share your results with viewers around the globe.

What are you waiting for? Visit HueDoo.com and join the tribe!

Sci-fi Style

Manga Style

Alternative Style

Bonus Disc

This book comes with a Bonus Disc full of tools to
help you save time and get professional-quality
coloring results.

On the disc, you'll find:

- Art for each coloring project in the book

- Hi-Fi Helpers: our custom actions, scripts, palettes and
 presets for Adobe® Photoshop®

- Bonus art to practice with

- Click-A-Tone starter set for gray-scale comics

- Exclusive video tutorials

And much more! Turn the page for directions on installing
the Hi-Fi Helpers.

How to **Install** the **Hi-Fi Helpers**

Before you dive into the coloring projects, break out the Bonus Disc and install the Hi-Fi Helpers—all those custom Photoshop presets, scripts and actions that will save you time and help you get excellent results.

1 Copy and Paste the Presets
Quit Photoshop. Referring to the illustration, locate the folders shown on the Bonus Disc. Copy and paste the contents of each folder into the corresponding folder in your Photoshop installation.

2 Load the Presets
Launch Photoshop. Load and/or verify the presets as follows:

- **Actions:** Choose Window menu > Actions. "Hi-Fi Hi-Lites" should be one of the action sets listed.
- **Brushes:** Choose Window menu > Brushes, then choose the set named "Hi-Fi Brushes."
- **Swatches:** Choose Window menu > Swatches. From the drop-down menu, choose Load Swatches, then load Hi-Fi Swatches.aco.
- **Scripts:** Choose File menu > Scripts. Hi-Fi Steps 1, 2, and 3 should be listed.
- **Tool settings:** Choose Window menu > Tool Presets. From the drop-down menu, choose Load Tool Presets, then load Hi-Fi Tool Presets.tpl.

3 Load the Color Settings
Choose Edit menu > Color Settings. Click Load. Navigate to the Bonus Disc, open the folder named "For Photoshop," and then open the folder "Hi-Fi Color Settings." Load the file Hi-Fi Default Color Settings.csf.

Already Have Some Hi-Fi Helpers?

If you are already using the Hi-Fi Helpers that came with our first book, *Hi-Fi Color for Comics*, you should still install the Hi-Fi Helpers that come with this book.

We've included several new Hi-Fi Helpers along with the original core set. You'll need them all for the projects in this book.

To install the new set, follow the directions on this page. If, while pasting files, you're asked whether you want to replace an older Helper file with a newer one, you can:

- Click **"No"** to keep the old file. (You might take this route if you added to one of our palettes and you want to keep your customizations.)
- Click **"Yes"** to replace the old file with a fresh new one. (In case you're wondering, the functionality of the core set of Helpers hasn't changed.)

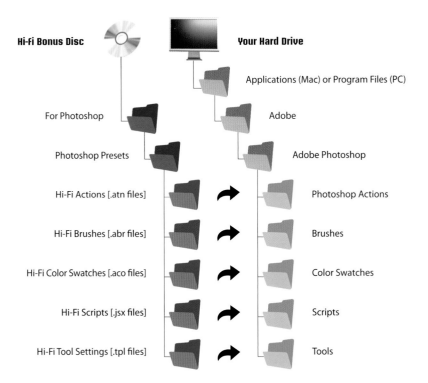

Default vs. Advanced Color Settings

The Bonus Disc includes two color settings files: Default and Advanced. At Hi-Fi, the Default settings file is our workhorse. It gives us great color that our clients can count on for everything from web to newsprint to glossy stock. Use the Default settings for great color and maximum versatility.

The Advanced settings file is provided mainly for power Photoshop users doing commercial print projects. If that's you, compare your vendor's specifications to the color settings in the Advanced file, and you'll know whether you should use it.

Configure the Photoshop Tools for Coloring

Have you installed the Hi-Fi Helpers as directed on the facing page? Good. Now, configure the Photoshop painting and selection tools as follows. These settings are important for successful coloring.

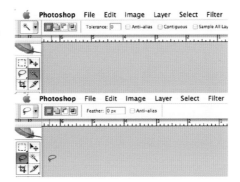

1 Configure the Magic Wand and Lasso Tools

For the Magic Wand tool, set Tolerance to 0 and disable Anti-alias. For the Lasso tool, set Feather to 0 pixels and disable Anti-alias. These settings will ensure clean, crisp edges for your coloring.

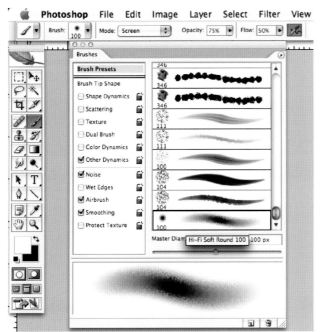

2 Select the Brush Preset

From the Brushes palette, choose the brush preset named "Hi-Fi Default Soft Round." The options for this brush are preset so you can do your best rendering.

To verify that you've selected the correct brush preset, double-check that the Brush mode is set to Screen, the brush opacity is 75 percent, and the brush flow is 50 percent.

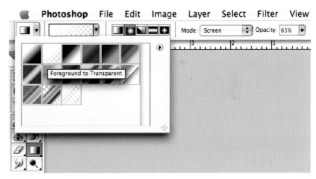

3 Select the Gradient Preset

Select the Gradient tool from the Tools window, then choose the following options. With these settings, you'll be ready to paint with light the Hi-Fi way.

- **Shape:** *Radial*. This shape most closely resembles real light emanating from a source.

- **Color preset:** *Foreground to Transparent*. That means your gradient screen will gently transition from the chosen foreground color to nothing (transparent), allowing underlying layers to show through with no harsh edges.

- **Gradient mode:** *Screen*. See explanation on the left.

- **Gradient opacity:** *65 percent*. With this setting, even where the gradient is the most dense, it will let some of the underlying colors show through so that objects appear bathed in light.

How Painting Tools Behave in Screen Mode

When the Brush and Gradient tools are in Screen mode, it's as if you are painting with colored light instead of opaque color. Also, the light on the object brightens more and more with each successive stroke. This lets you quickly build up realistic-looking lights.

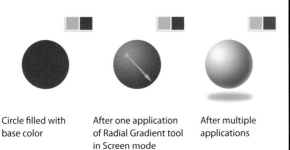

| Circle filled with base color | After one application of Radial Gradient tool in Screen mode | After multiple applications |

How to Use the **Automation** Scripts

 STEP 1 SCRIPT

Begin every project in this book by running the Hi-Fi Step 1 script.

1 On the Bonus Disc, find the black-and-white line art you want to color. Copy the file to your hard drive, then open it in Photoshop.

2 Choose File menu > Scripts > Hi-Fi Step 1.

3 Select a resolution when prompted by the script (see the chart "Which Resolution [PPI] to Choose" on this page).

4 Once the Hi-Fi Step 1 script has finished running, go to the Channels window (Window menu > Channels). The script will have created a new channel called "Line Art." Click the eyeball button to turn on Visibility for the Line Art channel.

5 Choose File menu > Save As, then save the file as a Photoshop document.

• ***IMPORTANT!*** Follow the file organization guidelines on page 15. If you try our organization system and stick with it, you'll always be able to find the file you need for any coloring project, and you will be very happy that you can't accidentally save over files you meant to keep.

You now have your working file—a Photoshop file in RGB color mode—ready to color.

Accessing the Hi-Fi Step 1 Script

Accessing the Hi-Fi Step 2 Script

 STEP 2 SCRIPT

Once your color rendering is complete, you may want to add special effects to your image. To prepare the file for special effects, run the Hi-Fi Step 2 script:

1 Choose File menu > Scripts > Hi-Fi Step 2.

2 The script will create two temporary layers: one named "Line Art" and one named "Special Effects." In the Layers window (Window menu > Layers), click "Special Effects" to ensure that it is the active layer before you start adding your glows and other effects.

Video Tutorial

Episode 1: 1-2-3 Automation Scripts

To see the Hi-Fi scripts in action, watch video tutorial episode 1 on the Bonus Disc.

Which Resolution [PPI] to Choose

PPI	Best for
600	Sometimes used for gray-scale or undersized art. Can result in very large files. Use only if directed by vendor.
400	Industry standard for coloring the standard-size comic book page (6.875" × 10.438" [17cm × 27cm]). Best compromise between fineness (for sharp line work and color) and livable file size.
300	Good for oversized art. (11" × 17" [28cm × 43cm] art colored at 300ppi will effectively become ~400ppi once the art is reduced to comic-book size.)
200	OK for flatting, practice coloring, and coloring images with very large dimensions (such as 24" × 36" [61cm × 91cm] or larger).

You can find in-depth step-by-step information
on using the **Automation Scripts** in our book
Hi-Fi Color for Comics.

 STEP 3
SCRIPT

When you have finished all the color rendering for your image, including any desired color holds or special effects, use the Hi-Fi Step 3 script to make a print-ready color separation.

Before running the Hi-Fi Step 3 script, be sure of the following:

- You have saved your working RGB .PSD file.

- Your Layers and Channels windows match the examples shown on this page.

- For the most accurate color separations, the Hi-Fi Color Preferences are installed as directed in "Load the Color Settings" on page 10.

1 Choose File menu > Scripts > Hi-Fi Step 3.

2 When prompted, select "with Special Effects" or "without Special Effects" and click OK.

3 Click OK. The script will generate a print-ready color separation complete with trapping.

4 Choose File menu > Save As and save the image as a TIFF file, adding the suffix "_CMYK" to the file name so you won't confuse this file with others. Use the file organization guidelines on page 15 to ensure you do not accidentally save over the original line art.

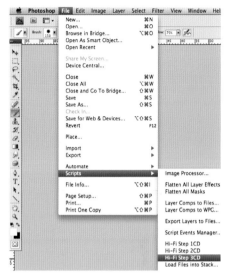

Accessing the Hi-Fi Step 3 Script

Is Your File Ready for the Step 3 Script?

Before you run the Hi-Fi Step 3 script, check your Layers and Channels palettes against the examples below.

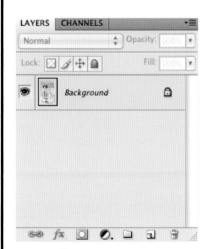

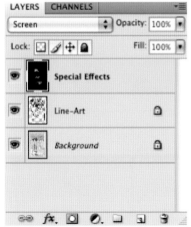

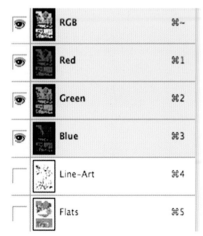

**Layers Palette
(Without Special Effects)**
Be sure all layers have been merged into the Background layer before running Step 3.

Layers Palette (With Special Effects)
Background, Line Art and Special Effects must be the only layers. If you created color holds, merge the Holds layer into the background before running Step 3.

Channels Palette
The Channels palette must have only the channels shown here. If you have created any additional channels, delete them before running Step 3.

Brush Up on the Hi-Fi Methods

Video Tutorials
Episode 2: SPF Flatting
Episode 3: 4-Step Rendering

To see the Hi-Fi flatting and rendering methods in action, watch video tutorials Nos. 2 and 3 on the Bonus Disc.

Select area
Pick color
Fill area

The Hi-Fi SPF Method for Flatting and Holds

1 Select Area
Select the area you want to add color to using the Lasso tool. You can alternate between the normal Lasso and the polygon Lasso by holding down the Option key (PC: Alt).

2 Pick Color
Pick a color to use for the area you have selected. Colors can come from the Photoshop color palette, from the color picker, or from other files including the Character Color Guides provided on the Bonus Disc.

3 Fill Area
Fill the selected area with your chosen color by pressing Option-Delete (PC: Alt-Backspace).

Tip
Pressing Option-Delete (PC: Alt-Backspace) fills the selected area with the foreground color. To fill it with the background color instead, press Command-Delete (PC: Ctrl-Backspace). Or you can load new colors into the color picker and alternate between the foreground and background colors as needed.

Hi-Fi 4-Step Process for Rendering

1 Select
Select the area of flat color you want to render using the Magic Wand tool.

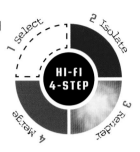

2 Isolate
Use Layer Via Copy (Mac: Command-J; PC: Ctrl-J) to place the contents of the selected area on a new layer. Select the new layer in the Layers palette, then check its Preserve Transparency/Transparency Lock button to fully protect the empty areas of the layer.

3 Render
Select each highlight area with the Lasso tool, then use the Brush or Gradient tool in Screen mode (see page 11) to add the highlight within the selected area. This technique is often called "cut and brush" or "cut and grad."

4 Merge
In the Layers palette, make sure the layer you created in Step 2 is the active layer. Then, from the drop-down menu in the Layers palette, choose Merge Down (Mac: Command-E; PC: Ctrl-E).

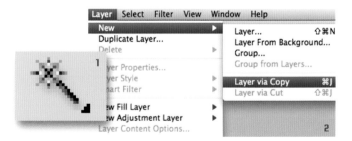

You can find in-depth step-by-step information on **Rendering** in our book *Hi-Fi Color for Comics.*

Organizing Your files

Colorists are responsible for a lot of files. For every comic book page you color, you'll have multiple files representing various stages of the coloring process. It's important to use a file organization system that minimizes your chances of saving over a file or making some other mistake that costs you a day's work.

 With Hi-Fi's simple system for file naming and organization, you'll always know what's what and where to find it.

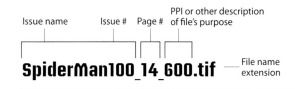

Use a File-Naming Convention

If you consistently use a file naming convention such as this one, you'll always know what a file is for even if it should get into the wrong folder. Also, this method helps you avoid the confusion and losses that can result from duplicate file names.

1 Project Folder

Name this folder with the title and issue number you're coloring.

2 Line-Art Folder

Contains line art to be colored.

SpiderMan100_14_600.tif

Some file-trafficking computer systems used by publishers have trouble with spaces or special characters in file names, so use hyphens (-) or underscores (_) instead. This problem is less common now than it was a few years ago, but it doesn't take any extra work to use an underscore and be safe.

3 Flats Folder

Pages with just the flat color fills added.

SpiderMan100_14_Flats.tif

Keeping the flats separate from the rest of your coloring makes it easy to go back to the flats if you need to.

4 CMYK TIFFs Folder

Color separations.

SpiderMan100_14_400_CMYK.tif

Append "_CMYK" to the file names so there is no doubt they are final print files.

5 RGB PSDs Folder

Contains working versions of your color render files.

SpiderMan100_14_400_A.psd
SpiderMan100_14_400_B.psd
SpiderMan100_14_400_C.psd

If you want to save versions of your files as you work on them, append a letter to each version's file name to make it obvious which version is the newest. Once your project is approved and printed, decide whether you want to archive all of these working files or just the final version of each page.

6 JPGs Folder

Contains 72ppi RGB JPEGs of your CMYK TIFF files.

SpiderMan100_14_400_CMYK.jpg

Every time you make a new CMYK TIFF, create a new RGB JPEG that you can e-mail if the penciller needs to double-check your work or an editor needs to see changes ASAP. Since you're making these review JPEGs from CMYK TIFF files, keep the "_CMYK" in the file name even though the JPEG should be stored as an RGB file. That way you know the JPEG that you and your editor are looking at came from the CMYK print file.

How to Use the Flats Channel

Paste completed flats in the Flats channel so you can easily select them with the Magic Wand, regardless of how rendered they become. To prepare the Flats channel:

1 Copy the flats by choosing Select > All, then Edit > Copy.

2 Open the Channels palette (Window > Channels) and click the channel thumbnail for the Flats channel.

3 Choose Edit > Paste, and a gray-scale version of your flats will appear. Choose Select > Deselect to drop the selection.

4 Click the channel thumbnail for RGB to reactivate those channels.

5 Click the channel visibility indicator (the eyeball) for the Line Art channel to unhide the line art. You're ready to start rendering.

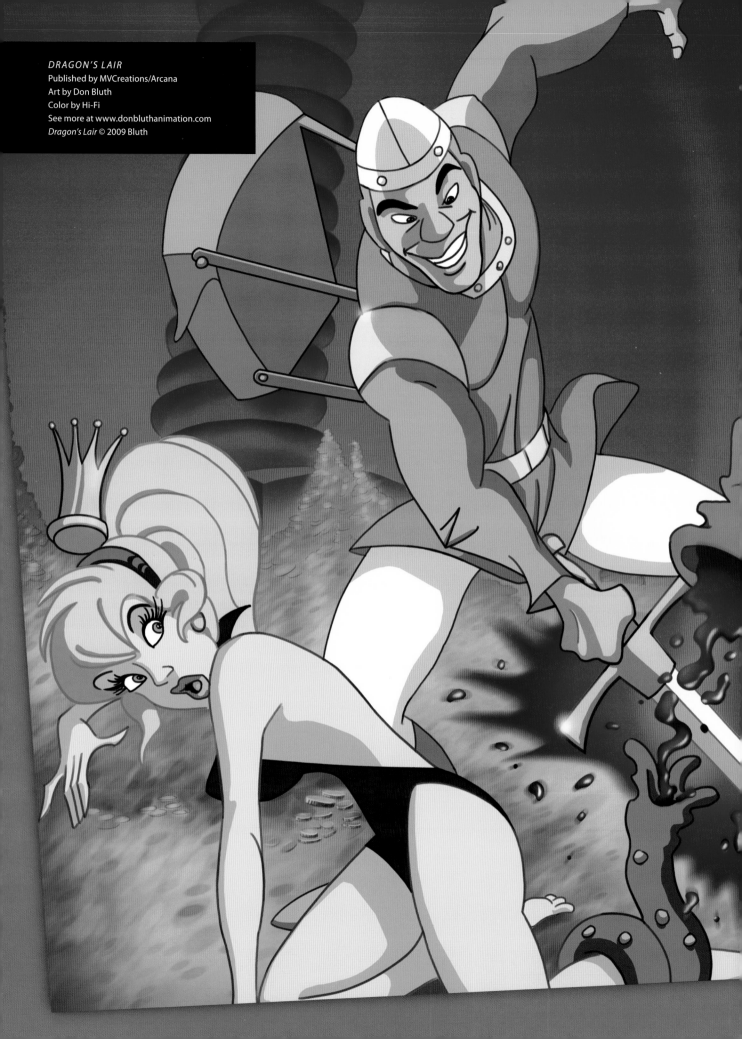

DRAGON'S LAIR
Published by MVCreations/Arcana
Art by Don Bluth
Color by Hi-Fi
See more at www.donbluthanimation.com
Dragon's Lair © 2009 Bluth

Animation Style

In fourth grade I read Mrs. Frisby and the Rats of NIMH *by Robert C. O'Brien. That summer,* The Secret of NIMH *was released in theaters. I sat mesmerized by the images on the screen. Animator Don Bluth created a rich and colorful world full of compelling characters who faced very real consequences. As an eight-year-old boy, it was a life-changing experience. I made it my mission to find out what I could about the man behind* The Secret of NIMH. *Don Bluth and his future business partner, Gary Goldman, met while working as animators at Disney on such films as* Robin Hood, The Rescuers *and* Pete's Dragon, *to name a few.*

After leaving Disney to form their own animation studio, Don and Gary collaborated on numerous animated features, including An American Tail, The Land Before Time *and* Anastasia. *These two visionaries are also responsible for the creation of the classic arcade games* Dragon's Lair *and* Space Ace, *which consumed most of my boyhood allowance. Imagine my delight twenty-five years later when I had the opportunity to work with Don Bluth on the* Dragon's Lair *comic book. Working with Don and Gary proves that childhood dreams can come true.*

Learn More About the Artist

Learn more about animation and see Don Bluth's artwork and video tutorials at www.donbluthanimation.com. You will find this Don Bluth drawing, and more, in *Dragon's Lair*: Volume 1 from Arcana Comics at www.arcanacomics.com and www.mvcreations.com.

SHERLOCK HOUND

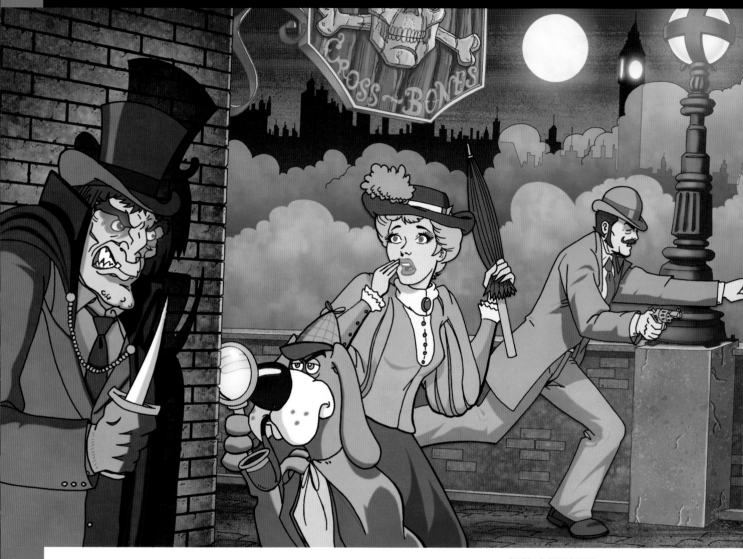

Paying homage to the classic Saturday morning cartoons, Mike Worley's Sherlock Hound is the sleuthingest, crimefightingest, clue-findingest dog in town. Television cartoons have a history of combining painted-style backgrounds with simple cell-shaded figures. The bright and colorful characters pop off the more deeper tones and textures of the settings. Use your favorite cartoons for inspiration when bringing *Sherlock Hound* to life in color.

SHERLOCK HOUND
Art by Mike Worley
Color by Hi-Fi
See more at www.worleytoons.com
Sherlock Hound © 2009 Worley and Miller

Learn More About the Artist
If you enjoy coloring this illustration from *Sherlock Hound*, visit Mike's website at www.worleytoons.com and let him know you appreciate his contribution to the book.

Stage 1: Prepare the Line Art and Add Flat Color

H I-F I STEP 1
SCRIPT

1 Before you start, install the Hi-Fi Helpers and configure the Photoshop tools as directed on pages 10–11. From the Bonus Disc, open the file Animation_SherlockHound_600.tif.

From the Photoshop Menu bar, choose File > Scripts > Hi-Fi Step 1 to prepare the line art for coloring.

Remember to unhide the Line Art channel (see page 12) after the Step 1 script is finished.

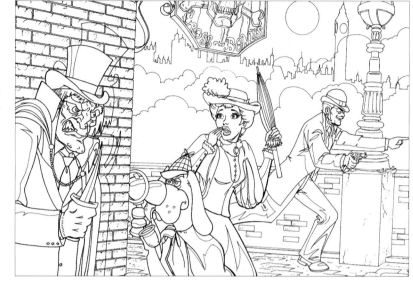

2 Use the Lasso tool and the Hi-Fi SPF method (see page 14) to add flat color fills to all the areas of the artwork. Use bright colors to achieve that classic television animation look.

SPF
Select Area
Pick Color
Fill Area

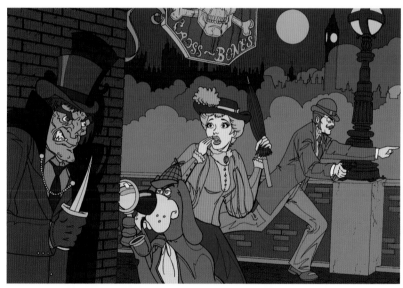

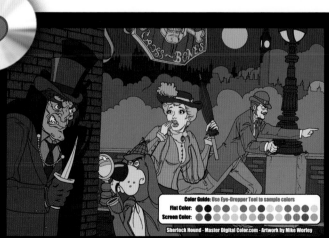

On the Disc: Color Guide

The Bonus Disc includes Color Guides for the projects in the book. Each Color Guide contains convenient swatches of the color pairs we used for flatting and rendering.

If you want to use our colors, just click each swatch with the Eyedropper tool to sample the color right into your Swatches palette.

Stage 2: Render the Sky

The midnight blue sky sets the mood, adds depth and conveys the eerie feeling of foggy Victorian London. The lighter blue pushes the skyline forward, setting the stage for the Phantom Ripper's villainous deeds. Make sure you've configured the Gradient and Brush tools as directed on page 11.

In the rendering steps you will often find screen tones expressed as a CMYK value because it's the most common way print professionals, clients, editors and artists share process color information.

1 Select the sky with the Magic Wand tool and use the Gradient tool to add some light emanating from the horizon. Use screen tone C90, M40, Y00, K00.

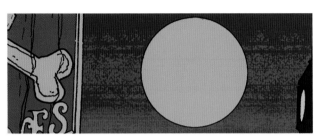

2 Use the Brush tool to add detail highlights to the night sky. Use Streaky Brush 02 with a large diameter such as 400 to add natural looking brushstrokes with a bit of texture.

Streaky Brush

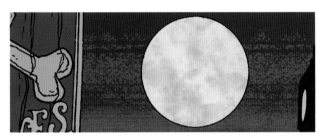

3 Use the Hi-Fi Helper file Moon02.tif to complete the evening sky.

Focus on the Details: Hi-Fi Helper Moon

1 Select the flat colored moon with the Magic Wand tool. Open the file Moon02.tif, then Select All and Copy the image. In the Sherlock Hound file, select the flatted moon with the Magic Wand tool, then choose Edit menu > Paste Into.

2 Choose Edit menu > Free Transform, then rotate and scale the pasted moon to make it fit.

3 Once you have the moon positioned, choose Merge Down from the pull-down menu in the Layers palette.

Stage 3: Add Texture to the Pillar, Walls and Ground

To create the look of fully painted backgrounds, use the Brush tool to create a variety of textures. With a few strokes you can give the impression of detail and depth to the ground, the masonry wall and the pillar holding the lamp post.

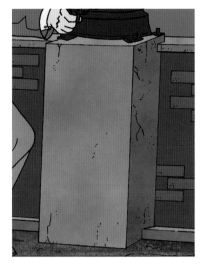

Stucco Brush 01

1 Use the Brush tool with Stucco Brush 01 to create a subtle stone texture on the pillar. Use screen tone C80, M30, Y10, K10.

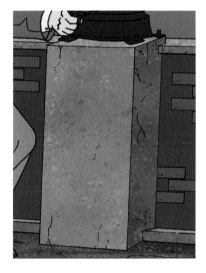

Spatter Brush 2

2 Use Spatter Brush 2 to add larger areas of stone texture to the pillar. Use the brush in Screen mode for the highlights and in Multiply mode for some darker texture. Use screen tone C80, M30, Y10, K10.

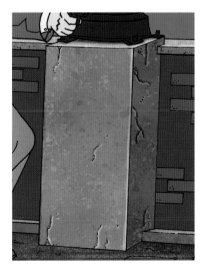

Fine Line Brush

3 Use Fine Line Brush to add highlights to the edges of the pillar. Use the same brush to add highlights and shadows to the cracks and chips in the stone. Use Screen mode for the highlights and Multiply mode to add shadows. Use screen tone C80, M30, Y10, K10.

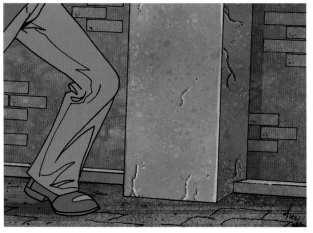

4 Use the same brushes and techniques from page 21 to create textures to the walls and ground in the scene.

Focus on the Details: Rendering the Lamp Post

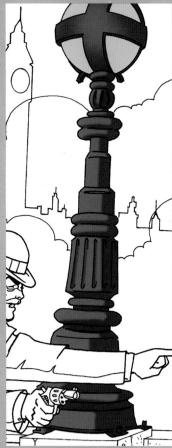
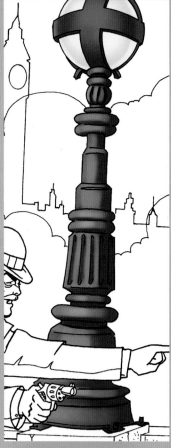
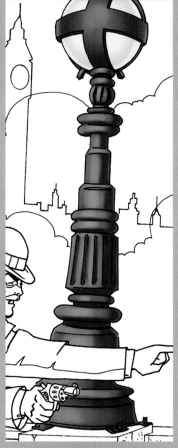

1 Use the Medium Faded Edge Brush to add basic highlights. Use screen tone C80, M30, Y10, K10.

2 Add central highlights to develop the cylindrical shape of the lamp post with the Medium Faded Edge Brush.

3 With the same brush, add the final level of detail and a subtle rim light (see page 36).

Stage 4: Add Atmosphere and Depth

Enhance the depth and atmospheric perspective by creating several levels of fog. Use a texture brush to give the fog volume and form. This will visually define the space between the middle ground and background.

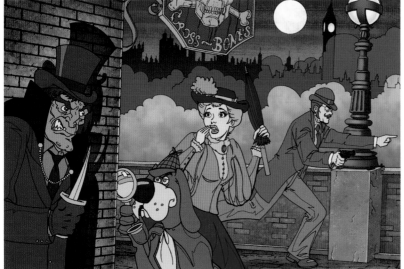

1 Use the Clouds 01 brush to render the lower level of fog. Use screen tone C80, M30, Y10, K10.

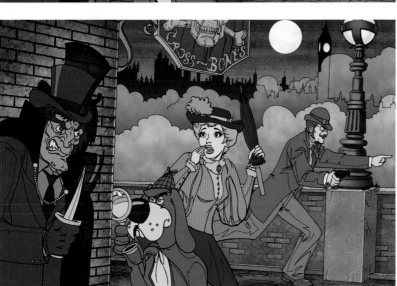

Brush Presets		
Brush Tip Shape	100	Hi-Fi Default Soft Round
☑ Shape Dynamics	500	Clouds 01
☑ Scattering	250	Smoke – Thick N Chunky
☑ Texture		Smoke – Scatter
☐ Dual Brush	887	
☐ Color Dynamics	900	Spatter Brush 1
☑ Other Dynamics		Spatter Brush 2
☐ Noise	1000	
☐ Wet Edges	1000	Rocky Texture Brush
☐ Airbrush		Kirby Dots 01
☑ Smoothing		
☐ Protect Texture		

Master Diameter 500 px

Clouds 01

2 Select the upper level of fog. Using the same brush and screen tone as on Step 1, paint in the fluffy foggy look. Leave the lower edge of the fog slightly darker than the upper edge for contrast and depth.

3 Use the Fine Line Brush (shown on page 21) to paint highlights onto the Cross-Bones sign.

HI-FI
4-STEP

1 Select
2 Isolate
3 Render
4 Merge

Stage 5: Render to the Figures

1 **Render the Phantom Ripper**
Add highlights and shadows to the Ripper character. Keep it relatively clean and simple with a single flat highlight value to complement each base tone. Pay careful attention to where the inker has used a fine line to indicate the boundaries of the highlights, such as on the sleeve, cape and top hat. (Note: We'll get to the glows on the eyes in the last stage; for now, leave the eyeballs as they are.)

Tip

Part of your job as a colorist is to set the mood for each piece you color. When you're coloring in the animation style, you want to find creative ways to make your villains creepy in a kid-friendly way. In this image, for example, it would have been too much to make the knife blade bloody. The greenish skin and hair and the subtly glowing red eyes make this villain creepy but not quite scary.

2 Color the Other Figures

Use the same techniques as you did with the Phantom Ripper to color Sherlock Hound, Lady Penelope and Doctor "Wrong Way" Watson. See the sidebar below for tips on color choices.

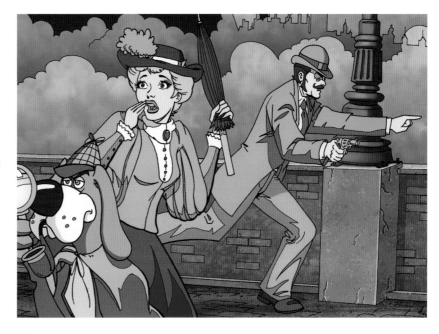

Key Elements of Animation Coloring Style

Clean Line Art

The line work is very open. It has very few areas of heavy shadow and no crosshatching or modeling to shade the color.

Bright, Flat Colors

Cartoon villains can be more colorful than those in a superhero comic book or video game. Villains are traditionally colored with secondary palettes consisting of purples, greens and even oranges.

Simple Rendering

The rendering is clean and simple with a highlight added to complement the base tones. Follow the highlight and shadow areas the artist has indicated such as on the jacket, cape and top hat.

Stage 6: Add Color Holds

1 When you're ready to start adding color holds, open the Actions palette (Window menu > Actions) and use its drop-down menu to load the Hi-Fi action set "Color Holds." For maximum simplicity, enable "Button Mode" from the pull-down menu. Click "Make Holds layer w/ Line-Art," and the action will create a Holds layer with the line art in it.

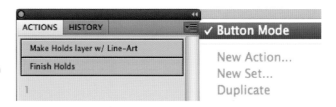

2 Check the Layers palette (Window menu > Layers) and verify that Holds is the active layer. Then Lasso around the first area of line work you want to color-hold. (A rough selection is fine; this layer has "Lock Transparent Pixels" enabled, so the empty space around the lines is protected.)

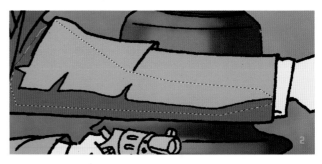

3 Choose a foreground color for the hold, then choose Edit menu > Fill and fill the selection with the foreground color. The first hold is complete. Use Select menu > Deselect to drop the selection.

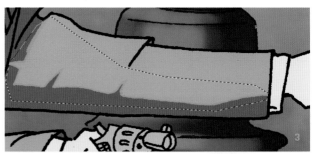

4 Repeat steps 2 and 3 to add the rest of your color holds. Refer to the illustration at the bottom of this page for guidance on where to put holds in the *Sherlock Hound* illustration.

When you're done, open the Actions palette and click "Finish Holds." The action will signal the Holds layer and Line-Art Channel to communicate with one another. The end result will be that only the color holds on the Holds Layer and the Line Art channel will update to reflect the changes. At this point, your color holds are complete.

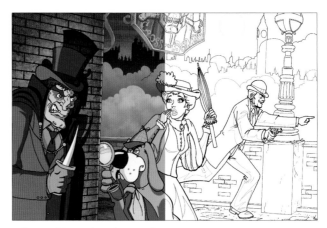

Color Holds, Animation-Style

This split image of the *Sherlock Hound* illustration shows you where color holds were used. Color holding each background elements creates a cohesive look that employs atmospheric perspective. With all the lines in the background color held, the only remaining solid back lines are those on the characters, making them pop off the background. The finishing touch is to color hold the lines that form a boundary between the base color and highlight color on a figure. You can see these lines on "Wrong Way" Watson's jacket, for example.

Video Tutorial

Episode 4: Color Holds

See how color holds are done! It's in video tutorial episode 4 on the Bonus Disc.

Stage 7: Add Special Effects and Save a High-Res File

HI-FI STEP 2 SCRIPT

1 Choose File menu > Scripts > Hi-Fi Step 2 to set up the file for special effects.

2 Use the Hi-Fi Default Soft Round brush to add subtle glows to the page. Use these screen tones: moon: C00, M35, Y75, K00; Big Ben: C00, M05, Y50, K00; lamp: C00, M05, Y50, K00; the Phantom Ripper's eyes: C00, M100, Y100, K00.

HI-FI STEP 3 SCRIPT

3 Once you have completed your image be sure to save your high-res .PSD file. If you want to make a final CMYK image ready to print, choose File menu > Scripts > Hi-Fi Step 3. Select "with Special Effects" and let the script run. Save your file as a CMYK TIFF and be sure not to save over your RGB .PSD file.

Share Your Results at HueDoo.com

To make a low-res version of a finished image for e-mail and online, use the Hi-Fi action "Save As JPG." Share your version and see what other *Master Digital Color* readers have done in the Hi-Fi reader forum at HueDoo.com!

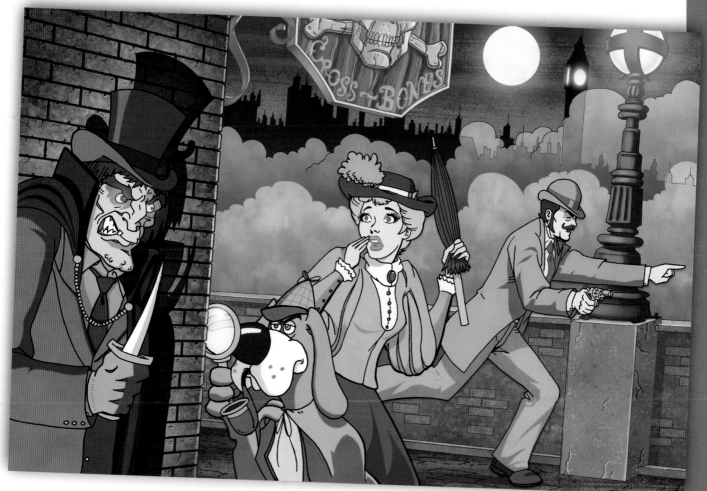

Master-Piece!

Your creative work is terrific. You started with a black-and-white drawing, added the flat colors, used the Hi-Fi 4-Step process for the rendering, made color holds, and added special effects to create a spectacular piece of artwork featuring Mike Worley's Sherlock Hound.

ROYAL TREASURES

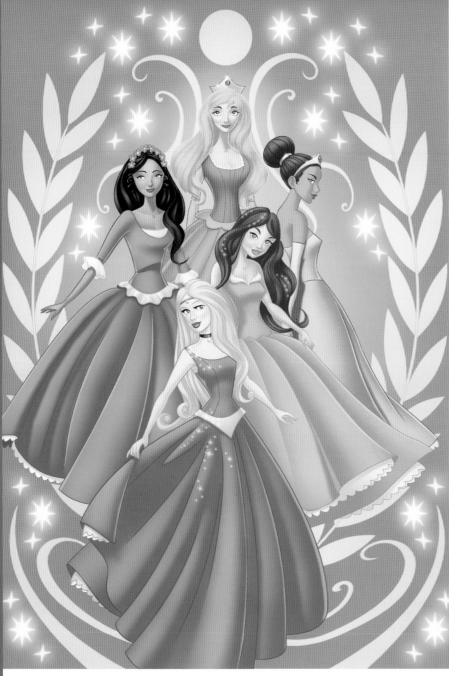

ROYAL TREASURES
Art by Dave Bryant
Color by Hi-Fi
See more at www.davebryantgo.blogspot.com
Royal Treasures © 2009 Bryant & Miller

Most animated television shows and movies are represented one way on-screen and used entirely differently in advertising, movie posters and product packaging. This style is referred to as "animation box art," a style first popularized when studios wanted to re-release older cartoons on video cassette tape, and they needed fresh art to sell the product. Since then, the style has become quite popular for everything from school supplies and lunch boxes to T-shirts and collectable art prints. Any fan of animation will appreciate this beautiful style of coloring.

Learn More About the Artist
If you enjoy coloring this image of *Royal Treasures*, stop by artist Dave Bryant's website www.davebryantgo.blogspot.com, and let him know how much you appreciate his contributions to this book.

Stage 1: Prepare the Line Art and Add Flat Color

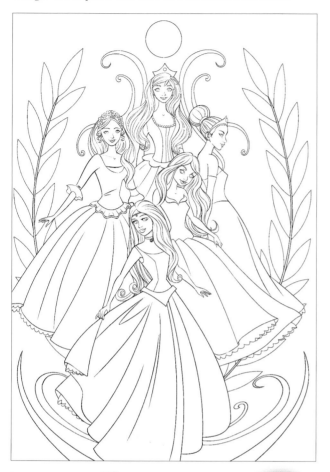

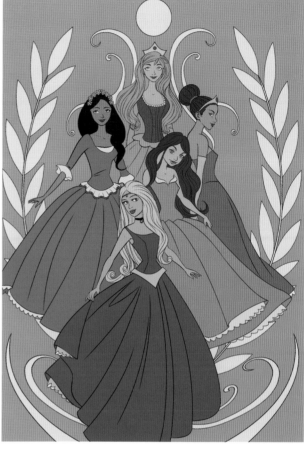

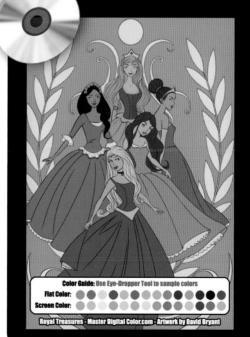

H I-F I STEP 1 SCRIPT

1 From the Bonus Disc, open the file Animation_RoyalTreasures_600.tif. From the Photoshop Menu bar, choose File > Scripts > Hi-Fi Step 1 to prepare the line art for coloring. Unhide the Line Art channel.

2 Use the Lasso tool and the Hi-Fi SPF method (see page 14) to add flat color fills to all the areas of the artwork. Give each princess a distinctive color for her hair and dress.

SPF
Select Area
Pick Color
Fill Area

On the Disc: Color Guide

The Bonus Disc includes Color Guides for the projects in the book. Each Color Guide contains convenient swatches of the color pairs we used for flatting and rendering.

If you want to use our colors, just click each swatch with the Eyedropper tool to sample the color right into your Swatches palette.

Color Guide: Use Eye-Dropper Tool to sample colors
Flat Color:
Screen Color:

Royal Treasures - Master Digital Color.com - Artwork by David Bryant

Stage 2: **Render the Figures**

When coloring each *Royal Treasures* princess, keep in mind this artwork is completely different from most comic book and cartoon art. The focus is on the fashions and hairstyles of the princesses themselves. Give each princess her own distinctive look.

Use the Lasso tool and Brush tool (see the sidebar on the next page) and the Hi-Fi 4-Step process (see page 14) to color each figure. Much of the focus for this illustration is on the fashion; therefore, start by coloring one of the dresses.

When making your selection, it may be best to start with the dresses, as the lighting decisions you make there will carry over to each figure's face, hair and accessories. As you are rendering, think about the lighting in this piece. The dresses are flowing, billowy and soft. Use lighting that highlights the form of the figures and the volume of the hairstyles. Keep the lighting consistent without secondary light sources. Feel free to add a subtle rim light to the edges of the object to help solidify the structure of the form in relation to the surrounding figures.

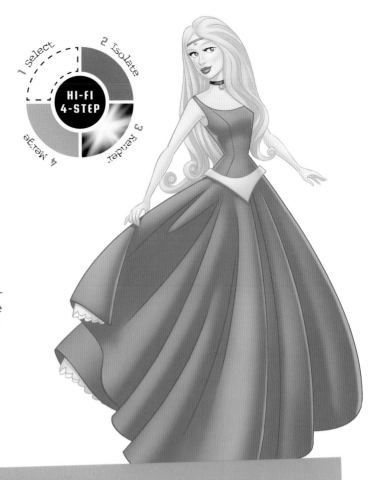

Key Elements of Animation Box Art Style

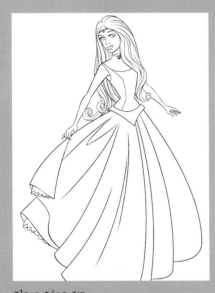

Clean Line Art

The artwork is open with very little areas of heavy shadow and no crosshatching or modeling in the line work.

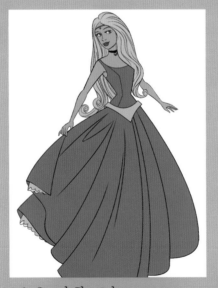

Soft, Pastel, Flat Colors

The base colors consist of soft pastel tones for the dresses and natural colors for the hair: blonde, brown, auburn and black. The princesses come from around the world representing a variety of regions and ethnicities and their hair color reflects that.

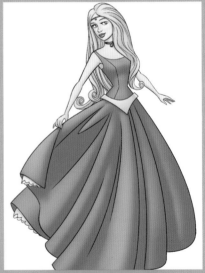

Soft Rendering, Yet Lighting Still Consistent

Keep in mind the light source while adding soft highlights to the dresses. Maintain consistent lighting while coloring her flesh and blonde hair.

Using the Cut-and-Brush Technique With a Soft Edge

The temptation with this animation style is to create most of the rendering freehand with the Brush tool. To maintain form, however, use the Lasso tool with Feather to constrain the brushstrokes within a selection. Keep highlights and contrast consistent over the range of similar objects (such as the dresses) so one area doesn't become more or less rendered than the rest.

Tool Settings

To achieve the effects created on Princess Alexandra, try these tool settings:

- Brush: Hi-Fi Default Soft Round
- Brush mode: Screen
- Lasso tool: Vary the Feather setting between 2 and 12 pixels, depending on how far you want the highlight to spread beyond the edge of your selections.

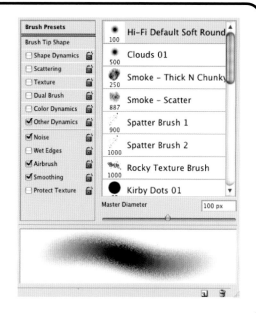

Focus on the Details: Creating Distinct Box Art Characters

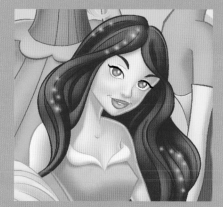

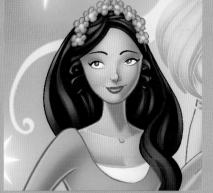

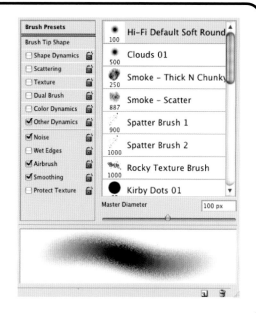

Isabella
Princess Isabella was born and raised in Scotland and wears a delicate pink dress that offsets her lovely red locks.

Jahanara
Princess Jahanara hails from India and wears a dress made of exotic jade-colored silk with colorful flowers contrasting in her raven hair.

Ubani
Princess Ubani is descended from Egyptian royalty and wears a dress of golden saffron and a bejeweled gold tiara.

Adelaide
Princess Adelaide is of French birth and she is usually seen sporting a stylish dress made in multiple shades of pink.

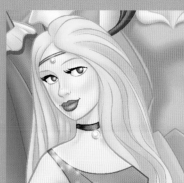

Alexandra
Princess Alexandrea hails from the new world and surrounds herself with sapphire jewels and dresses.

Stage 3: **Add Color Holds**

1 Use the Make Holds action (see page 26) to set up the file for color holds.

2 Use the Lasso tool to select the areas of the line work you want to change from black to a color.

3 Choose the foreground color you want to use, then fill the selected area with the color using Edit > Fill. This is very similar to the SPF method used for flatting, the major difference is that only the black artwork will be affected by the color you fill with.

4 When you are finished with your color holds, play the Finish Holds action (see page 26) before moving on.

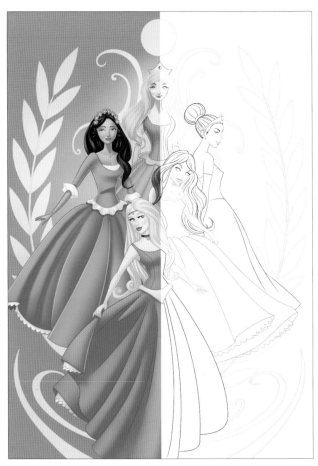

Color Holds for Box Art
In this illustration, nearly every line is color held. The only areas left black are Princess Jahanara's hair and eyebrows as well as all the princesses' eyelashes.
 The color has been removed on the right side of the example allowing you to see where the black line art has been changed to a color.

Stage 4: **Add Special Effects**

 STEP 2 SCRIPT

1 From the Photoshop Menu bar, choose File > Scripts > Hi-Fi Step 2 to set up the file for special effects. Open the Layers palette and click the Special Effects layer to make it the active layer.

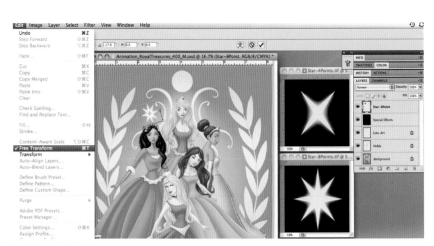

2 Open the Hi-Fi Helper files Star-4Points.tif and Star-8Points.tif (or feel free to use stars you've made).
 Copy and paste (or select and drag) a star into the main image. The star will appear in a new layer above the Special Effects layer. In the Layers palette, select this new layer and set its mode to Screen. Now, choose Edit > Free Transform to rotate, scale and position your star.

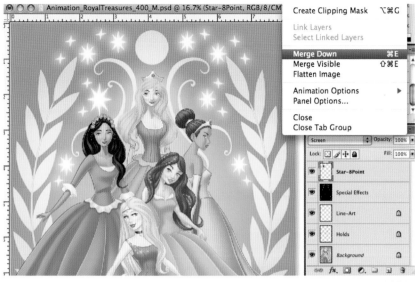

3 Once the star is positioned exactly where you want it, choose the Merge Down command from the drop-down menu in the Layers palette.

Repeat from step 2 to add several more stars to the image.

Open the Hi-Fi Helper file Sparkle 02.tif. Using the same steps you used to add the stars, add some red sparkles to Princess Isabella's red hair. Add golden sparkles to the crowns and jewelry, and add blue sparkles to Princess Alexandra's blue dress.

Stage 5: Save a High-Res File

 STEP 3 SCRIPT

Once you have completed your image, save your high-res .PSD file.

If you want to make a final CMYK image ready to print, choose File > Scripts > Hi-Fi Step 3 from the Menu bar.

Since this image does not have many solid black areas remaining in the inked artwork, select "without Special Effects" and let the script run. Save your file as a CMYK TIFF and be sure not to save over your RGB .PSD file.

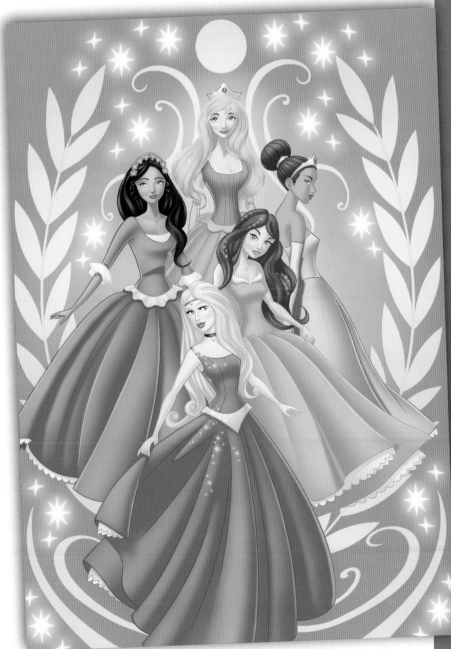

TOMMI TREK

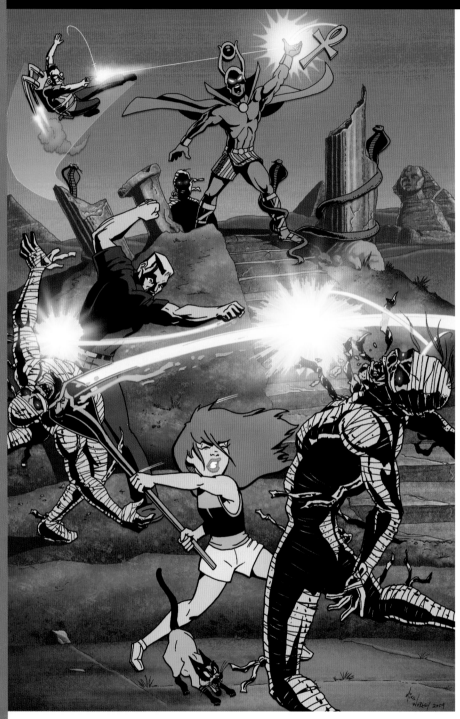

TOMMI TREK VS. THE MUMMIES
Art by Mike Worley
Color by Hi-Fi
See more at www.worleytoons.com
Tommi Trek © 2009 Miller & Worley

When Tommi Trek was a child, her parents were killed in a fiery zeppelin disaster. Now she travels the world with her cat, Outlaw, in search of adventure. In *Tommi Trek vs. The Mummies*, Professor Trek and company run up against the nefarious Kobra King and his army of the walking dead.

Inspired by action cartoons and adventure films, *Tommi Trek*'s color style features painted style backgrounds with most of the figures colored in flat tones.

Stage 1: Prepare the Line Art and Add Flat Color

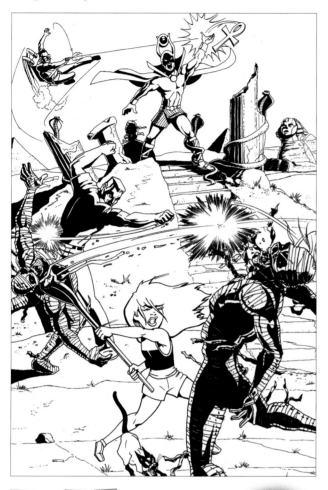

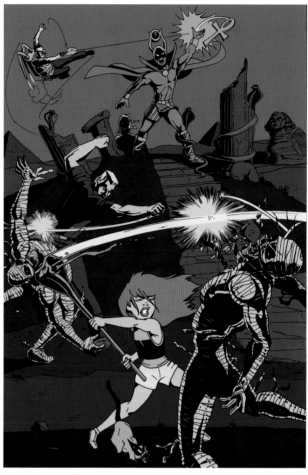

H I-F I
STEP 1 SCRIPT

1 From the Bonus Disc, open the file Animation_Trek_vs_Mummies_600.tif. From the Photoshop Menu bar, choose File > Scripts > Hi-Fi Step 1 to prepare the line art for coloring. Unhide the Line Art channel.

2 Use the Lasso tool and the Hi-Fi SPF method (see page 14) to add flat color fills to all the areas of the artwork. Use exotic colors for the desert background and dull grays for the mummies.

SPF
Select Area
Pick Color
Fill Area

On the Disc: Color Guide

The Bonus Disc includes Color Guides for the projects in the book. Each Color Guide contains convenient swatches of the color pairs we used for flatting and rendering.

If you want to use our colors, just click each swatch with the Eyedropper tool to sample the color right into your Swatches palette.

Stage 2: Add Background Textures and Highlights

Use the Hi-Fi 4-Step process (see page 14) to render the background elements in this scene, starting with the pillars and steps.

1 Use Stucco Brush 01 to create a subtle stone texture while adding highlights to the pillars and steps. Use screen tones C50, M15, Y35, K5.

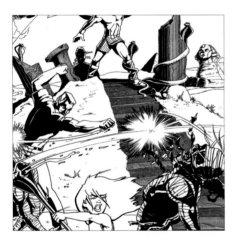

2 Use Spatter Brush 2 with a large diameter such as 1000px to add texture to the pillars and steps. Use the brush in Screen mode for light-colored texture and in Multiply mode for some darker areas of texture. Use screen tone C50, M15, Y35, K5.

3 Use the Fine Line Brush to add highlights to the edges of the pillars and steps. Use the same brush to add highlights and shadows to the cracks and chips in the stone. Use the brush in Screen mode for the highlights and in Multiply mode for the shadows. Use screen tone C50, M15, Y35, K5.

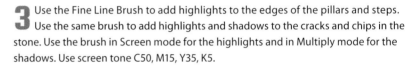

4 Use the Hi-Fi 4-Step process and the same brushes you used in Steps 1–3 to add basic highlights and textures to the mound. Remember to use the bracket keys [and] to change the size of these brushes. Use screen tone C100, M65, Y00, K00.

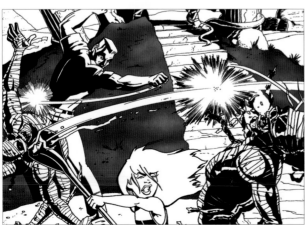

Rim Lighting

Rim lighting is a thin, well-defined highlight that can be used to define where two surfaces of an object meet, such as the horizontal and vertical surfaces of the stone steps. It can also be used to define the point where a surface wraps around and moves out of the point of view of the viewer, as in cylindrical columns and sand dunes.

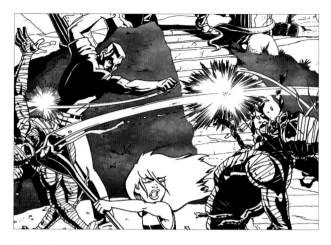

5 Add stronger highlights and texture to the area around Kobra King's feet to draw the viewer's eye up the mound toward the Kobra King himself. Try screen tone C50, M15, Y35, K5.

6 Using the Hi-Fi 4-Step process and the Brush tool (Stucco Brush 01 and Spatter Brush 2) to render the lower areas of the mound and the ground at the bottom of the steps. Leave shadows on the ground to help anchor Tommi Trek and Outlaw the cat on the ground. Without cast shadows, the pair may appear weightless as if they are floating in mid-air.

Focus on the Details: Refining the Background

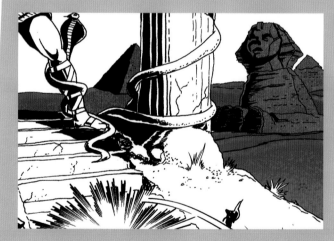

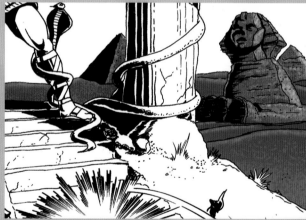

1 Using the Hi-Fi 4-Step process and various texture brushes, add areas of subtle light into the far background scene. Use screen tone C15, M75, Y25, K00.

2 Suggest dimension by adding more light to the side of the Sphinx and pyramids. Add a rim light to the top edge of each sand dune for depth. Use screen tone C15, M75, Y25, K00.

Stage 3: Render the Sky

Create an atmospheric sky for your illustration with colors that suggest twilight to create interaction with the viewer. How does the waning light alter the mood of the illustration? Do the violet and purple hues direct the viewer's eyes to the warmer colors of the figures? Does its subtle texture create extra depth? The answers to these questions affect the entire illustration.

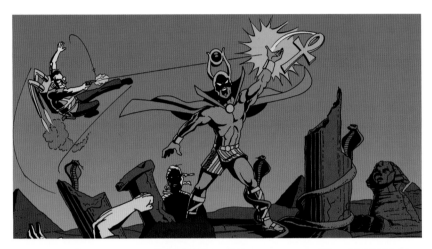

1 Select the sky with the Magic Wand tool and use the Gradient tool to add some light emanating from the horizon. Use screen tone C00, M60, Y20, K00.

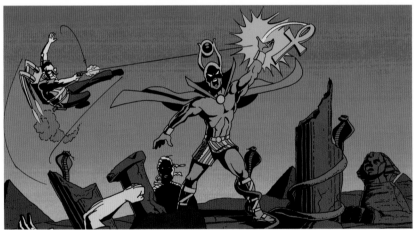

2 Use Streaky Brush 02 to add detail highlights to the night sky. Use screen tone C00, M60, Y20, K00.

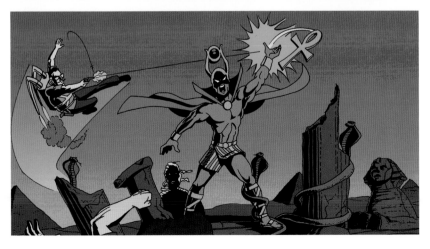

3 Use the Gradient tool to lighten the speed trail behind Professor Trek.

Stage 4: Color the Figures

In the Hi-Fi colored version of this *Tommi Trek* scene, there's little to no rendering in the figures. It works because of the large inked shadows, which serve as high-contrast rendering. The resulting scene looks harshly lit, helping to heighten the tension in this dynamic action/adventure story. You can take the same approach, or you can use the Hi-Fi 4-Step process to add some rendering and detail.

Stage 5: Add Color Holds

1 Use the Make Holds action (see page 26) to set up the file for color holds.

2 Lasso a rough selection around the first area of line work you want to color.

3 Try this technique for choosing hold colors: First use the Eyedropper tool to grab the base color of an area, then use the Color Picker to create a darker version of that color, and use that for the hold. Use Edit > Fill to fill the selection with the chosen color.

4 When you're finished adding color holds, play the Finish Holds action (see page 26) before moving on.

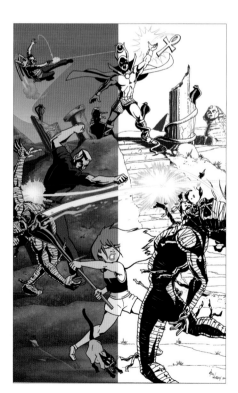

Tip
If you change your mind about your flat color choices at this stage, use the Magic Wand tool to select the flatted area and then fill it with a new color.

Choosing Color Holds for This Scene
The background of this *Tommi Trek* illustration has a painted look, which you achieve by color-holding all the lines in each and every background element. Let all the lines in the figures remain black, to make the characters stand out against the background. Also, the impact of the large inked shadows would be lost if these areas were changed to a color other than black.

Stage 6: Add Special Effects

HI-FI STEP 2 SCRIPT

1 From the Photoshop Menu bar, choose File > Scripts > Hi-Fi Step 2 to set up the file for special effects. Open the Layers palette and click the Special Effects layer to make it the active layer.

2 Open the Hi-Fi Helper file Flare02.tif.

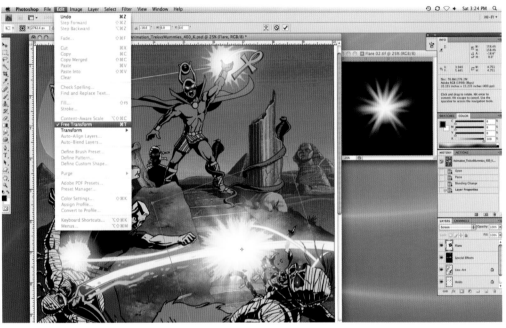

3 Copy and paste (or select and drag) a flare onto the *Tommi Trek* image. The flare will appear on a new layer above the Special Effects layer. In the Layers palette, select this new layer and set its mode to Screen.

Choose Edit > Free Transform to rotate, scale and position the flare.

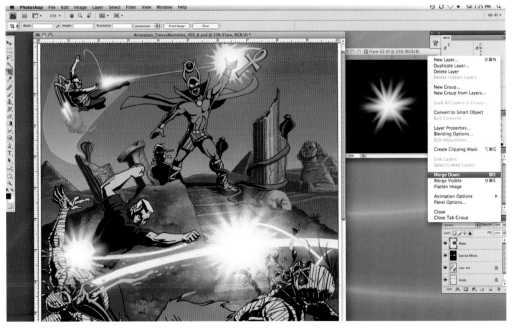

4 Once you have your flare positioned exactly where you want it, choose the Merge Down command from the drop-down menu in the Layers palette.

Repeat step 3 to add the remaining flares to the image. Use the Hi-Fi Helper file MuzzleBlast.tif for the blasts on Professor Trek's rocket pack and gun.

Stage 7: Save a High-Res File

HI-FI STEP 3 SCRIPT

Once you have completed your image, be sure to save your high-res .PSD file. If you want to make a final CMYK image ready to print, choose File > Scripts > Hi-Fi Step 3 from the Menu bar. Select "with Special Effects" and let the script run. Save your file as a CMYK TIFF and be sure not to save over your RGB .PSD file.

Learn More About the Artist
If you enjoyed coloring this image of *Tommi Trek*, stop by artist Mike Worley's website: www.worleytoons.com and let him know how much you appreciate his contributions to this book.

Share Your Results at HueDoo.com
To make a low-res version of a finished image for e-mail and online, use the Hi-Fi action "Save As JPG." Share your version and see what others have done in the Hi-Fi reader forum at HueDoo.com!

Animation Field Trip

Watch your favorite animated cartoon or TV show, and pay attention to backgrounds, special effects, color palettes and color holds. Then go to the toy section of your favorite store and find those same properties. Look for differences and similarities between the print and screen versions.

How do things translate from the cartoon to the package? Can you tell where they had to push or bend the property to make it work in print? Do you think kids or people that don't work in digital color notice these differences? In what properties do you notice the biggest differences?

For the last part of this homework assignment, think up your own original idea for a group of cartoon characters, draw them, and color them using the techniques in *Master Digital Color*.

Share Your Homework at HueDoo.com
We encourage our students to peek at each others' homework! Join the reader forum at HueDoo.com and share your homework results in the Hi-Fi reader forum.

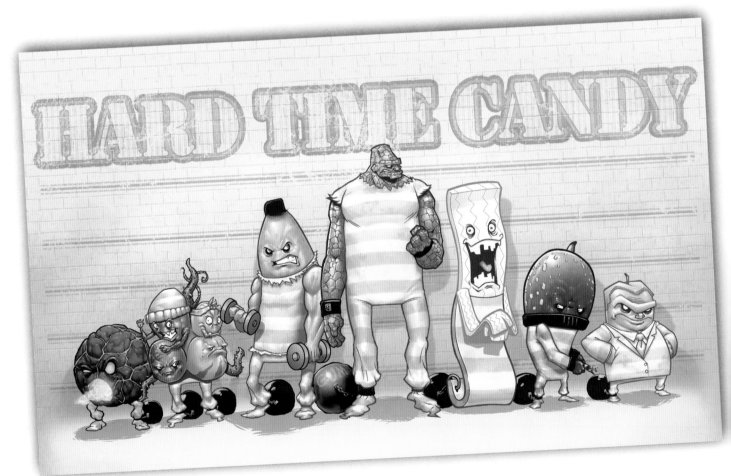

HARD TIME CANDY
Art and color by Hi-Fi's Dustin Yee
Hard Time Candy © Dustin Yee

Characters Designed for Multiple Uses
Artist Dustin Yee created these characters to work on screen, in print and for video games and toys.

Set the Scene

If you have completed the three animation-style tutorials you will have rendered a foggy London cityscape, created a pink princess background, and colored the pyramids of ancient Egypt. Settings play an important role in comic and animation art.

Your challenge is to create four background setting variations for this animated version of Martheus Wade's *Jetta*.

You want to establish a believable setting for the character to inhabit. You can paint your backgrounds directly into Photoshop or feel free to draw your backgrounds on paper, import them into Photoshop where you can color them and use the "Paste Into" command to insert your backgrounds behind Jetta. You can also use Hi-Fi Helpers and special effects to enhance the backgrounds you create for this animation-style artwork.

Start by thinking about Jetta's story: what does she look like and what would she be wearing in an animation world? After you have flatted and rendered Jetta, you need to put her in an interesting background. Try a variety of settings. Maybe Jetta is preparing to battle thugs in the alley of a large city. Or she could be fighting assassins in a bamboo forest. Perhaps she is standing high above the city on a rooftop overlooking the streets below. She could even be surfing off the coast of Hawaii. Your imagination is the only limit to what is possible.

In addition to the physical location of the setting you need to think about the mood of the setting as well. You could create a spooky feeling background first. Then maybe a lighter, softer, mood with a gentle sunset. What about an action-packed mood using speed lines to imply action?

Use location and mood to establish fun, exciting, believable settings for Jetta to live in.

Bonus Disc

Homework Challenge File: Ani_Jetta_600.tif

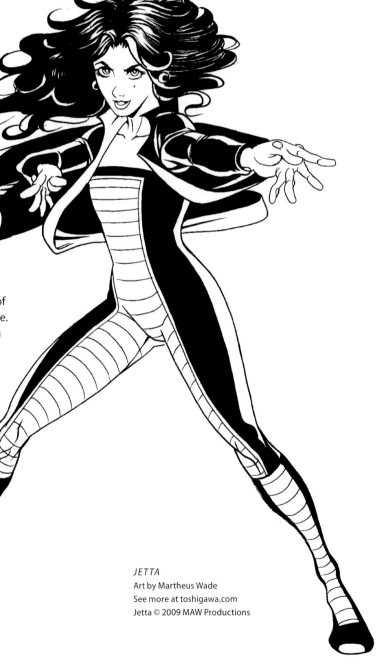

JETTA
Art by Martheus Wade
See more at toshigawa.com
Jetta © 2009 MAW Productions

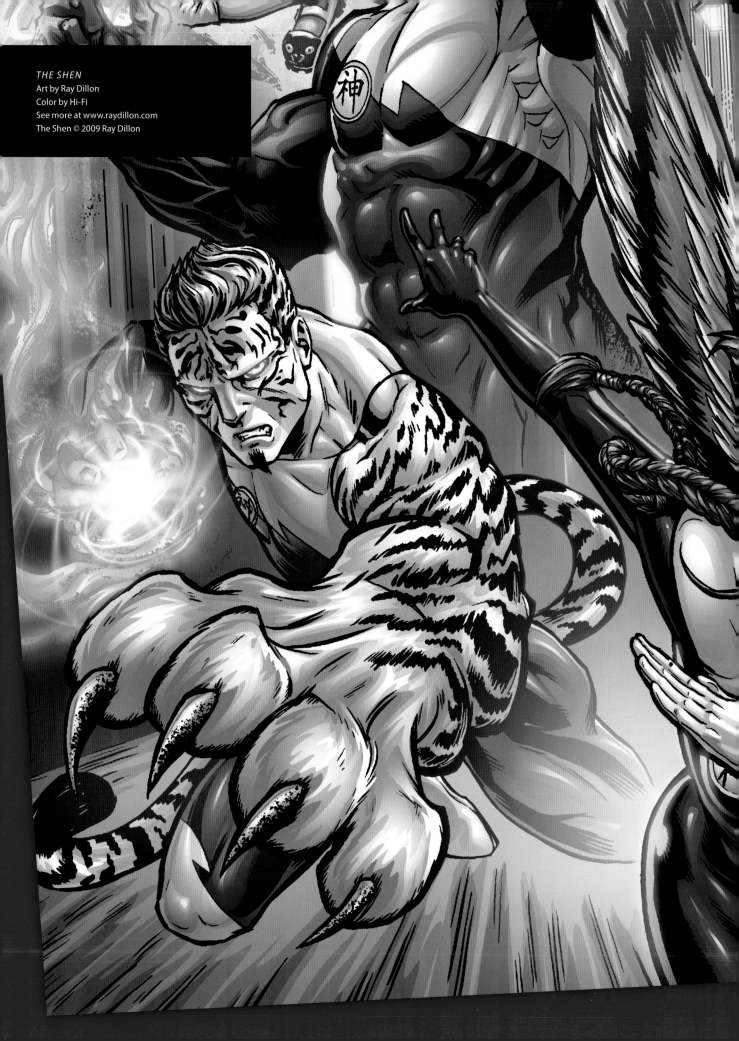

Superhero Style

Superheroes. The foundation of modern comics, superheroes have been approached in a variety of visual representations from squeaky clean super-friends to dark and brooding knights. As a colorist, you need to adapt your coloring styles to suit the artwork for any given comic book story. Heroes have been colored in flat primary colors and have evolved with technology to airbrush styles that were popular in the 1980s and on to the basic gradients of early digital color in the 1990s. The superfast computers and advanced imaging tools available today give you infinite possibilities when it comes to creating a unique look and feel for each project you color.

Learn More About the Artist
Ray Dillon is an artist working in comic books, film, video games and trading cards. Owner of Golden Goat Studios, Inc., Ray has penciled, inked, colored, painted and lettered comics for nearly a decade. He lives in Salina, Kansas, with his wife, Renae De Liz (artist for IDW, Archie and Image), and their son, Tycen.

THE SCARAB

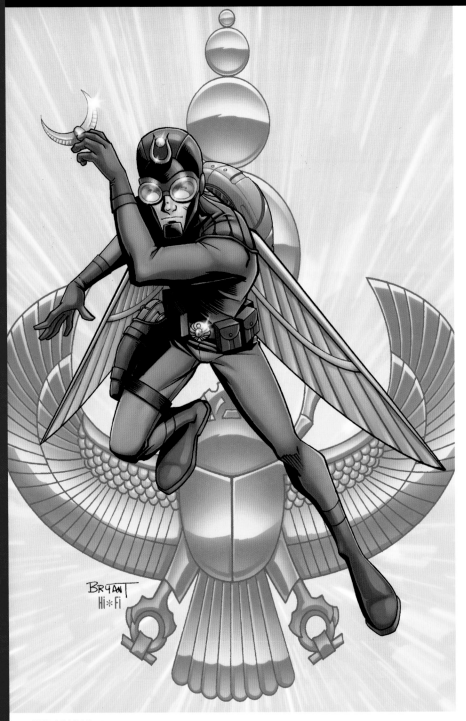

Among crumbling tombs of a lost civilization, archaeologist Kris Nichols discovers an ancient secret and in exchange for his life, vows to protect the innocent and uphold justice as the Scarab.

For *The Scarab* your approach is primarily Brush-tool based. Your goal is to explore the variety of techniques the Brush tool has to offer while incorporating the cut-and-brush and cut-and-grad techniques to create a hybrid look unique to *The Scarab*. The more time you spend with these tools, the more dexterity you will have to bring your vision to the colors. Once you have full control over the Brush tool, the only limit to what you can achieve is your own creativity.

THE SCARAB
Art by Dave Bryant
Color by Hi-Fi
See more at www.davebryantgo.blogspot.com
The Scarab © 2009 Bryant & Miller

Stage 1: Prepare the Line Art and Add Flat Color

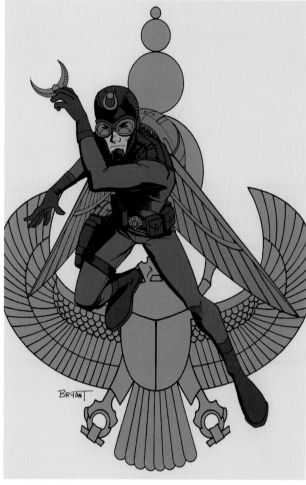

HI-FI
STEP 1
SCRIPT

1 From the Bonus Disc, open the file Hero_Scarab_600.tif. From the Photoshop Menu bar, choose File > Scripts > Hi-Fi Step 1 to prepare the line art for coloring. Unhide the Line Art channel.

2 Use the Lasso tool and the Hi-Fi SPF method (see page 14) to add flat color fills to all the areas of the artwork. For the Scarab, try a blue and gold theme to reflect the ancient Egyptian heritage of his powers.

SPF
Select Area
Pick Color
Fill Area

Color Guide: Use Eye-Dropper Tool to sample colors
Flat Color:
Screen Color:
The Scarab - Master Digital Color.com - Artwork by David Bryant

On the Disc: Color Guide

The Bonus Disc includes Color Guides for the projects in the book. Each Color Guide contains convenient swatches of the color pairs we used for flatting and rendering.

If you want to use our colors, just click each swatch with the Eyedropper tool to sample the color right into your Swatches palette.

Stage 2: Add the Background

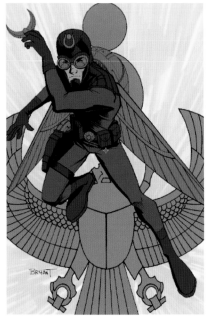

1 Open the Hi-Fi Helper file Warp_LightSpeed.tif or use any warp or flare you have made. From Photoshop's Menu bar, choose Select > All, then Edit > Copy.

2 Return to the Scarab's window. Use the Magic Wand tool to select the entire background. (Tip: turn off the Magic Wand's "Contiguous" option.) Then, from the Menu bar, choose Edit > Paste Into.

3 The warp will appear as a new layer above the Background layer. The layer mask hides areas of the warp that are outside of the original background selection. Set the layer mode for this new layer to Screen.

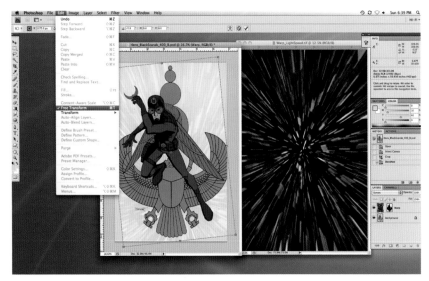

4 From the Menu bar, choose Edit > Free Transform to rotate, scale and position your warp. When you are happy with the transformation push Return (PC: Enter) to apply the transformation.

5 Once you have the warp positioned exactly where you want it, choose the Merge Down command from the drop-down menu in the Layers palette.

New Layer... ⇧⌘N
Duplicate Layer...
Delete Layer
Delete Hidden Layers

New Group...
New Group from Layers...

Lock All Layers in Group...

Convert to Smart Object
Edit Contents

Layer Properties...
Blending Options...
Edit Adjustment...

Create Clipping Mask ⌥⌘G

Link Layers
Select Linked Layers

Merge Down ⌘E
Merge Visible ⇧⌘E
Flatten Image

Animation Options ▶
Panel Options...

Stage 3: Rendering the Golden Scarab

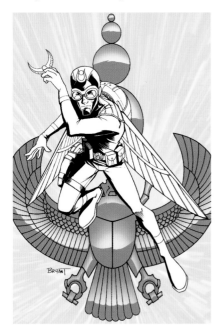 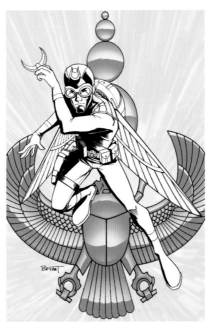 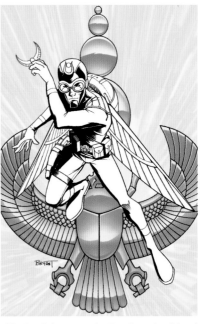

1 Start by imagining where the horizon line would be on the scarab's wings, body, tail and discs. The color has been removed from the figure to help you focus on the background elements.

2 Use the Gradient Brush tool to add light rising from below your imaginary horizon line on the wings, tail, body and discs. Add rim lighting and detail to the edges of the wings and legs.

3 Finish by using the Brush tool to blend the area along the imaginary horizon line. Add any final details and highlights.

Focus on the Details: Rendering Reflective Metallic Surfaces

The key to rendering metallic surfaces is to make the surface look as if it is reflecting a surrounding landscape.

1 Select a flatted object with the Magic Wand, then isolate it using Layer Via Copy. Use the Color Picker to select a color that suggests light reflecting off a metallic surface. For gold and brass, select warm golden tones. Lasso around the top half of the shape, creating a jagged horizon line, then use the Gradient tool on the selection to suggest light coming from below the horizon.

2 Use the Gradient tool to bring a hint of light from the bottom of the object to create the illusion of land receding toward the horizon.

3 Use the Brush tool to add a subtle glow along the horizon that blends subtly into the darker color. Imagine a sunrise just peeking over the horizon.

Video Tutorial

Episode 5: Metallic Surfaces

Look on the Bonus Disc for video tutorial episode 5 about rendering metallic surfaces.

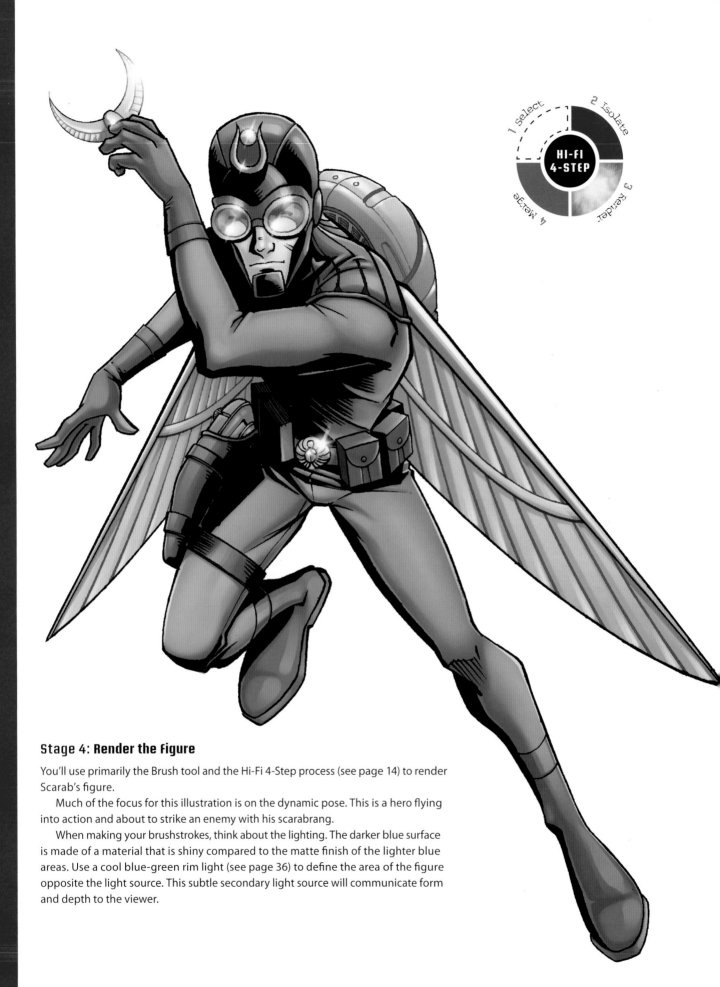

HI-FI 4-STEP

1 Select
2 Isolate
3 Render
4 Merge

Stage 4: Render the Figure

You'll use primarily the Brush tool and the Hi-Fi 4-Step process (see page 14) to render Scarab's figure.

Much of the focus for this illustration is on the dynamic pose. This is a hero flying into action and about to strike an enemy with his scarabrang.

When making your brushstrokes, think about the lighting. The darker blue surface is made of a material that is shiny compared to the matte finish of the lighter blue areas. Use a cool blue-green rim light (see page 36) to define the area of the figure opposite the light source. This subtle secondary light source will communicate form and depth to the viewer.

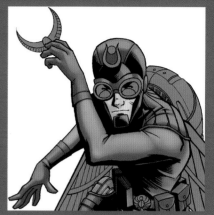

1 Study the inked shadows; they are clues to where the highlights should go. The deepest shadows on an object are directly opposite the light source, so the primary light source here is above the figure and slightly to the viewer's right.

Use the Hi-Fi Default Soft Round Brush to add the first level of highlights to the Scarab. Start by creating a general sense of light and shadow within the figure's form. Remember, if the first brushstroke you lay down isn't perfect, you can always undo and try again. Take your time to create a solid foundation for your figure before adding details.

2 Use the following Photoshop default brushes, which have a slightly harder edge than the Hi-Fi Default Soft Round, to clearly define where the highlight areas begin and end: Round Brush, 125px Fade; Round Brush, 100px Fade; and Round Brush, 75px Fade.

Highlights are crucial to creating realistic-looking human anatomy, and even more so with muscular superheroes. Notice here how the highlights define the separate yet connected structures of the shoulder, bicep, elbow, forearm and wrist. You might find it helpful to look at reference books, such as Buddy Scalera's *Comic Artist's Photo Reference* series.

3 Add a second set of highlights, the core highlights, using these Hi-Fi brushes: Normal Paint – Brush 01 and Normal Paint – Brush 02.

These highlights help define the Scarab's form and also serve to marry the underlying construction of the form to the surface rendering.

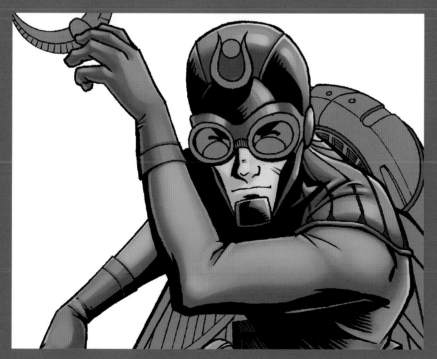

4 Use the Medium Faded Edge Brush to add final highlights to the figure. In essence, you're making decisions about the surface and using your rendering skills and the Hi-Fi 4-Step process to communicate your decisions to the viewer.

Use the Blending Brush to smooth away any imperfections.

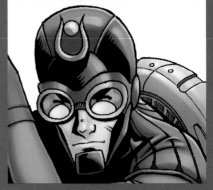

1 When adding your first level of highlights, the most important aspect to keep in mind is the overall roundness of the head.

2 The second level of highlights start to bring out definition of individual elements like the goggles and facial features.

3 Finish the face and head by adding details to the cowl and goggles, and refine details like the nose, earpiece and golden areas on the cowl.

Key Elements of Superhero Style

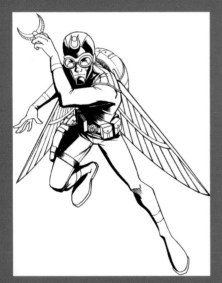

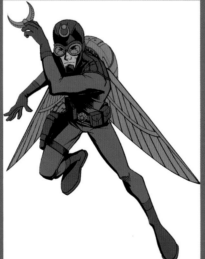

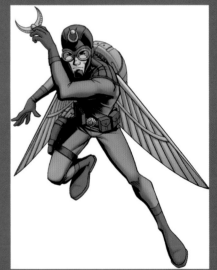

Well-Defined Line Art
Dave Bryant's artwork features clearly defined elements highlighted by varying line weights and solidly inked areas indicating shadows.

Flat Color
Use two shades of blue to break down the Scarab's costume and gold for his goggles, flight pack and other details.

Rendering
The ambient light source is above and slightly to the right. Keep this in mind to create a consistent and believable figure.

Stage 5: Add Color Holds

1 Use the Make Holds action (see page 26) to set up the file for color holds.

2 Lasso a rough selection around the first area of line work you want to color.

3 Use the Color Picker to choose a color for the hold, then choose Edit > Fill and fill the selection with the foreground color, or you can simply use the Fill Command (see the sidebar below).

4 Repeat steps 2 and 3 to create the remaining holds. For the holds on the golden scarab, use the Eyedropper to get a flat color from the artwork, then use the Color Picker to create a slightly darker version of that color for the hold.

5 When you are finished adding holds, play the Finish Holds action (see page 26) before moving on.

Fill Command

There is a shortcut for Edit > Fill that's commonly referred to as the "Fill Command." This is Option + Delete (Mac) or Alt + Backspace (PC).

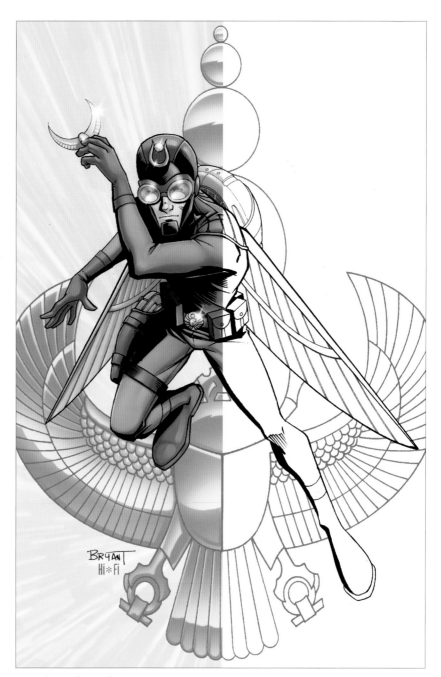

Choosing Color Holds for a Superhero

To add depth to this illustration, color-hold all the lines in the golden scarab in the background, but leave the lines in the figure black (except for a few lines within the goggles and flight pack where color holds are helpful).

For a superhero who's leaping toward the viewer, you want to really push the background/foreground contrast to emphasize power and speed. Superheroes are all about extremes, so don't be afraid to exaggerate your color choices to create more contrast and depth.

Stage 6: Add Special Effects

 STEP 2
SCRIPT

1 From the Photoshop Menu bar, choose File > Scripts > Hi-Fi Step 2 to set up the file for special effects.

Flare02.tif

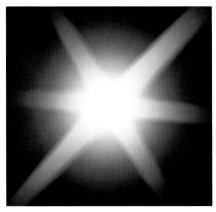

Sparkle03.tif

2 Open the Hi-Fi Helper files Flare02.tif and Sparkle03.tif.

3 Copy and paste (or select and drag) a flare onto the Scarab image. The flare will appear on a new layer above the Special Effects layer. Select that new layer in the Layers palette and set its mode to Screen. Then, from the Menu bar, choose Edit > Free Transform to rotate, scale and position the flare. When you are happy with the transformation, hit Return (PC: Enter) to apply the transformation.

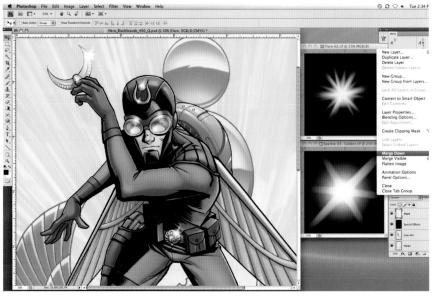

4 Once you have your flare positioned exactly where you want it, choose the Merge Down command from the Layer palette drop-down menu.
 Repeat these four steps to add multiple flares and sparkles to the image.

Stage 7: Save a High-Res File

 STEP 3 SCRIPT

Once you have completed your image, save your high-res .PSD file.

If you want to make a final CMYK image that's ready to print, choose File > Scripts > Hi-Fi Step 3 from the Menu bar.

Select "with Special Effects" and let the script run. Save your file as a CMYK TIFF. Do not save over your RGB .PSD file.

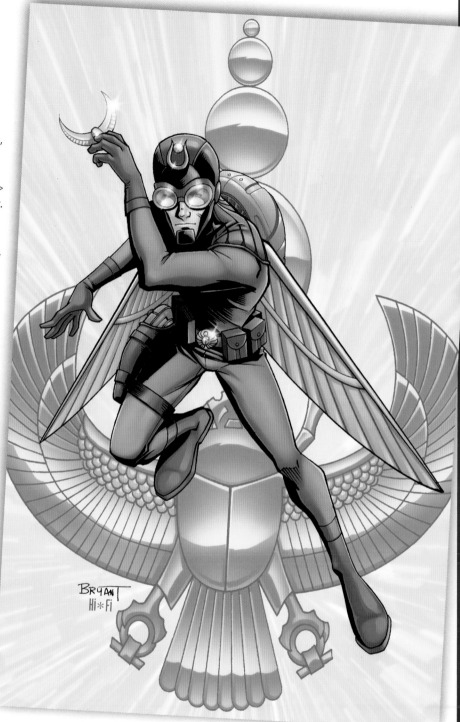

Learn More About the Artist
If you enjoyed coloring this illustration of *The Scarab*, stop by Dave Bryant's website: www.davebryantgo.blogspot.com and let him know how much you appreciate his contribution to this book.

Share Your Results at HueDoo.com

To make a low-res version of a finished image for e-mail and online, use the Hi-Fi action "Save As JPG." Share your version and see what others have done in the Hi-Fi reader forum at HueDoo.com!

THE SHEN

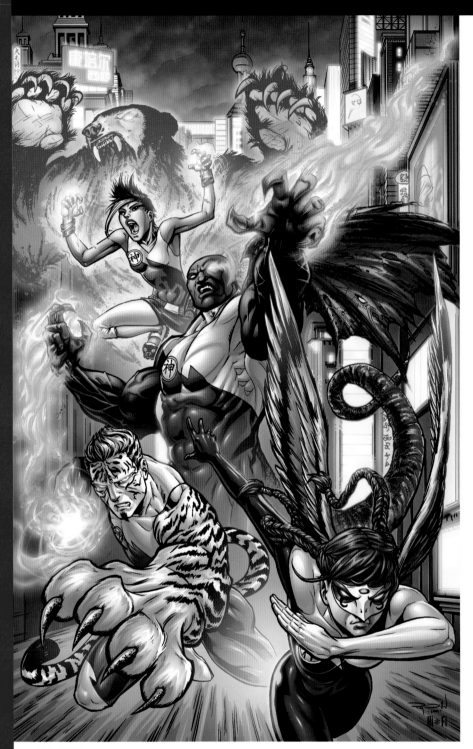

Ray Dillon's tale of *The Shen* is set in modern day and follows the adventures of four strangers from around the globe visiting Shanghai. After a plane crash they manifest powers and are revered as deities walking among mortal men to stop unforeseen supernatural forces from bringing an end to the world.

The Shen Are...

Benjamin Song—power of the dragon
Jena Huang—power of the hawk
Billy Hu—power of the tiger
Cali Hung—power of the bear

THE SHEN
Art by Ray Dillon
Color by Hi-Fi
See more at www.raydillon.com
The Shen © 2009 Ray Dillon

Stage 1: Prepare the Line Art and Add Flat Color

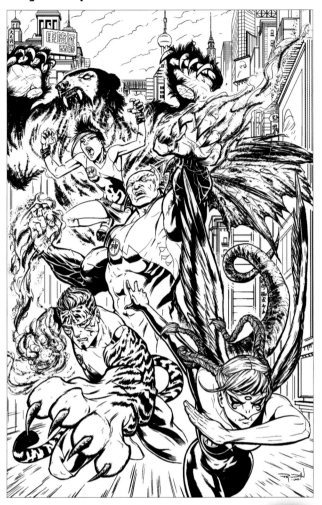

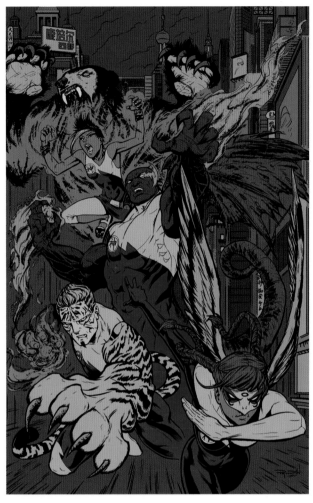

 STEP 1
SCRIPT

1 From the Bonus Disc, open the file Hero_Shen_600.tif. From the Photoshop Menu bar, choose File > Scripts > Hi-Fi Step 1 to prepare the line art for coloring. Unhide the Line Art channel.

2 Use the Hi-Fi SPF method (see page 14) to add flat color fills. Use cool, dark colors for the cityscape. For the figures, use a limited number of neutral tones: sometimes less variety creates more clarity, and clarity is key in an illustration with this much action.

SPF
Select Area
Pick Color
Fill Area

On the Disc: Color Guide

The Bonus Disc includes Color Guides for the projects in the book. Each Color Guide contains convenient swatches of the color pairs we used for flatting and rendering.

If you want to use our colors, just click each swatch with the Eyedropper tool to sample the color right into your Swatches palette.

Color Guide: Use Eye-Dropper Tool to sample colors
Flat Color:
Screen Color:

The Shen - Master Digital Color.com - Artwork by Ray Dillon

Rendering Techniques for Superhero Team Portraits

The rendering for a superhero team portrait needs to show the team in (literally) a unified light, yet it should also allow the viewer to focus on each team member's unique powers. The direction of the light source may already be defined by the inker, but the choices you, the colorist, make during rendering will largely determine the overall effectiveness of the portrait.

For starters, you must keep the direction of the light source consistent across all the figures in order to anchor them together believably in the same scene. (Watch out for inconsistent lighting when combining photo reference from different sources.)

See below for several other rendering techniques you can use to maximize the power of a team portrait. And remember: Superheroes are extreme, so push; exaggerate!

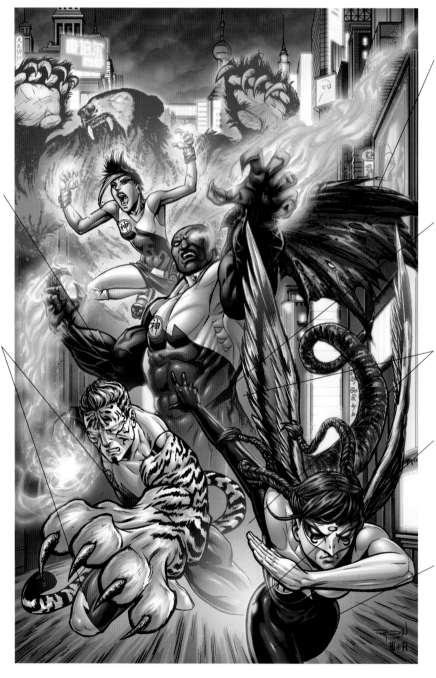

Directional lighting creates distinct shadows that emphasize physical form—especially important for super-muscular characters.

Atmospheric perspective (the phenomenon of nearby objects appearing sharper and more contrasting than distant ones) can be exaggerated and used within a single figure to make a character look as if he's leaping off the page.

Use the Lasso tool to control where light is added with the Brush tool to imply various surface textures. Benjamin's dragon wing and tail look rough compared to the slickness of his costume.

Differences in contrast (aided by glows and color holds) can be used to create depth and visual separation between overlapping characters.

Leaving some uncluttered spaces between the figures makes it easier to pick out the individuals.

Rim lighting defines a surface where it falls out of view or where two surfaces meet. Here, the rim light separates Jena's figure from the background elements.

Intense light shows off surface textures, such as this highly reflective costume. The slick material suggests speed.

Stage 2: Render the Cityscape

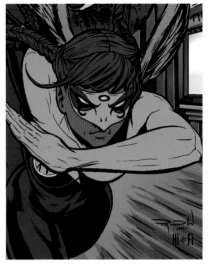

1 Make the sky dark and stormy by adding natural-looking, foreboding clouds with the Clouds 01 brush.

2 Use the cut-and-brush technique (see page 14) to add cool highlights to the buildings and pale golden lights to the windows.

3 Use the Lasso tool to make burst-style cuts on the ground to integrate the color and rendering into the artwork around the figures near the ground.

Key Elements of the Superhero Cut-and-Brush Style

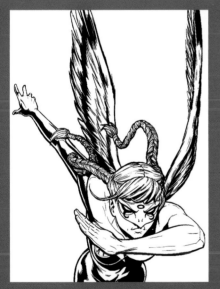

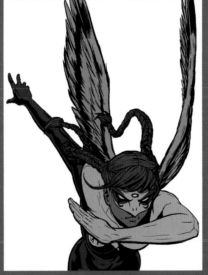

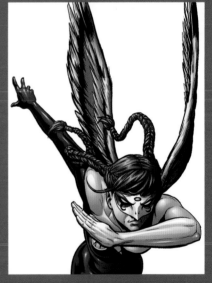

Dynamic Line Art
Ray Dillon's artwork is dynamic and full of energy. Combine core shadows with varying contour lines to clearly define the figures' forms while suggesting the primary and secondary light sources.

Neutral Flat Color
Use neutral tones for the figures that will stand out against the cool blues of the background. With so much action in this illustration, clarity is key. Sometimes less variety creates more clarity when making your color selections.

Rendering for a Harmonious Whole
The primary light source is above and slightly to the left of the figures. Keep this in mind while rendering to ensure all four figures work together in harmony.

Stage 3: Add Highlights and Details

This illustration of the Shen is representative of many comic book covers and illustrations you may be asked to color. The scene is packed with action and characters. It can easily become muddied and disjointed without a bit of planning. Try breaking down the scene into different elements: Perhaps you want to render only the red elements first, or completely color one figure before moving onto the next. Sometimes it may feel more natural to render all the flesh tones before adding highlights to the costumes. Which approach works best? Depending on the project and the deadline, it may be any one or any combination. Experiment and find the solution that works best for you.

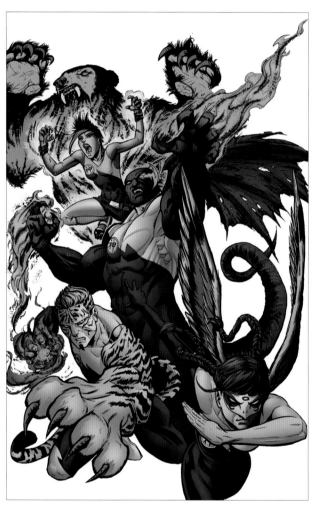

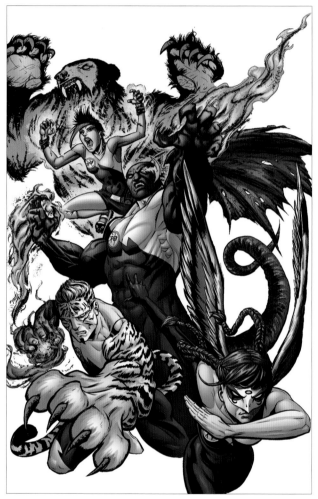

1 Add the first cuts, keeping in mind that the primary light source is above the figures and slightly to the viewer's left. Use the Hi-Fi 4-Step process (see page 14) and the Hi-Fi Default Soft Round brush. To add the halo around Cali Hung (inside the spirit of the bear), use the Hi-Fi brush called Brush & Shrub.

2 Using the same techniques as in Step 1, add the second level of highlights, refining the first cuts. On Billy Hu's tiger paw, make jagged selections to create the representation of fur. On areas where similar colors overlap (such as where Jena Huang's arm and hand intersect with Benjamin Song's abdomen), plan your highlights to help separate and clarify the forms.

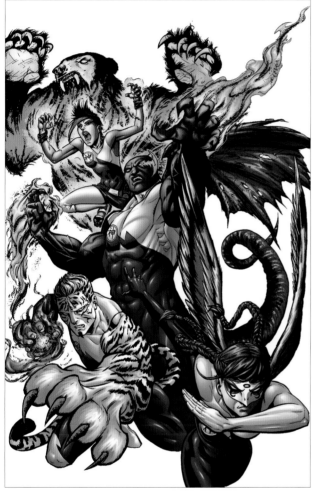

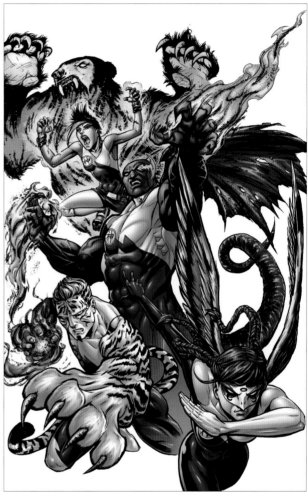

3 Add the third and final level of cuts, using these tips:

- For the highlights on the costumes, keep the cuts small and tightly focused, and use the lightest screen tones to create a shimmery look.

- For the flesh and fur, focus on adding detail and creating contrast while maintaining a matte appearance.

- For the dragon wings and tail, use chunky, irregular highlights for a rough-hewn look.

- For Jena Huang's hawk wings, use a natural golden beige tone, and leave a portion of the wings in shadow to help create form and depth.

4 Finish the rendering with these details:

- Render the highlights on the smallest features such as the eyes, teeth, lips and claws.

- Add a cool blue rim light (see page 36) to the lower edges of the figures.

- Add subtle rim lighting to Benjamin Song's neck and chest where the light of the dragon fire reflects on his body. Do the same on Jena Huang's arm and side.

- Add the strong blue side lighting to Billy Hu's face, chest and tail (imagine his tiger blast as the source of this light).

- When you are finished with the rendering, save your file before moving on.

Stage 4: Add Color Holds

If you've done the preceding projects in this book, you've become well versed at making color holds, so we'll give you this split image as your guide for where to add the holds to *The Shen*.

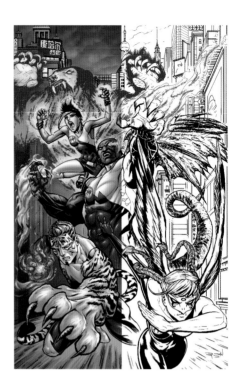

1 Use the Make Holds action (see page 26) to set up the file for color holds.

2 Lasso a rough selection around the first area of line work you want to color; then choose the hold color and use Edit > Fill to fill the selection with the chosen color.

3 Repeat Step 2 to add the remaining color holds.

4 When you're finished adding color holds, play the Finish Holds action (see page 26) before moving on.

Stage 5: Add Special Effects

The special effects in this illustration are glows, and lots of them. We'll show you the steps one at a time.

 STEP 2 SCRIPT

1 From the Photoshop Menu bar, choose File > Scripts > Hi-Fi Step 2 to set up the file for special effects. When the script is finished, open the Layers palette and click the Special Effects layer to make it the active layer.

2 Use the Hi-Fi Default Soft Round brush to add glows to the lights in the windows and to the neon signs in the background.

3 Using a vibrant blue tone (try C100, M65, Y00, K00) and the technique from Step 2, add glows in the following areas:
- Around Cali Hung and the spirit of the bear
- In the space between Benjamin, Billy and Jena
- Around Billy Hu's white tiger power blast

Use the Hi-Fi Helper files LightTwirl01.tif and Flare02Blue.tif to add extra mystical light to the tiger blast (see page 20 to review the instructions for pasting in files).

4 For Benjamin Song's dragon fire, brush in an orange glow using the Hi-Fi Default Soft Round. Add floating fiery orange embers (try C00, M65, Y85, K00) and particles to the fire effect using the Hi-Fi brush named Brush & Shrub 02.

Stage 6: **Save a High-Res File**

 STEP 3 SCRIPT

When you're done, be sure to save your high-res .PSD file. To make a print-ready CMYK image, choose File > Scripts > Hi-Fi Step 3, then save the file under a new name so you don't save over the RGB .PSD file.

And, of course. . .we hope you'll show us your work in the reader forum at HueDoo.com!

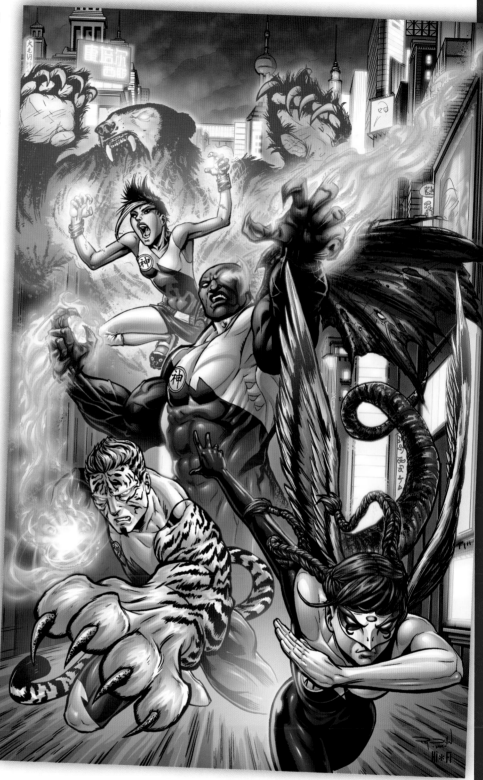

Learn More About the Artist

If you enjoyed coloring this illustration of *The Shen*, stop by Ray Dillon's website www.raydillon.com and let him know how much you appreciate his contribution to this book.

CODE ZERO

One temptation when coloring superhero comics is to apply the same basic color style to a variety of comic books created by an even wider variety of artists. While this can work, often a better approach is to survey the artwork for a project and ask yourself this question: "What does this artwork ask of me?"

In the case of Jim Hanna's artwork for *Code Zero*, you immediately notice angles and variation of lines used throughout the image. It might be fun to challenge yourself to create a color style that complements the art while using many of the tips and techniques you have already mastered.

CODE ZERO
Art by Jim Hanna
Color by Hi-Fi
See more at www.realjimhanna.blogspot.com
Code Zero © 2009 Jim Hanna

Stage 1: Prepare the Line Art and Add Flat Color

HI-FI STEP 1 SCRIPT

1 From the Bonus Disc, open the file Hero_CodeZero03_600.tif. From the Photoshop Menu bar, choose File > Scripts > Hi-Fi Step 1 to prepare the line art for coloring. Unhide the Line Art channel.

2 Use the Lasso tool and the Hi-Fi SPF method (see page 14) to add flat color fills to all the areas of the artwork. Use cool, desaturated colors for this nighttime setting. Take care not to miss any of the costume and character details.

SPF
Select Area
Pick Color
Fill Area

On the Disc: Color Guide

The Bonus Disc includes Color Guides for the projects in the book. Each Color Guide contains convenient swatches of the color pairs we used for flatting and rendering.

If you want to use our colors, just click each swatch with the Eyedropper tool to sample the color right into your Swatches palette.

Stage 2: Color the Figures

Jim Hanna's line work is very angular, so try making your cuts (selections) angular with many straight lines and hard edges. Your challenge is to adapt your rendering to best suit the artwork.

When choosing screen colors, think about the lighting. This scene is set at night under a moonlit sky. You could choose to render everything with a cool blue light, but it may be more effective to lean toward the cool end of typical ambient lighting for clarity of action and storytelling. (Comic book editors generally like to see characters close to their true colors for the majority of each issue.)

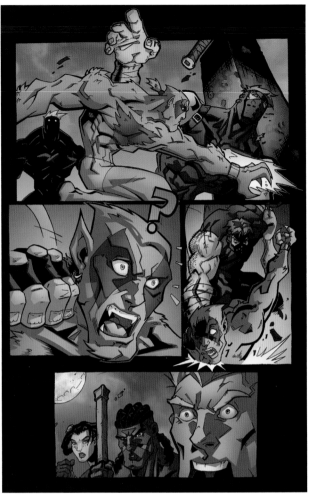

1 Use the Hi-Fi 4-Step process (see page 14) and the Gradient tool to add base cuts to the figures.

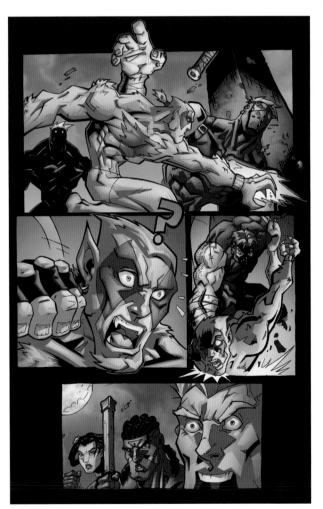

2 Continue using the cut-and-grad technique to create multiple levels of highlights. This is the stage at which you can incorporate some more stylized selections; for example, cuts that incorporate thick-thin elements, or ones that are segmented to imply action.

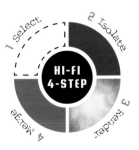

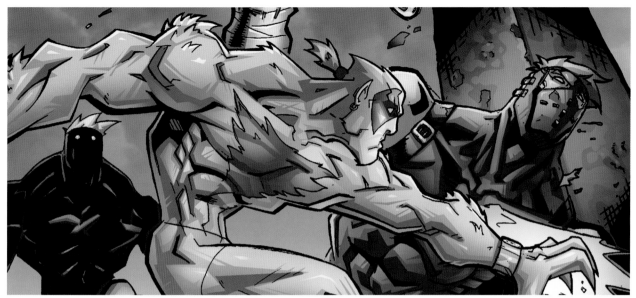

3 Add final details to the figures, specifically the areas where lighting would create the brightest highlights. In the example, you can see this in the core highlights that visually connect the shoulder to the elbow and the elbow to the wrist, as well as the specular highlights on the shoulder, tip of the nose and chin. Add a combination of warm yellow and cool aqua rim lights to define the edge of each character where the surface of their skin, fur or costume falls out of view to increase depth and to help clarify the figures' forms where they overlap.

Focus on the Details: Refining Chupacabra's Face

First Cuts
The first level of cuts should be broad areas of light and shadow that define the forms of the head and face.

Second Cuts
The second level of cuts brings out the definition of the facial features. Some of these cuts can be stylized.

Final Cuts
Last, add cuts for details such as the final highlight on the eyebrows, cheekbones, tip of the nose, lips and tip of the chin, as well as warm and cool rim lights.

Color Holds in This Illustration
The color has been removed from the right half of this illustration so you can see where the holds are.

Stage 4: Add Special Effects

 STEP 2 SCRIPT

1 From the Photoshop Menu bar, choose File > Scripts > Hi-Fi Step 2 to set up the file for special effects. After the script runs, choose Window > Layers, then select the Special Effects layer to make it the active layer.

2 Use the Brush tool to add glows. The punch in panel one is a prime candidate for a glow, as are the impact in panel three and the moon in the last panel.

Stage 3: Add Color Holds

1 Use the Make Holds action (see page 26) to set up the file for color holds.

2 Lasso a rough selection around the first area of line work you want to color.

3 Use the Color Picker to choose a color for the hold, then choose Edit > Fill and fill the selection with the foreground color.

4 Repeat Steps 2 and 3 to create the remaining holds.

5 When you are finished adding holds, play the Finish Holds action (see page 26) before moving on.

Only the Special Effects layer is visible on the right side of the example to help you visualize where to add your glows.

Stage 5: Save a High-Res File

 STEP 3 SCRIPT

Once you have completed your image, save a high-res .PSD file. If you want to make a final CMYK image ready to print, choose File > Scripts > Hi-Fi Step 3 from the Menu bar. Select "with Special Effects" and let the script run. Save your file as a CMYK TIFF; do not to save over your RGB .PSD file.

Show us your work in the reader forum at HueDoo.com!

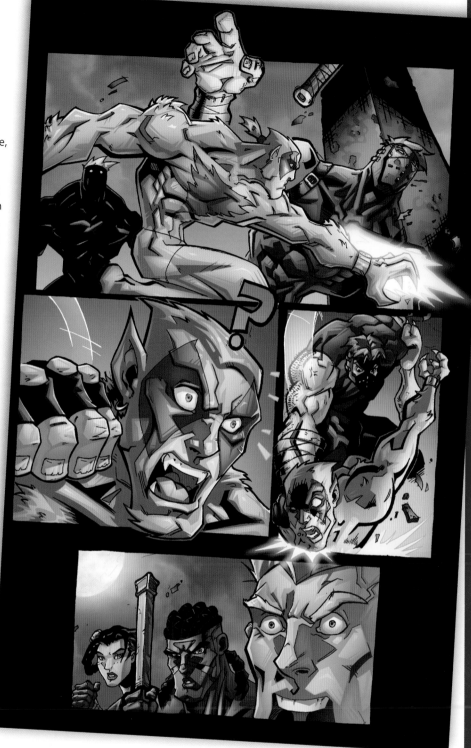

Establish the Era

The great thing about superheroes and their enemies is that they come in all shapes, sizes and nationalities. During your visit to Superhero Style, you focused on metallic surfaces, the structure and anatomy of figures and how to really make the art pop off the page.

This illustration by Martheus Wade whisks you away to another land where you are still dealing with heroes and villains, but these characters wear traditional battle armor in place of spandex costumes. Based on what you have learned, how will these changes in setting and character design affect your approach to color choices and rendering? You may need to do a little research and see what these costumes would have looked like in the past—a time to use that art history!

Your challenge is to color *The Encounter* in a way that's dynamic yet appropriate for the look and feel of the art, characters and setting.

Looking at the illustration, you'll see that you will need every technique you learned during your trip through Superhero Style to color this illustration. Note the metallic swords, various poses, a closeup on a face, many color hold opportunities and special effects. Use your color choices, lighting and rendering to help communicate the story and action of this illustration clearly to the viewer.

THE ENCOUNTER
Art by Martheus Wade
See more at www.toshigawa.com
Jetta © 2009 MAW Productions

Bonus Disc: Homework Challenge Files

Hero_Encounter_p04_600.tif

Hero_JettaShi_p14_600.tif

Share Your Homework at HueDoo.com

We encourage our students to peek at each others' homework! Join the reader forum at HueDoo.com and share your homework results in the Hi-Fi reader forum.

Define the Mood and Feel With Color

Traditionally in classic superhero comics, heroes wore primary color costumes like red, blue and gold, while villains often sported secondary colors like purple, green and orange. Times have changed, yet color still plays a crucial role in defining the look of villains and creatures.

Your challenge is to color this illustration by Martheus Wade and, in so doing, to use color to define the look and feel of the figures and their setting.

Wade has drawn a forest with creatures being summoned out of the muck and mire of the earth. What color sky best represents this mood and feel? In panel two, is that a light fog rolling over the ground or steam rising from cracks in the earth's surface? The decisions you make about the setting will help determine the overall mood and feel for the illustration.

The figure in panel one has horns. Is he a demon? A genie? Some other creature? What colors will you use to signify his persona? What colors will you assign the creatures rising from the mud to show their subservience to their master? What will you do to make the figures dominate over the background elements?

How can you use color holds and special effects to show the background without overplaying it so the characters are lost? In panels two and four, there are a few background characters. What treatment could you give them to push them back from the main figures without losing them among the trees?

Use what you know to render the figures in a superhero style. Remember to pay attention to muscles and anatomy to keep the figures believable. You could also add texture to the horns and maybe even the skin of several of the creatures. Every hero has to face a villain, and often the villains are not clad in spandex.

JETTA: TALES OF THE TOSHIGAWA
Art by Martheus Wade
See more at www.toshigawa.com
Jetta © 2009 MAW Productions

LADY DEATH
Created by Brian Pulido
Art by Stephen Hughes
Color by Hi-Fi
See more at www.brianpulido.com
Lady Death is ™ and © Mischief Maker Media, Inc. & Avatar Press, Inc.

Pin-Up Style

Lady Death *creator Brian Pulido shares his insights about the role color plays when writing and creating characters like Lady Death:* "Color is key. It has an emotional effect on the reader. I'm always out to create contrast with Lady Death and her design supports that. As a pale character surrounded by primary colors, she truly stands out.

"When approaching a character like Lady Death a colorist should keep a few key concepts in his or her mind. Lady Death's skin is white, but her body does need modeling and a colorist must be conscious of how shadows play on her body."

"Lady Death has many facets: She can be a killer, she can be sensuous, she can be a warrior. Colorists have to start by thinking about how they would accent her and how to make her look dangerous, but alluring.

"The decisions the colorist makes with regard to lighting and color choices will define the sinister beauty that is Lady Death."

Learn More About the Artist
Brian Pulido wrote and directed the feature film *The Graves*, starring Tony Todd (*Candy Man*) and Bill Moseley (*The Devil's Rejects*). Pulido founded Chaos! Comics and has written hundreds of comics including *Lady Death*, *Evil Ernie*, *Purgatori* and licensed comics including *A Nightmare on Elm Street*, *Chucky*, *Friday the 13th* and *Texas Chainsaw Massacre*. He wrote two episodes for the *Re/Visioned: Tomb Raider* animated series. He is on the Hero Initiative's fundraising board, has received the Comic Book Legal Defense Fund's Defender of Liberty Award and is the Chief Creative Officer for Coffin Comics.

SHI

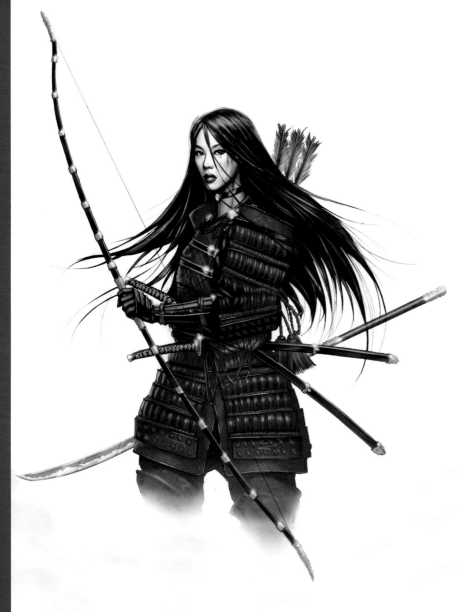

William Tucci's pencil style has many fine lines and descriptive detail. The pencil work may limit the openness for color in some areas, but the benefit is you can choose colors that mesh almost seamlessly with the grays of the artwork, creating a look similar to a fully painted piece.

Tucci's best-known series, *Shi*, features a young girl who paints her face white to resemble a legendary Japanese warrior—the Tiger of Death. *Shi* is a multi-time Eisner Award nominee that has sold more than four million comic books in four languages worldwide. In this portrait, Tucci has contrasted young Ana Ishikawa's petite, feminine form with the bulk of her armor and weapons.

SHI
Art by William Tucci
Color by Hi-Fi
See more at www.crusadefinearts.com
Shi © 2009 William Tucci

Stage 1: **Prepare the Line Art and Add Flat Color**

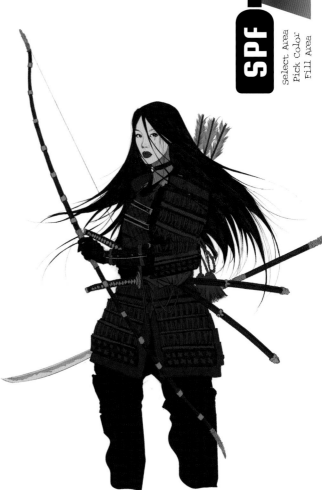

HI-FI
STEP 1
SCRIPT

1 From the Bonus Disc, open the file PinUp_Shi_BattleArmor_400.tif. From the Photoshop Menu bar, choose File > Scripts > Hi-Fi Step 1 to prepare the line art for coloring. Unhide the Line Art channel.

2 Use the Lasso tool and the Hi-Fi 4-Step Process (see page 14) to add flat color fills to all areas of the artwork. Use the Color Guide from the Bonus Disc to find ideal flat and screen colors that will mesh with the grays of the pencil lines.

The flat colors should clearly define the elements of Shi's armor. Resolve any questions about the construction of the armor during flatting to avoid wasted time later.

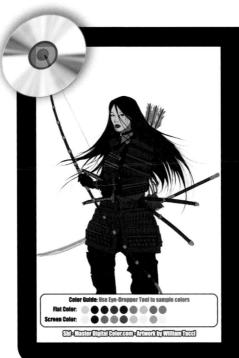

Color Guide: Use Eye-Dropper Tool to sample colors
Flat Color: ● ● ● ● ● ● ● ● ● ●
Screen Color: ● ● ● ● ● ● ● ● ● ●
Shi - Master Digital Color.com - Artwork by William Tucci

On the Disc: Color Guide

The Bonus Disc includes Color Guides for the projects in the book. Each Color Guide contains convenient swatches of the color pairs we used for flatting and rendering.

If you want to use our colors, just click each swatch with the Eyedropper tool to sample the color right into your Swatches palette.

Stage 2: **Render the Costume**

Consult the Color Guide on the Bonus Disc for ideal screen colors. For the costume, consistency is key to success. Strive for consistent highlights so that no one area of the costume looks more fully rendered than another.

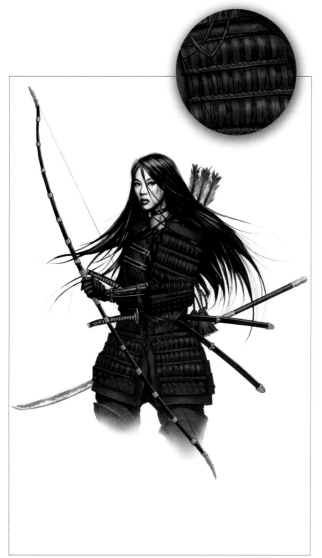

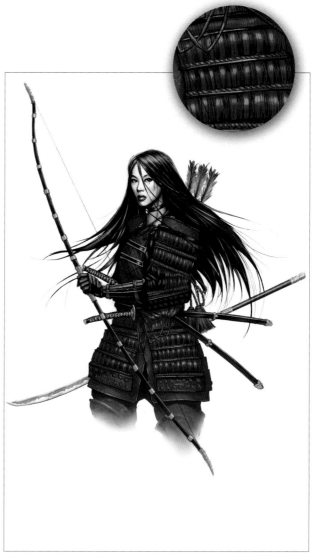

1 Use the Lasso and Brush tools and the tips on page 78 to add the base cuts. Render the red areas first, then black, then gold. Pay attention to the light direction and create shadows around each red link to showcase the weight of the armor. Focus the ambient light along the center of her figure from her shoulder to the elbow and from the hip down to the knee we can't see.

2 Add the second level of cuts to create additional shape and form in the elements of her costume. Visualize the ambient light falling from above Shi's head down her face, along her shoulder and extending through to her elbow and hips before fading away toward the knee.

Work to keep the highlights and contrasts consistent over the entire costume so that no one area becomes more fully rendered than another. Consistency is key.

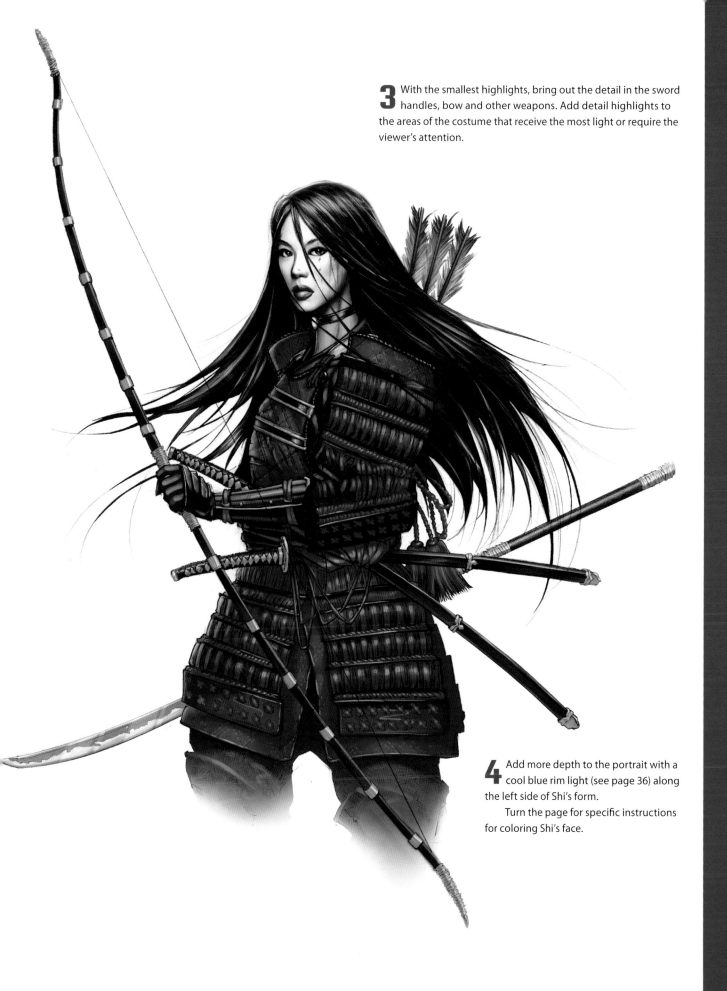

3 With the smallest highlights, bring out the detail in the sword handles, bow and other weapons. Add detail highlights to the areas of the costume that receive the most light or require the viewer's attention.

4 Add more depth to the portrait with a cool blue rim light (see page 36) along the left side of Shi's form.

Turn the page for specific instructions for coloring Shi's face.

Focus on the Details: Highlighting Techniques for Beautiful Faces

Here's the same character, Ana Ishikawa, out of disguise. Once you know these highlighting techniques for pretty female faces, you can adapt them for other angles and lighting situations.

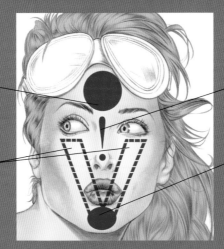

Circular highlight for youthful-looking rounded forehead

Highlights shaped like an exclamation point for the bridge and bulb of the nose

V-shaped cut from eyes to chin mimics the way light naturally falls on the face

Roundish chin highlight with space left above it for the under-lip shadow

1 Use the Lasso and Brush tools to apply the cut-and-brush technique to the face. Work from the general to the specific, adding highlights in four levels to create the rendered face. For the first set of highlights, use the guideline shapes shown above, but make more intricately shaped highlight cuts for the shadow shapes under the eyes, nose and lower lip. Notice the slight shadows that remain under the brow ridges.

2 Continue to use the cut-and-brush technique for the second level of high-lights within the areas in Step 1. Refine your selections with the Lasso tool to indicate greater definition to the features. Add more light with the Brush tool.

3 Brighten the basic highlight areas with a third set of cuts to define the structure of the nose and eyelids and tighten up the details on the cheek-to-nose transitions. Subtly imply more definition in areas such as the jaw and ears.

4 Add a last set of cuts to brighten the areas on the nose and chin. Finish this pretty picture by adding rim lights.

Stage 3: Render the Face and Hair

Shi's face is turned to one side in this portrait. The basic highlights shown on the facing page are still useful; you just need to imagine how the shadows change a bit as the face turns.

The Right Flat Color Can Be Crucial

This is one of those situations where you really need a flat color that blends well with the color of the line work. In Shi's hair, the right flat color (see the Color Guide on the Bonus Disc) will blend right into the color of the scanned pencils so that you don't have to select and fill every last strand. The wrong flat color will look harsh and pasted on.

1 Color Shi's Face
First, look at the demo on the facing page about highlighting a beautiful face. That "map" of highlights is an excellent basis for rendering a face that the viewer is seeing pretty much head on.

Shi's face is shown in more of a three-quarter view, so imagine what happens to the highlight map as the face is turned in relation to the light source, and do your four stages of highlights accordingly.

Forehead highlight is more to one side

The more distant cheek is less brightly lit than the nearer cheek

The V-shape of light on the cheeks is now interrupted by the nose's shadow

Jawline catches some light, making the chin highlight an elliptical shape

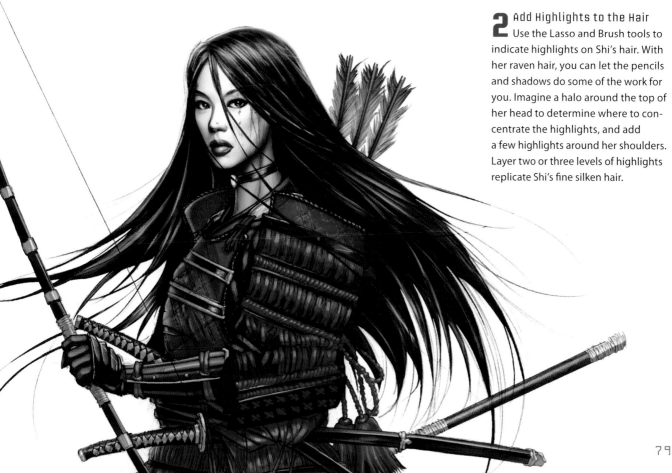

2 Add Highlights to the Hair
Use the Lasso and Brush tools to indicate highlights on Shi's hair. With her raven hair, you can let the pencils and shadows do some of the work for you. Imagine a halo around the top of her head to determine where to concentrate the highlights, and add a few highlights around her shoulders. Layer two or three levels of highlights replicate Shi's fine silken hair.

Stage 4: Paste a Fog Texture Into the Foreground

1 From the Bonus Disc, open the Hi-Fi Helper texture Fog & Dust 02.tif. From the Photoshop Menu bar, choose Select > All, then Edit > Copy. Close the texture image and return to your *Shi* image. Choose Edit > Paste. The fog texture will appear on a new layer above the *Shi* image.

2 From the Photoshop Menu bar, choose Edit > Free Transform. Position, scale, rotate and skew the fog and dust image to create the look of Shi's lower legs and feet becoming obscured by the fog. Once the fog and dust image is positioned as you like it, use the Return (PC: Enter) key on your keyboard to exit Free Transform mode and make your changes permanent.

3 Use the Eraser tool to remove any fog and dust areas you wish to remain uncovered, such as the bow. This gives the impression of the bow remaining in front of the fog.

Once you are happy with the final look of the fog and dust, save your image.

From the Layers palette, choose Merge Down from the pull-down menu. This will merge the fog and dust image into the *Shi* illustration.

From the Photoshop Menu bar, choose File > Save As to save another version of your file before moving on.

Stage 5: Add Special Effects

 HI-FI STEP 2 SCRIPT

1 From the Photoshop Menu bar, choose File > Scripts > Hi-Fi Step 2 to set up the file for special effects.

2 Open the Hi-Fi Helper files Flare02.tif and Sparkle03.tif.

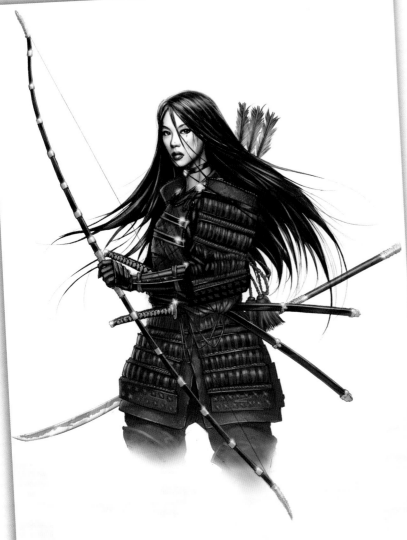

3 Open the Layers palette and select the Special Effects layer to make it the active layer. Copy and paste (or select and drag) a flare onto the Shi image. The flare will appear in a new layer above the Special Effects layer. Set the layer mode of the new layer to Screen.

4 From the Menu bar, choose Edit > Free Transform to rotate, scale and position the flare.

5 From the drop-down menu in the Layers palette, choose Merge Down to make the flare part of the Special Effects layer.

6 Repeat Steps 3–5 to add several more flares and sparkles to the image.

Stage 6: Save a High-Res File

HI-FI STEP 3 SCRIPT

Once the image is complete, save your high-res .PSD file.
If you want to make a final CMYK image ready to print, choose File > Scripts > Hi-Fi Step 3 from the Menu bar. Select "with Special Effects" and let the script run. Save your file as a CMYK TIFF, being careful not to save over your RGB .PSD file. Remember to share your results at HueDoo.com!

Learn More About the Artist

If you enjoyed coloring this image of *Shi*, stop by artist Billy Tucci's website www.crusadefinearts.com and let him know how much you appreciate his contribution to this book.

STRANGERS IN PARADISE

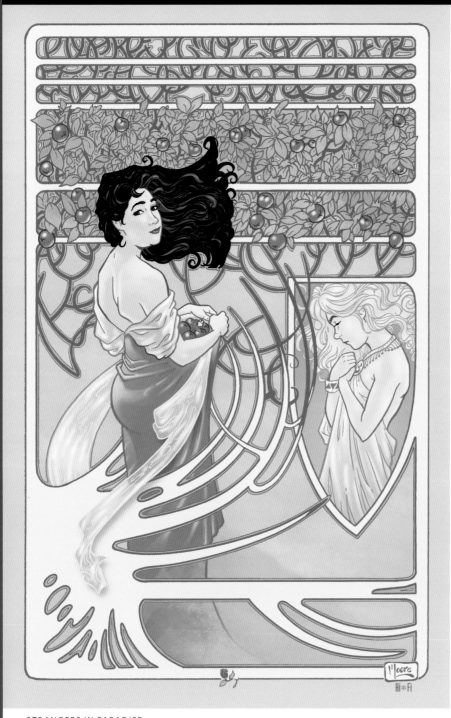

Terry Moore's *Strangers in Paradise* does not fit any specific visual mold—it features images that range from delicate pen-and-ink illustrations, to comic-strip-inspired images, and even gritty noir-inspired compositions. Further showcasing his range and talent, Terry produced this beautiful pin-up inspired by the lithographs of Art Nouveau pioneer Alfons Mucha. Many of the antique prints and posters were made using stone lithography. Even today, the subtle lighting and detail Mucha and other artists were able to achieve using that technology is breathtaking.

STRANGERS IN PARADISE
Art by Terry Moore
Color by Hi-Fi
See more at www.abstractstudiocomics.com
Strangers in Paradise © 2009 Terry Moore

Stage 1: Prepare the Line Art and Add Flat Color

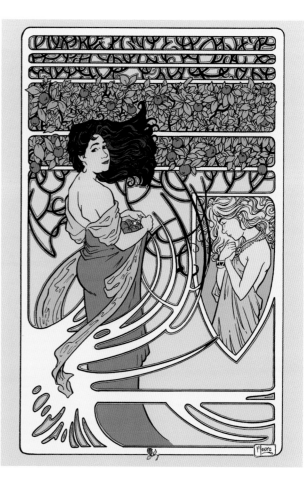

HI-FI STEP 1 SCRIPT

1 From the Bonus Disc, open the file PinUp_SIP52_600.tif. From the Photoshop Menu bar, choose File > Scripts > Hi-Fi Step 1 to prepare the line art for coloring. Unhide the Line Art channel.

2 Use the Lasso tool and the Hi-Fi SPF method (see page 14) to add flat color fills to all areas of the artwork. To achieve the retro look of an old art print, start with earthy base tones and less-saturated values. Pay special attention to the Art Nouveau elements to ensure they are clearly defined. Use warm values for the figures.

SPF
Select Area
Pick Color
Fill Area

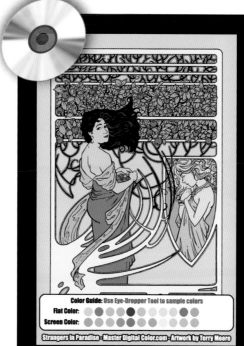

Color Guide: Use Eye-Dropper Tool to sample colors
Flat Color:
Screen Color:

Strangers in Paradise - Master Digital Color.com - Artwork by Terry Moore

On the Disc: Color Guide

The Bonus Disc includes Color Guides for the projects in the book. Each Color Guide contains convenient swatches of the color pairs we used for flatting and rendering.

If you want to use our colors, just click each swatch with the Eyedropper tool to sample the color right into your Swatches palette.

Stage 2: Color the figures

Your challenge is to create highlights that define the form of Francine's figure without overrendering the colors. In keeping with the retro-litho look of this illustration, your goal is to create the representation of form, not a photo-realistic reproduction.

1 Start With the Skin
Begin with the flesh, since the human forms are much of the focus of this illustration. Use the Lasso and Brush tools and the Hi-Fi 4-Step process (see page 14), and see the tips in the sidebar on the facing page

There are two ambient light sources here, both slightly above and behind the figures. These lights frame and define the forms while creating a subtle halo around the figures for a dramatic portrait.

Francine is the main focus of the portrait, so the rendering on Katchoo should be softer and have lower contrast than the rendering on Francine. This will focus the viewer's eye on Francine first, then allow them to wander over to Katchoo. Part of your job as the colorist is to decide what's important and use color and light to help guide the viewer's eye through the artwork.

2 Render the Clothing
Add highlights to the clothing next. The dresses are billowy and soft, so the highlights should be smooth and soft-edged. Be consistent about the light direction as you apply highlights to the cylindrical folds of fabric.

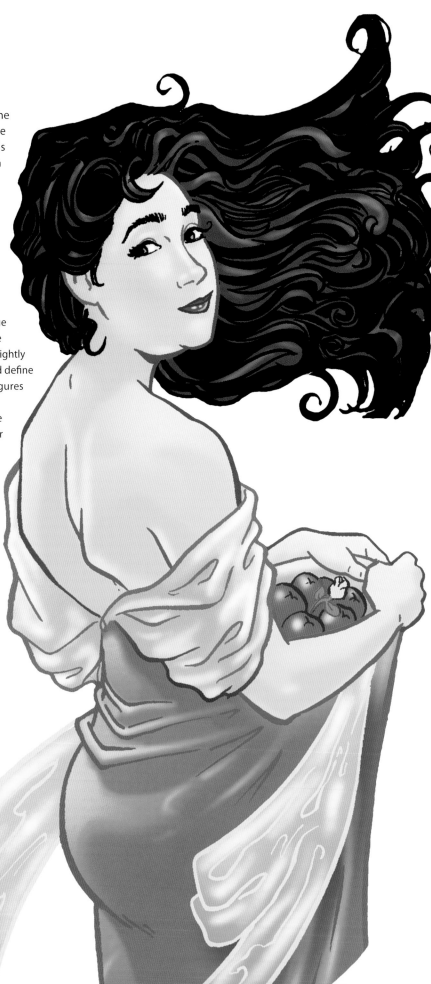

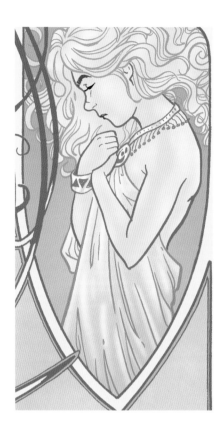

Creating Soft Blends With Medium-Edged Shadows

For most of the projects, you'll use the Lasso tool with a hard edge to select the areas where you want to add highlights. You then use the Brush tool (or Gradient tool) to add light to your selections. By using the Lasso and Brush tools you are able to control where the light falls on each area. For this project, you will use the Lasso tool with a feather to create the look of a softer edge while still maintaining full control of where your highlights are applied. This control allows you to work quickly and accurately while achieving even, consistent results.

- Brush Tool: Hi-Fi Default Soft Round

- Brush mode: Screen

- Decrease Brush size: [

- Increase Brush size:]

- Lasso tool: Vary the Feather setting between 2–6 pixels

The key to this technique is using the Lasso tool with different amounts of feathering, depending on how softly you want the light to spread beyond the edge of the selection. Within the area of highlight, the brush blends freely with the base tone.

Keyboard Shortcut

As you render the skin and clothing, use the bracket keys [and] to vary the brush size quickly and easily.

If you are using a standard mouse and not a pressure sensitive graphics tablet, you may find best results by lowering the opacity of the Brush tool to 15–35 percent. Click and drag the mouse to create even brushstrokes. This will allow you to achieve the softer rendering and subtle blending as shown in the example.

Stage 3: Render the Background

1 To add a bit of visual tension, create subtle rendering on the vines and leaves using the Brush tool (try the Rocky Texture Brush or your favorite texture brush). Contrast those with stronger highlights and more pronounced rendering on the fruit.

That variation of intensity within the background isn't the normal, consistent approach often taken in comic artwork. It places a sense of importance on the fruit and on Francine's relationship to the world as she gathers the fruit.

2 Terry Moore indicates a subtle blending of Francine's dress into the background. First, blend the dress color into the background color using your Brush tool in Normal mode. Then, set the Brush back to Screen mode and choose one of the Hi-Fi texture brushes, such as Rocky Texture or Stucco, to indicate a bit of the ink blending that would have occurred on an old stone lithography plate.

Stage 4: Add Color Holds and Finish

1 Use the Make Holds action to set up the file for color holds (see page 26).

2 To achieve the retro-litho look, color-hold nearly every bit of Terry Moore's gorgeous line work. Only Francine's hair and eyes will remain solid black. Since the majority of the line art is green, that would be the best hold to start with.

Select the area you want to color-hold first. Choose the desired hold color using the Color Picker, then use Edit > Fill to fill the selection with the color. Repeat for each remaining hold.

3 When you are finished with your color holds, play the Finish Holds action (see page 26).

4 When you have completed your image, save the high-res .PSD file. If you want to make a final CMYK image ready for printing, choose File > Scripts > Hi-Fi Step 3 from the Menu bar. Select "without Special Effects" and let the script run. Save your file as a CMYK TIFF, being careful not to save over the RGB .PSD file.

Remember to share your results at HueDoo.com!

Learn More About the Artist
If you enjoyed coloring this image of Strangers in Paradise, stop by artist Terry Moore's website www.abstractstudiocomics.com and let him know how much you appreciate his contribution to this book.

JETTA: TALES OF THE TOSHIGAWA

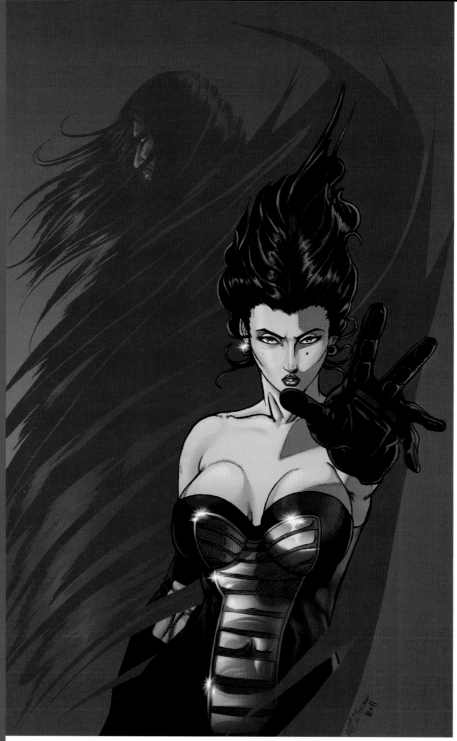

Jetta is a young Japanese woman born into the Toshigawa ninja clan. Divided between her loyalty to her clan and her secret desires, Jetta discovers that fighting her destiny may be harder than answering to it.

In our previous book, *Hi-Fi Color for Comics*, you learned the two fundamental techniques for rendering comic art: cut and brush and cut and grad. With this lesson, you'll add Photoshop's Smudge tool to your toolbox—and, with it, a new skill to experiment with and incorporate into your future projects.

Learn More About the Artist
If you enjoyed coloring this image of *Jetta*, stop by artist Martheus Wade's website www.toshigawa.com and let him know how much you appreciate his contribution to this book.

JETTA
Art by Martheus Wade
Color by Hi-Fi
See more at www.toshigawa.com
Jetta © 2009 MAW Productions

Stage 1: Prepare the Line Art and Add Flat Color

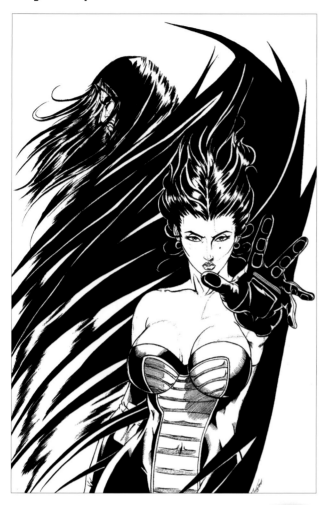

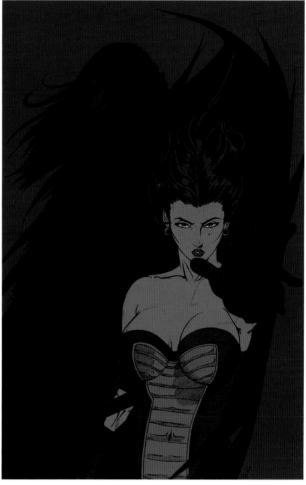

 HI-FI STEP 1 SCRIPT

1 From the Bonus Disc, open the file PinUp_ JettaRain_600.tif. From the Photoshop Menu bar, choose File > Scripts > Hi-Fi Step 1 to prepare the line art for coloring. Unhide the Line Art channel.

2 Use the Lasso tool and the Hi-Fi SPF method (see page 14) to add flat color fills. Jetta is of Asian descent, so choose a fleshtone that reflects her ethnic heritage. To clearly define the construction of Jetta's figure-enhancing costume, choose a contrasting flat color for the center panel.

SPF
Select Area
Pick Color
Fill Area

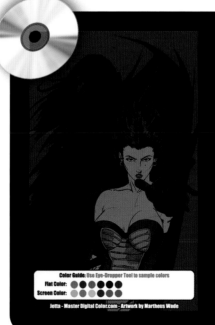

On the Disc: Color Guide

The Bonus Disc includes Color Guides for the projects in the book. Each Color Guide contains convenient swatches of the color pairs we used for flatting and rendering.

If you want to use our colors, just click each swatch with the Eyedropper tool to sample the color right into your Swatches palette.

Stage 2: Color the Figure

Start by highlighting Jetta, using the Lasso tool and the Hi-Fi SPF method (see page 14). For this artwork, start with solid color fills and no brush to create relatively hard-edged highlights that look almost posterized. For the metallic areas, use the Lasso tool and the default brush.

Render the metallic portions of the costume using the techniques you learned on page 49. You can also watch the video tutorial on rendering metallic surfaces, episode 5 on the Bonus Disc..

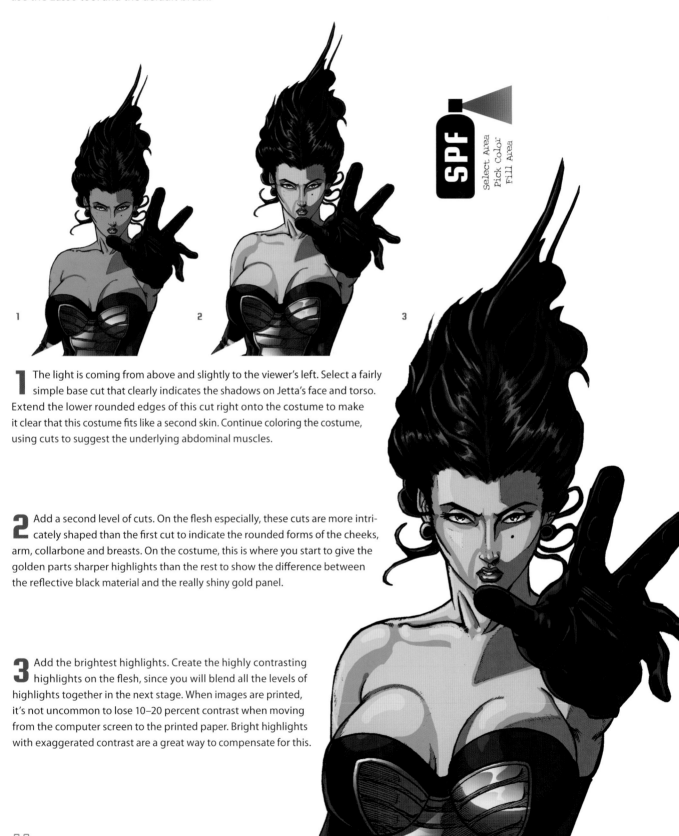

1 The light is coming from above and slightly to the viewer's left. Select a fairly simple base cut that clearly indicates the shadows on Jetta's face and torso. Extend the lower rounded edges of this cut right onto the costume to make it clear that this costume fits like a second skin. Continue coloring the costume, using cuts to suggest the underlying abdominal muscles.

2 Add a second level of cuts. On the flesh especially, these cuts are more intricately shaped than the first cut to indicate the rounded forms of the cheeks, arm, collarbone and breasts. On the costume, this is where you start to give the golden parts sharper highlights than the rest to show the difference between the reflective black material and the really shiny gold panel.

3 Add the brightest highlights. Create the highly contrasting highlights on the flesh, since you will blend all the levels of highlights together in the next stage. When images are printed, it's not uncommon to lose 10–20 percent contrast when moving from the computer screen to the printed paper. Bright highlights with exaggerated contrast are a great way to compensate for this.

Stage 3: Blend Colors With the Smudge Tool

Looking for a fun new way to create a painted look? The Smudge tool allows you to push and blend areas of color together in a way that can resemble detailed brushwork, often in a fraction of the time. Use the Smudge tool to create hybrid styles that combine the best of cut-and-brush coloring and freehand brush techniques.

Keyboard Shortcut

As you work through this stage, you can use the bracket keys [and] to vary the size of the Smudge tool quickly and easily.

Video Tutorial
Episode 6: Smudge Tool

Check out the Bonus Disc for video tutorial episode 6 about blending with the Smudge tool.

1 Begin with Jetta's flesh floating in its own layer. Make sure Preserve Layer Transparency is on. Before you start smudging, save your file, then use File > Save As to save it under another name for the smudging stage. You may want to return to the pre-smudged file as you work on perfecting this new technique.

2 Select the Smudge tool from Photoshop's tool palette. Then, from the Photoshop Menu bar, select Window > Tool Presets and choose Smudge Medium.

3 Choose the first area you want to smudge. Select the area with the Lasso tool and isolate it using Layer Via Copy. (This is much like the Hi-Fi 4-Step process for rendering [see page 14], except the third step is Smudge instead of Render.)

Click and drag the Smudge tool along the edge where two or more highlights meet. You'll see the colors blend as you drag the Smudge tool. Vary the diameter of the Smudge tool to achieve broad blending or more refined blends. Keep some areas where the colors meet crisp and smudge others to create a semipainted look.

Repeat Steps 1–3 to blend the dark areas of Jetta's costume.

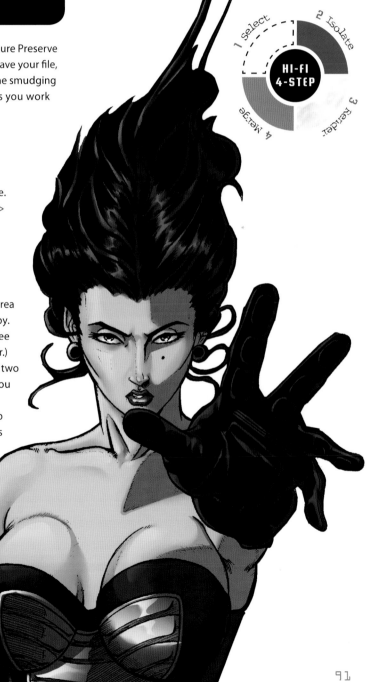

Stage 4: Add Side Light and the Background

Create a unified look for the figure and background through the use of gradients and color holds.

1 Use the Lasso to select the shadow areas on Jetta; this is where we're going to add a secondary light source. Then use the Gradient tool in Screen mode to create a red glow coming from right to left. This side light will tie the figure into the background.

 You can use the smudge technique shown on page 91 to blend the red highlights into the figure.

2 Use the Hi-Fi 4-Step process (see page 14) with the Gradient tool to add a subtle red fade to the background.

3 Use the Lasso and Brush tools and the Hi-Fi 4-Step process to render the villain's face.

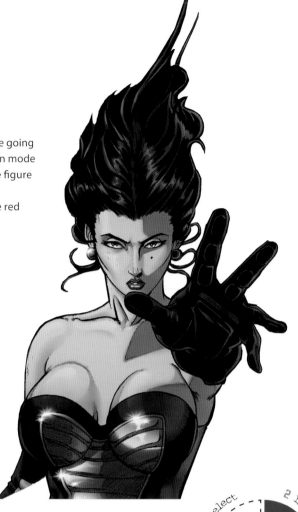

Stage 5: Add Color Holds

1 Use the Make Holds action (see page 26) to set up the file for color holds.

2 Use the Lasso tool to select the area you want to color-hold. Choose a color with the Color Picker (for this piece, a dark red), then choose Edit > Fill from the Photoshop Menu bar and fill the selection with the foreground color.

3 This hold will create atmospheric perspective that pushes the ghostly figure into the background, allowing Jetta to be the focal point of the illustration.

 When you are finished with your color holds, play the Finish Holds action (see page 26) before moving on.

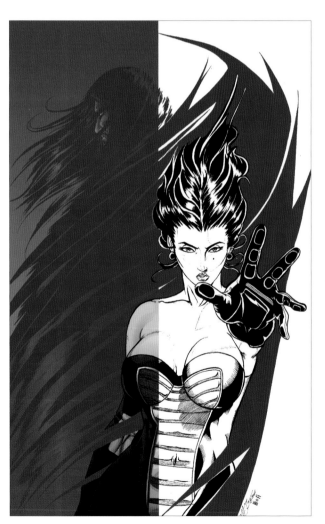

Stage 6: Add Special Effects and Save

For added drama and to further differentiate the gleaming gold areas from the other shimmering materials, we'll add some sparkles to them.

1 Open the Hi-Fi Helper named Flare 02.tif, or use a flare or sparkle you've created.

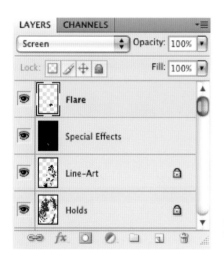

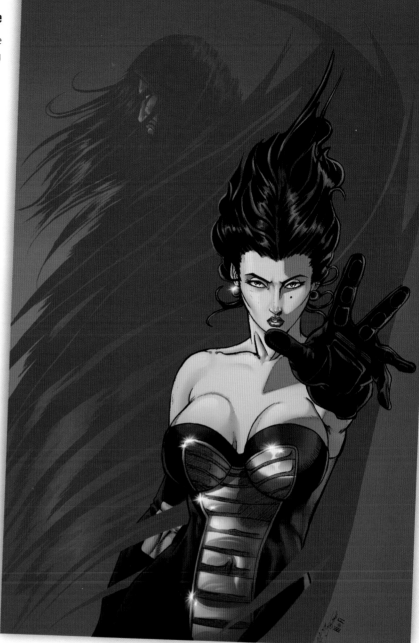

HI-FI STEP 2 SCRIPT

2 Return to the *Jetta* image. From the Photoshop Menu bar, choose File > Scripts > Hi-Fi Step 2 to set up the file for special effects. In the Layers palette (Window > Layers), select the Special Effects layer to make it the active layer.

Copy and paste (or select and drag) the flare from the other window into the *Jetta* image. The flare will appear in a new layer above the Special Effects layer. In the Layers palette, select this new layer and set its mode to Screen.

HI-FI STEP 3 SCRIPT

3 Choose Edit > Free Transform and rotate, scale and position the flare where you want it. When you are happy with the transformation, hit Return (PC: Enter) to apply the transformation. Then merge the flare with the Special Effects layer by choosing Merge Down from the drop-down menu. Repeat Step 2 to add the remaining flares to the image.

When you have completed your image, save the high-res .PSD file. If you want to make a final CMYK image ready for printing, choose File > Scripts > Hi-Fi Step 3 from the Menu bar. Select "without Special Effects" and let the script run. Save your file as a CMYK TIFF, being careful not to save over the RGB .PSD file.

Remember to share your results at HueDoo.com!

Rendering the face

This section showed you how to emphasize a woman's face, how to break it down and make her pin-up worthy. Take what you learned and use those techniques on a man. While some things are the same, you'll need to pay attention to masculine details that are different from those of a woman.

Use the techniques from Focus on the Details: Highlighting Techniques for Beautiful Faces (see page 78). Apply the same tips for rendering the forehead, cheeks, chin and nose to this illustration.

What should the jawline look like? What about the cheeks and chin? Does the exclamation point style selection still work well to create a highlight for the nose? It's OK for a man to have more character lines on his face—you don't want him to look too "pretty," especially if he's a warrior named Markus Fang.

Other elements to keep in mind are his warrior armor and weapons. What colors will you use for each area? What parts of the costume are fabric or armor? How do the variety of surfaces reflect light? Would the surfaces be matte or shiny?

Finally, this image combines a penciled portrait similar to the artwork featured in Highlighting Techniques for Beautiful Faces as well as an inked figure much like the figure of Jetta. How will this combination of inked and penciled art affect your approach to the illustration?

MARKUS FANG
Art by Christian Duce Fernandez
See more at www.shannondenton.com
Markus Fang © 2009 Shannon Eric Denton
Markus Fang created by Shannon Eric Denton and Ross LaManna

Bonus Disc: Homework Challenge Files

PinUp_MarkusFang_300.tif

PinUp_Mermaid_600.tif

Share Your Results at HueDoo.com

Use the *Markus Fang* art to practice rendering a man's face and form. Once you have completed the image, you can share your colored version of Markus Fang and see how other *Master Digital Color* readers colored the image at HueDoo.com.

Use Pop Culture References

Pin-up artwork has evolved over the years, encompassing many tastes from cheesecake to goth and everything in between. Artist David Hahn has created a fresh take on the popular mermaid mythos by infusing elements of pop culture with an eye for pin-up style and attitude.

Your challenge is to convey several key elements while also making this piece your own, all while complementing David's gorgeous artwork.

- **First Element: Setting**
 The setting is underwater. How will that affect your color selection? What will you do with the background to clearly illustrate the ocean's depths? Can you use color holds to help illustrate the setting? Would some Hi-Fi Helpers be useful?

- **Second Element: Textures**
 There are a variety of surfaces in this illustration. Is the angel made of stone or is it a wooden mascot from a wrecked ship? Would it be rough in texture and deteriorating or look new? The mermaid's tail is open for color. Would it be smooth or should it have scales? What about the crab and fish?

- **Third Element: Lighting and Depth**
 Where is the light source in this illustration? Is there sunlight filtering down from above? Is a submarine casting a spotlight on the mermaid? Is there some other unseen lighting? What of the fish to the left of the drawing—is it bioluminescent? Would the murky depths create atmospheric perspective between the underwater objects in the illustration?

The artist has drawn the mermaid with unique hairstyle, makeup, and clothing. How will this affect your approach to rendering her? What sort of story do imagine for this mermaid? Is she part of an all-mermaid band? Does she visit underwater nightclubs? What pop-culture influences will you refer to before rendering her?

> **Share Your Results at HueDoo.com**
>
> Once you have completed the image, you can share your colored version of David Hahn's Mermaid and see how other *Master Digital Color* readers colored the image at HueDoo.com.

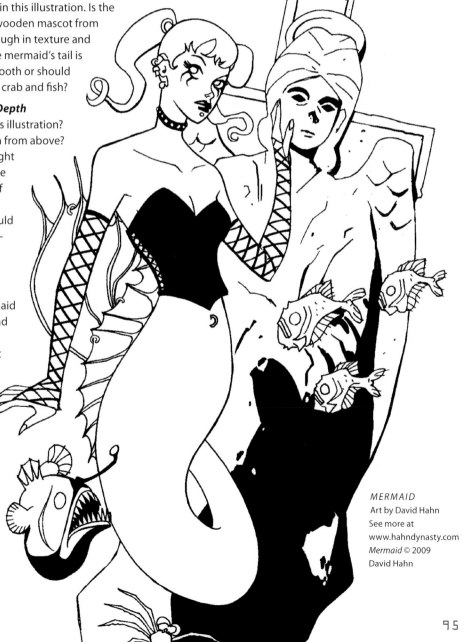

MERMAID
Art by David Hahn
See more at
www.hahndynasty.com
Mermaid © 2009
David Hahn

STAR TREK: MISSION'S END
Published by IDW
Art by Joe Corroney
Color by Hi-Fi
See more at www.joecorroney.com
Star Trek: Mission's End © 2009 IDW

Science fiction Style

When it comes to science fiction, illustrator Joe Corroney is a fan favorite. Here, Joe shares some insights into his creative process and the approach he takes when collaborating with Hi-Fi:

"As the penciler, I'm always thinking ahead in terms of seeing the final artwork in color. As I draw, I leave room for special effects, textures and atmospheric elements that cannot necessarily be rendered in pencil and that may look more effective in color. In most of the science-fiction artwork I create with Hi-Fi, there's a necessary demand for certain coloring techniques and effects for the composition whether its an atmospheric glow to separate a series of portraits, the horizon lighting glow of a planetary atmosphere, the motion blur of a speeding spaceship, the fading of color from a character's figure into an outer-space background to give the illusion of depth or simply the right color palette. It's always our intention to be as true to the characters and stories in the completed illustration and transport the viewer to a place that is as unique, alive and colorful at it is as comfortable, familiar and faithful to the source material."

Learn More About the Artist

Perhaps best known for his *Star Wars* illustrations, artist Joe Corroney captures not only the likenesses of well known characters, but also the essence of each universe he portrays. Fans may be surprised to find Joe's beautiful cover art gracing comic books also. Ranging from action titles like *G.I. Joe*, *Indiana Jones* and *24: Nightfall*, to dramatic books such as *Fallen Angel*, *Lord of the Rings* and *Spike*, Joe delivers stunning visuals while delighting fans with his continued work illustrating covers for sci-fi mainstays *Farscape*, *Doctor WHO* and *Star Trek*.

SUBHUMAN

SUBHUMAN
Art by Mark Schultz
Color by Hi-Fi
See more at www.fleskpublications.com
SubHuman © 2009 Mark Schultz

Artist Mark Schultz is best known for his speculative adventure comics in which fact and fiction meet. Spend any time marveling at Schulz's work, and you'll recognize his inspirations: Robert E. Howard, Edgar Rice Burroughs and Jules Verne all must have influenced him at an early age.

Schulz's *SubHuman* is an undersea adventure story featuring Krill Stromer and her team of marine investigators. This beautiful cover from the *SubHuman* series is done in a vintage style resembling movie posters and pulp-fiction book covers from the mid-twentieth century.

Stage 1: Prepare the Line Art and Add Flat Color

Is it possible to create focus, depth and drama using color choices, with very little help from highlighting and gradients? This vintage-style coloring project will stretch your mind!

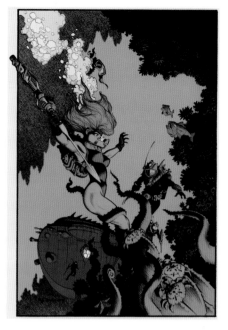

 STEP 1
SCRIPT

1 From the Bonus Disc, open the file SciFi_SubHuman_600.tif. From the Photoshop Menu bar, choose File > Scripts > Hi-Fi Step 1 to prepare the line art for coloring. Unhide the Line Art channel.

2 Use the Hi-Fi SPF method (see page 14) to add flat color fills. Take your time. There won't be a lot of rendering, so the flatted image needs to stand on its own. Flatting tips:

- Use earthy tones, in keeping with the limitations of old printing technologies (see sidebar). Your color choices won't necessarily be *realistic*; you're using a limited range of muted colors to *represent* the wider range of real-life colors.

- Use contrasts of *saturation*. Reserve the most saturated colors for the focal points. Place the least saturated tones on the most distant objects. Use different levels of saturation on like objects (such as the divers) to indicate their relative distance from the viewer.

- Use contrasts of *temperature* (warm vs. cool). To our eyes, warm colors appear to advance, while cool colors recede. So use cool tones for the murky green depths, but use warm tones for the foreground and the main action.

- Use changes in *hue* to accomplish lighting effects for which you might normally use a gradient. Example: Most of the coral is flatted with a green, but one area is pink—creating the appearance of a colored side light using flat colors alone.

On the Disc: Color Guide

Since this project is mostly about the flatting, you might find it helpful to have the Color Guide open while you're flatting.

Vintage Tech

As early as the late 1800s, technology existed for reproducing full-color originals. But it was a costly and slow process. For many decades, the high cost of full-color reproduction made it impractical for all but the most widely circulated printed matter.

To save money, publishers often used a cheaper color-repro process called mechanical separation. An artist created a black-and-white line illustration, then a print technician added color to it.

The mechanical separation process involved hand-cutting pieces of acetate the same size and shape as each area of color to be printed. That handcrafted aspect—along with the technical limitations of the older inks, plates and presses—resulted in an art style that was more representational than realistic, with little highlighting, no gradients to speak of, and a limited palette of rather flat-looking colors.

That representative art style, born out of technical necessity, is still reflected in modern coloring.

Stage 2: **Render the Coral Reef and Sea Creatures**

As you render the foreground elements, allow the inked shadows and textures to carry the composition. Use just a few subtle highlights to enhance clarity and depth. The Color Guide (see page 99) includes swatches of the screen colors we used.

1 Set the Brush tool to Screen mode and select the Hi-Fi brush preset Brush & Shrub. Add organic-looking highlights on the coral.

2 For the rest of the highlighting, switch to the Hi-Fi brush preset Normal Paint-Brush 02. Highlight the fish's bellies with a warm tone to help distinguish the fish from the murky green depths. Remember to keep the fish muted so as not to pull attention away from the main focus of the scene, the heroine, Krill Stromer.

3 The tentacles and nearby coral appear to be lit from diagonally below. If this weren't a retro piece, you might reach for the Gradient tool. Instead, just brush in simple highlights with the brush Normal Paint-Brush 02. Most of the definition has already been accomplished by the inked shadows.

You might be tempted to render the tentacles in a high-contrast fashion to create the appearance of glossy skin. However, underwater light is diffuse, so a subtle matte look for the tentacles is more appropriate.

Render the starfish subtly, using a different screen color.

4 Add subtle highlights to the under-sides of the crabs' legs and claws. (Crabs, like many water creatures, are light-colored on their undersides so that they will blend in with the water's sunlit surface when viewed from below.)

For the spots on the crabs' shells, use the Hi-Fi brush preset Amphibian Texture Brush in Multiply mode at 30 percent opacity.

Stage 3: Render the Submersible and Divers

To define the shape of the submersible, we'll use a few very subtle gradients. The divers receive a bit of highlighting, but not too much.

Tip

This illustration is unique among the projects in this book in that it does not use three visible stages of rendering (first, second and third levels of highlighting). They needn't all be the same intensity, but they are all applied in the same seamless manner.

1 Look at the sensors and hydroelectrodes that protrude from the submersible. The shadows on them indicate an unseen light source located below the sub and toward its port side. Add highlights on the protrusions, directly between the shadows and the light source.

To define the rounded form of the submersible, create subtle uplighting with the Gradient tool. Then do the same for the ballast tank on the side.

2 Add some highlights to the nearest diver, but keep it simple. Use even fewer highlights on the next closest diver. The one farthest back (by the sub) doesn't need any highlighting at all.

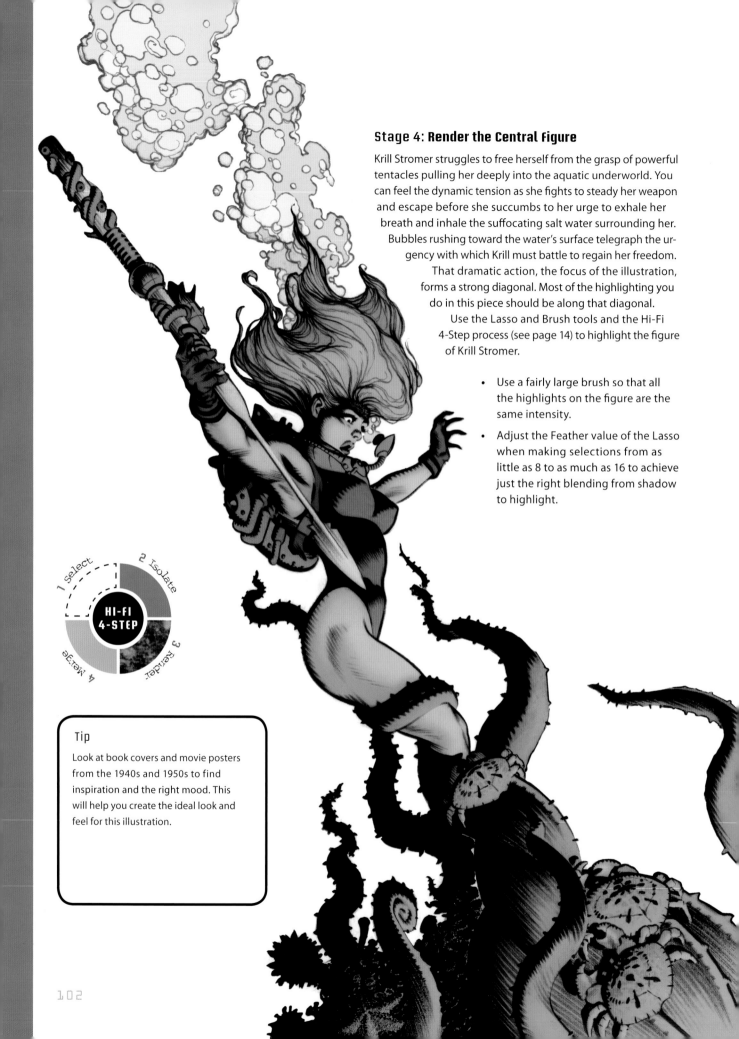

Stage 4: Render the Central Figure

Krill Stromer struggles to free herself from the grasp of powerful tentacles pulling her deeply into the aquatic underworld. You can feel the dynamic tension as she fights to steady her weapon and escape before she succumbs to her urge to exhale her breath and inhale the suffocating salt water surrounding her. Bubbles rushing toward the water's surface telegraph the urgency with which Krill must battle to regain her freedom. That dramatic action, the focus of the illustration, forms a strong diagonal. Most of the highlighting you do in this piece should be along that diagonal.

Use the Lasso and Brush tools and the Hi-Fi 4-Step process (see page 14) to highlight the figure of Krill Stromer.

- Use a fairly large brush so that all the highlights on the figure are the same intensity.

- Adjust the Feather value of the Lasso when making selections from as little as 8 to as much as 16 to achieve just the right blending from shadow to highlight.

Tip

Look at book covers and movie posters from the 1940s and 1950s to find inspiration and the right mood. This will help you create the ideal look and feel for this illustration.

Stage 5: Add Color Holds

Now we'll use color holds to create atmospheric perspective and push some elements of this image into the extreme background. That will help emphasize the main action in the foreground.

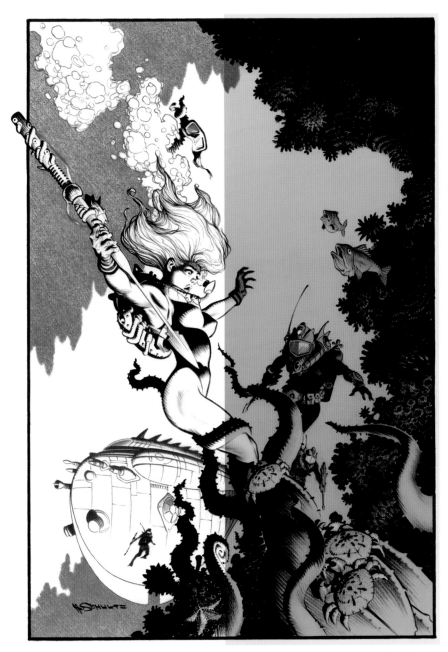

The color has been removed on the left side of the example allowing you to see clearly where the black line art has been changed to a color.

1 Use the Make Holds action (see page 26) to set up the file for color holds.

2 Use the Lasso tool to select the first area you want to color-hold. Choose a color with the Color Picker, then choose Edit > Fill from the Photoshop Menu bar and fill the selection with the foreground color.

3 Repeat Step 2 to add the rest of your color holds.

4 When you are finished with your color holds, play the Finish Holds action (see page 26) before moving on.

Stage 6: Add Special Effects and Save

The coloring in this illustration is all about subtlety. Your special effects should be understated as well. The well-lit interior of the sub illuminates the surrounding depths. That illumination is soft, though: Ocean water is full of debris, plankton and other small sea creatures that scatter and diffuse any light.

The left side of this image shows only the Special Effects layer to help you visualize where to add your glows.

HI-FI STEP 2 SCRIPT

1 From the Photoshop Menu bar, choose File > Scripts > Hi-Fi Step 2 to set up the file for special effects. In the Layers palette (Window > Layers), select the Special Effects layer to make it the active layer.

2 Use the Brush tool to add subtle glow effects to the Special Effects layer. The windows on the submersible are one opportunity to add a glow; another is the light affixed to the diver's helmet. What other areas might benefit from special effects?

HI-FI STEP 3 SCRIPT

3 When you have completed your image, save the high-res .PSD file. If you want to make a final CMYK image ready for printing, choose File > Scripts > Hi-Fi Step 3 from the Menu bar. Select "without Special Effects" and let the script run. Save your file as a CMYK TIFF, being careful not to save over the RGB .PSD file.

Share Your Results at HueDoo.com

To make a low-res version of a finished image for e-mail and online, use the Hi-Fi action "Save As JPG." Share your version and see what others have done in the Hi-Fi reader forum at HueDoo.com!

Learn More About the Artist

If you enjoyed coloring this image of Krill Stromer from *SubHuman* by Mark Schultz, be sure to visit Mark at www.fleskpublications.com and let him know how much you appreciate his contributions to this book.

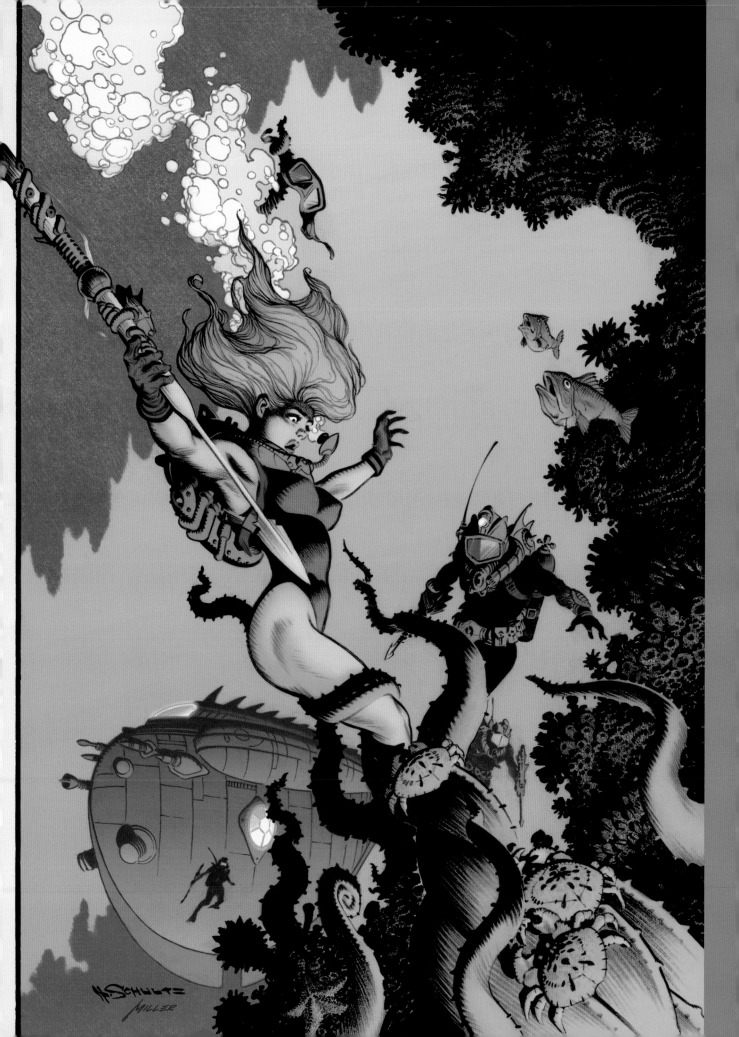

ECHO

Terry Moore ended his Eisner Award-winning series *Strangers in Paradise* after more than a decade, then took a year off. When he came back to comics, he released an all-new science-fiction series titled *Echo*. Sometimes lightning does strike twice.

In this illustration for *Echo*, you can see the influence of classic pin-up art and pulp-fiction covers.

ECHO
Art by Terry Moore
Color by Hi-Fi
See more at www.abstractstudiocomics.com
Echo © 2009 Terry Moore

Stage 1: Prepare the Line Art and Add Flat Color

Terry Moore's artwork is clean and open with very few areas of heavy shadow, no crosshatching and very little modeling in the line work. This gives you the opportunity to clearly model forms and surfaces using a combination of ambient and secondary lighting.

 STEP 1
SCRIPT

1 From the Bonus Disc, open the file SciFi_Echo2_600.tif. From the Photoshop Menu bar, choose File > Scripts > Hi-Fi Step 1 to prepare the line art for coloring. Unhide the Line Art channel.

2 Use the Lasso tool and the Hi-Fi SPF method (see page 14) to add flat color fills. Use deep, cool, desaturated base tones. (In the rendering stage, you'll add warm highlights that will create additional contrast.) Flat all the chrome spheres the same color.

Marquee or Lasso?

The safest way to select any shape is with the Lasso tool. If you use the Marquee tool to select a circular that isn't perfectly round, or a square one that isn't quite straight, there will be gaps in your flatting.

You can try the Elliptical Marquee tool for flatting the spheres as long as you view the art at 100 percent so that you can see and fix any imperfections.

SPF
Select Area
Pick Color
Fill Area

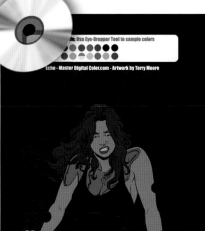

Use Eye-Dropper Tool to sample colors

Echo - Master Digital Color.com - Artwork by Terry Moore

On the Disc: Color Guide

The Bonus Disc includes Color Guides for the projects in the book. Each Color Guide contains convenient swatches of the color pairs we used for flatting and rendering.

If you want to use our colors, just click each swatch with the Eyedropper tool to sample the color into your Swatches palette.

Stage 2: Add a Texture to the Background

In this stage, you'll add a Hi-Fi Helper texture to the background. A texture can be used like a subtle warp effect to draw attention to a focal point.

1 Open the Hi-Fi Helper file Splatter_02.tif or feel free to use a texture of your own. Choose Select > All, then Edit > Copy. Close the splatter file.

2 Using the Magic Wand tool, select the background, then choose Edit > Paste Into. The splatter will appear in a new layer. Set the mode of this new layer to Screen.

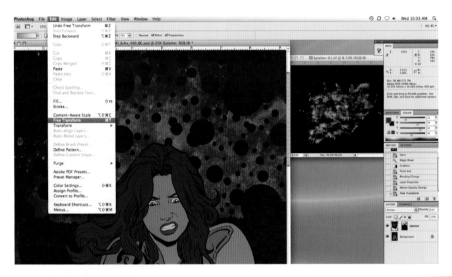

3 Choose Edit > Free Transform, then rotate, scale and position the splatter so that it seems to radiate from a spot behind Julie's head. Press Return (PC: Enter) to finalize the transformation.

4 Choose the Merge Down command from the drop-down menu in the Layers palette.

Focus on Details: Rendering a Chrome Sphere

1 Start with a dark gray circle. Lasso the "sky" area and brush in some light.

2 Select a smaller circle inside the first. Highlight along the lower edge of the selection.

3 Select a thick ring at the sphere's edge. (One way to do this is to select an interior circle, then choose Select > Inverse.) Add rim lights at the top and bottom of the selection with the Radial Gradient tool.

4 Brush in a glow over the horizon line. Finish with a few round mirrorlike highlights. Be sure to save your sphere!

You can watch a video tutorial for rendering shiny metal on the Bonus Disc, episode 5 and check out page 49 for more on rendering metal.

Stage 3: **Render the Chrome Spheres**

In the first issue of Terry Moore's *Echo*, metal spheres rain down on Julie Martin and bond with her skin, forming a breastplate with a strange insignia. What does it mean, and why is the government out to get her? To bring this vision to life, you need to become an expert at rendering reflective surfaces.

1 First we'll render a chrome sphere that you can save and reuse. Create a new document (4" × 4" [10cm × 10cm], 400ppi, Transparent). On a new layer, select a circle and fill it with a dark gray. Render your sphere as directed on the facing page.

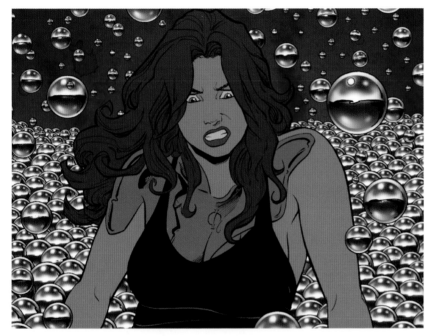

2 Select your rendered sphere and choose Edit > Copy. Select a sphere in the Echo image and choose Edit > Paste Into. Use Edit > Free Transform to scale and position the sphere, then press Return (PC: Enter) to apply the transformation.

Add more spheres the same way, starting in the foreground and working back. Tweak the overlaps by changing layer order. Merge some layers to keep the file manageable.

To simplify the next step, merge the foreground spheres near Julie (the ones that do not receive the gradient in Step 3) into one layer named Spheres Foreground, and merge the remaining spheres into another layer named Spheres Distance.

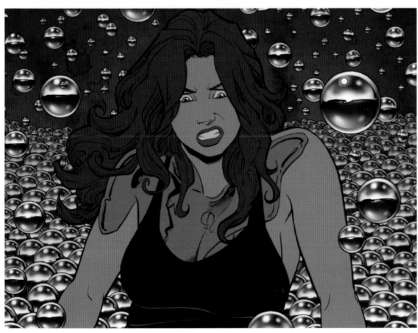

3 Select the contents of the Spheres Distance layer, then use the Linear Gradient tool in Normal mode to apply a gradient of the background color from back to front. This makes the mass of spheres appear to recede into the distance.

Stage 4: Render the Skin Tones

When rendering the skin tones, vary the Feather value of the Lasso tool anywhere between 0 and 12 to achieve just the right blend between your freehand brushwork and the cut-and-brush highlights.

1 Start by rendering a strong halo-like rim light on Julie's shoulders and arms. This highlight should be very strong and bright, creating extreme contrast with the base tone. Use brushes Normal Paint Brush 01 and Normal Paint Brush 02 (slightly softer edge). Try screen tone C00, M65, Y85, K00.

2 Using softer strokes, paint ambient highlights on Julie's skin. These highlights should be roughly half the intensity of the rim light. You may need to reduce the opacity of your Brush tool by 25–50 percent to achieve soft highlights. Leave a core shadow between the rim light and your ambient highlights.

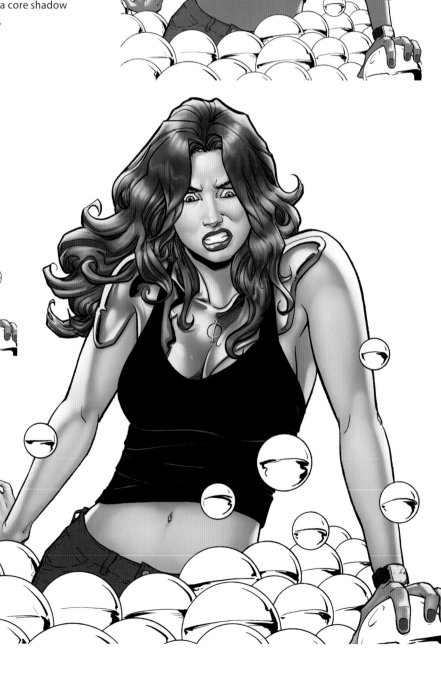

3 Add a second set of highlights to the figure, paying special attention to the construction and form of her anatomy. Build up core highlights along the junction from the shoulder to the elbow to the wrist, creating a convincing representation of an arm. Julie's stomach should look smooth and lean, not overly muscled. Render the metal breastplate, remembering the techniques you used on the metal spheres (see page 108).

If you have difficulty with any of the anatomy, you might find it helpful to look at a reference book.

Focus on the Details: Rendering Hair

1 Use your Brush tool to loosely define the highlights on Julie's hair, paying close attention to the crown of her head.

2 Reduce the size of the brush and add a second level of highlights to her hair.

3 Add final highlights and details to Julie's hair with the Brush tool and a rim light to the back side of her head, pushing her forward in the composition.

Focus on the Details: Highlighting the Face

1 Start by adding soft highlights to the forehead to give it a sense of roundness. Add subtle highlights above Julie's eyebrows to suggest a furrowed brow.

Indicate the ridge and tip of the nose, then highlight her cheeks, jaw and chin. For best results, bring the light from the center of each pupil to the tip of the chin.

2 Add a second level of highlights. Be sure to leave a rim of shadow where the hair is casting a shadow on the forehead.

Add final highlights. Keep the cheek highlights soft to define shape while retaining a youthful-looking smoothness. Go over the entire face with the Medium Faded Edge Brush to smooth out imperfections.

Stage 5: Add Special Effects

HI-FI STEP 2 SCRIPT

1 From the Photoshop Menu bar, choose File > Scripts > Hi-Fi Step 2 to set up the file for special effects.

2 Open the Hi-Fi Helper file Sparkle_Tall.tif or use any sparkle Hi-Fi Helper you have made.

3 Copy and Paste or drag a sparkle onto the *Echo* image. The sparkle will appear as a new layer above the Special Effects layer. Select the layer with the sparkle and set the layer mode to Screen.

4 From the Menu bar, choose Edit > Free Transform to rotate, scale and position your sparkle.

5 Once you have your sparkle positioned exactly where you want it, choose the Merge Down command from the drop-down menu in the Layers palette.
 Repeat Steps 2–5 to add several sparkles to the image.

6 Use the Brush tool to add glows to Julie's shiny metal breastplate and several of the metal spheres in the foreground.
 The right side of this image shows only the Special Effects layer to help you visualize where to add your glows and sparkles.

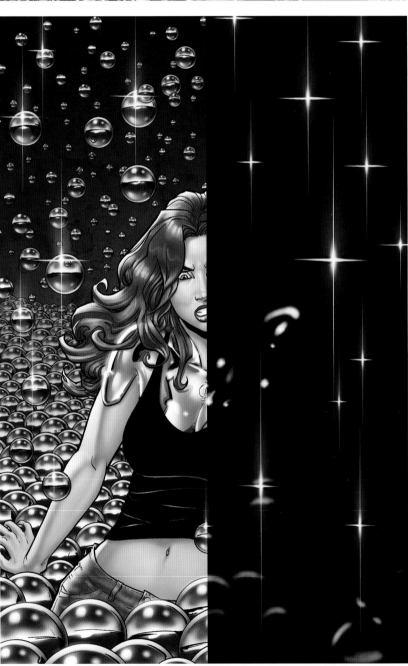

Stage 6: **Save a High-Res File**

HI-FI STEP 3 SCRIPT

Once you have completed your image, save your high-res .PSD file.

If you want to make a final, ready-to-print CMYK image, choose File > Scripts > Hi-Fi Step 3 from the Menu bar. Select "with Special Effects" and let the script run. Save your file as a CMYK TIFF and be sure not to save over your RGB .PSD file.

Learn More About the Artist
If you enjoyed coloring this image of Julie from Terry Moore's *Echo*, then visit Terry at www.abstractstudiocomics.com and let him know how much you appreciate his contributions to this book.

Share Your Results at HueDoo.com
To make a low-res version of a finished image for e-mail and online, use the Hi-Fi action "Save As JPG." Share your version and see what others have done in the Hi-Fi reader forum at HueDoo.com!

KELL & TORA

Brian Denham's *Kell & Tora* is set in a strange and alien environment—just the setting you might expect from the current artist on *The X-Files* comic series from WildStorm. Denham began his career in 1994 on a miniseries written by Alan Moore. The Texas native has also pencilled his share of titles for Marvel, including *Iron Man: Hypervelocity*, *Nova*, *Man-Thing*, *Thunderbolts* and *The Avengers*.

At first glance, Denham's illustration style calls to mind the work of Frazetta, Vallejo and Olivia. To complement this illustration, you're going to try a color approach inspired by sci-fi and fantasy paintings. Brian Denham has created iconic characters in *Kell & Tora*; your mission is to create equally iconic colors.

KELL & TORA
Art by Brian Denham
Color by Hi-Fi
See more at www.briandenham.com
Kell & Tora © 2009 Brian Denham

Stage 1: Prepare the Line Art and Add Flat Color

Brian Denham's artwork nicely balances open areas for rendering with clearly defined shadows. The use of various line weights enhances the shadows.

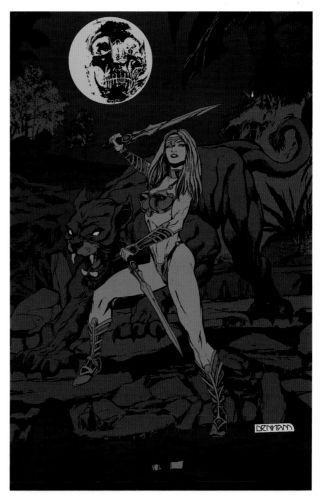

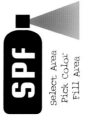

SPF
Select Area
Pick Color
Fill Area

HI-FI STEP 1
SCRIPT

1 From the Bonus Disc, open the file SciFi_Kell&Tora_600.tif. From the Photoshop Menu bar, choose File > Scripts > Hi-Fi Step 1 to prepare the line art for coloring. Unhide the Line Art channel.

2 Use the Lasso tool and the Hi-Fi SPF method (see page 14) to add flat color fills to all areas of the artwork. Start with natural base values tending toward darker tones. For the look of an alien environment, try a reddish sky.

Color Guide: Use Eye-Dropper Tool to sample colors
Flat Color:
Screen Color:

Kell & Tora - Master Digital Color.com - Artwork by Brian Denham

On the Disc: Color Guide

The Bonus Disc includes Color Guides for the projects in the book. Each Color Guide contains convenient swatches of the color pairs we used for flatting and rendering.

If you want to use our colors, just click each swatch with the Eyedropper tool to sample the color right into your Swatches palette.

Video Tutorial

Episode 7: Alien Vortex

Watch episode 7 on the Bonus Disc for tutorial on creating the alien vortex in this illustration.

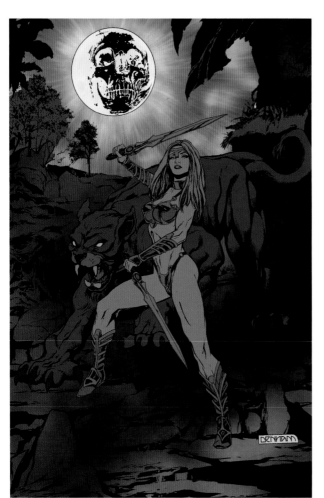

Stage 2: Render the Background and Stones

Use Hi-Fi Helpers to speed up your background rendering and prepare yourself for success.

1 All the Hi-Fi Helpers for this project are located in Tutorial Project Files\4-Sci-Fi\Kell & Tora\Hi-Fi Helpers. Open Variegated Stone.tif, Moon Golden.tif and Red Alien Sky.tif.

2 For each Hi-Fi Helper, copy the Helper image, then select its destination area in the *Kell & Tora* image and choose Edit > Paste Into. Each Helper will appear in a new layer.

3 Choose Edit > Free Transform to scale, rotate and position each element.

4 When the Hi-Fi Helpers are where you want them, merge *only* the moon and sky layers into the Background layer. Name the remaining layer Landscape, and then go on to the next step, rendering the stones.

5 In the Layers palette, click Landscape to make sure it's the active layer.

6 Choose the Hi-Fi Default Soft Round brush (Screen mode, 75 percent opacity).

7 Use the Hi-Fi 4-Step process (see page 14) to add the first level of highlights to the stony landscape. To create an other-worldly look, use different screen colors for different rocks. Cycle through the following: Orange: C00, M50, Y85, K00; purplish-blue: C70, M65, Y00, K00; yellow: C35, M25, Y85, K20; cyan blue: C90, M50, Y00, K00.

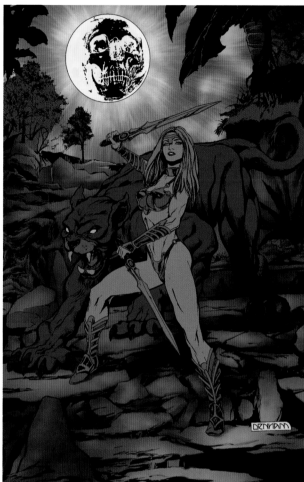

8 Using the same brush and brush settings as in Step 6, add a second level of highlights to the stones. Use the same screen colors in the same locations as in Step 7. Strengthen the highlights on the areas of the stones that are receiving the most light from the flaming moon of death. In this case, the strongest highlights are on the horizontal stone faces. This will help distinguish the horizontal stones from the vertical ones, revealing a solid footpath for Kell and Tora.

Using the Hi-Fi 4-Step process, isolate the trees and greenery on their own layer for rendering. Add subtle highlights to the vines and grassy areas behind the figures. Add a first level of highlighting to the trees and other greenery using the yellow screen color from Step 7 and the Hi-Fi brush preset Brush & Shrub in Screen mode.

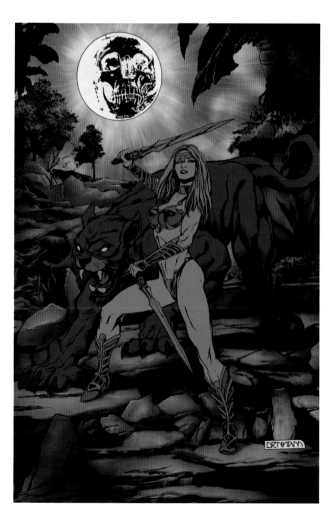

9 Create the third level of highlights on the stone, choosing as desired from the four screen colors you've been using. Focus on creating depth. To clearly define the terracing, use more red further back to help the stones recede into the distance, and place brighter, more focused highlights near the figures to create a focal point.

Add a second level of highlights to the trees and greenery using the same screen color as in Step 8.

Using the Eyedropper tool, sample some of the reds in the sky and use them as screen colors to brush some of the moon's reddish light onto the trees.

Stage 3: **Color the Figures**

Illuminated by a flaming death moon, Kell and Tora look heroic and noble. Use strong lighting that defines these characters' physical strength—especially on Tora, who stands guard near Kell, always ready to attack or defend.

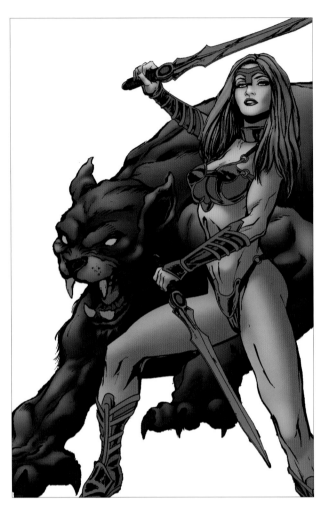

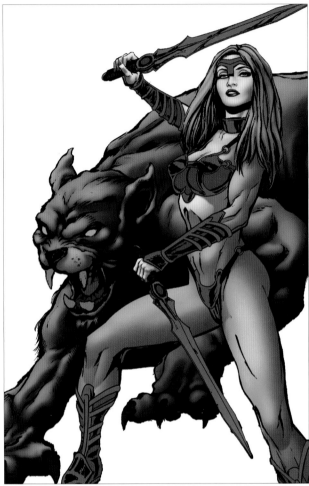

1 Use the Lasso and Brush tools and the Hi-Fi 4-Step process to create subtle highlights on the figures. Work out the lighting on the figures before investing time on details such as the costume and swords.

Use the bracket keys [and] on your keyboard to increase or decrease the Brush size quickly as needed. Adjust the Feather value of the Lasso tool from as little as 2 to as much as 12 to achieve just the right look for your cut-and-brush technique.

Use Contrasts to Clarify a Pose

When limbs, weapons and bodies are overlapping and crossing, it needs to be clear at a glance who's who and what's what. Look for opportunities to clarify as you color. Here, contrasts of value and color temperature help us easily see Kell's body against the complex shapes behind her. Value contrast also clarifies Kell's arm and sword where they cross in front of her body.

2 Use the cut-and-brush technique to build up the highlights areas you created in Step 1. Use the brightest highlights to emphasize important focal areas, such as the faces and Tora's sinewy, taut muscles. Let the flatting do some of the work for you by leaving the shadow areas unrendered.

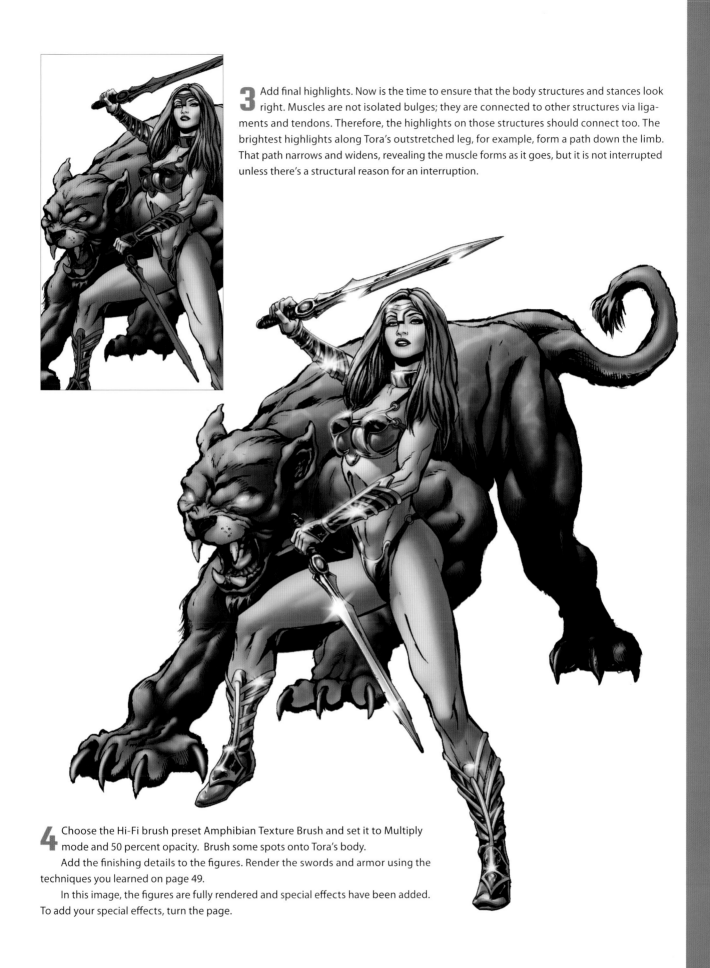

3 Add final highlights. Now is the time to ensure that the body structures and stances look right. Muscles are not isolated bulges; they are connected to other structures via ligaments and tendons. Therefore, the highlights on those structures should connect too. The brightest highlights along Tora's outstretched leg, for example, form a path down the limb. That path narrows and widens, revealing the muscle forms as it goes, but it is not interrupted unless there's a structural reason for an interruption.

4 Choose the Hi-Fi brush preset Amphibian Texture Brush and set it to Multiply mode and 50 percent opacity. Brush some spots onto Tora's body.

Add the finishing details to the figures. Render the swords and armor using the techniques you learned on page 49.

In this image, the figures are fully rendered and special effects have been added. To add your special effects, turn the page.

Stage 4: Add Color Holds, Special Effects and Save

Color holds and special effects add atmosphere, depth and excitement to this illustration of *Kell & Tora*.

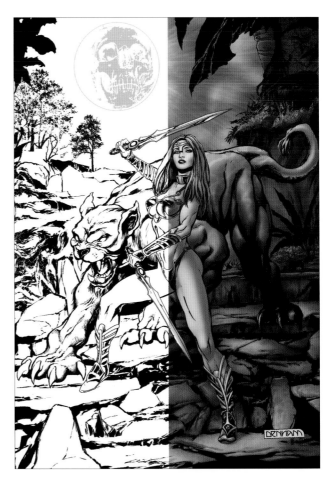

1 Use the Make Holds action (see page 26) to set up the file for color holds.

2 Use the Lasso tool to select the first area you want to color-hold. Choose a color with the Color Picker, then choose Edit > Fill from the Photoshop Menu bar and fill the selection with the foreground color.

3 Repeat Step 2 to add the rest of your color holds. When you are finished with your color holds, play the Finish Holds action (see page 26).

 STEP 2 SCRIPT

4 From the Photoshop Menu bar, choose File > Scripts > Hi-Fi Step 2 to set up the file for special effects.

5 To the Special Effects layer, add:

- Glows using the Gradient and Brush tools.
- Glows on Kell's armor and swords, using Hi-Fi Helper flares and sparkles and the process on page 112.
- Dramatic red atmospheric perspective behind the figures, using the Lasso and Gradient tools.

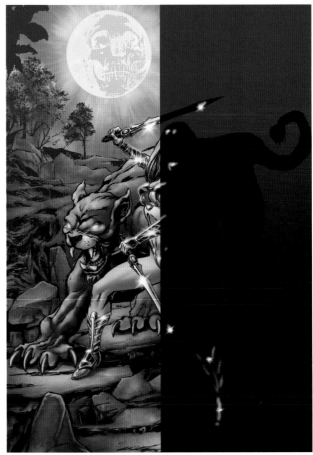

 STEP 3 SCRIPT

6 When you're done, save the high-res .PSD file. If you want to make a final CMYK image ready for printing, choose File > Scripts > Hi-Fi Step 3. Select "with Special Effects" and let the script run. Save your file as a CMYK TIFF, being careful not to save over the RGB .PSD file.

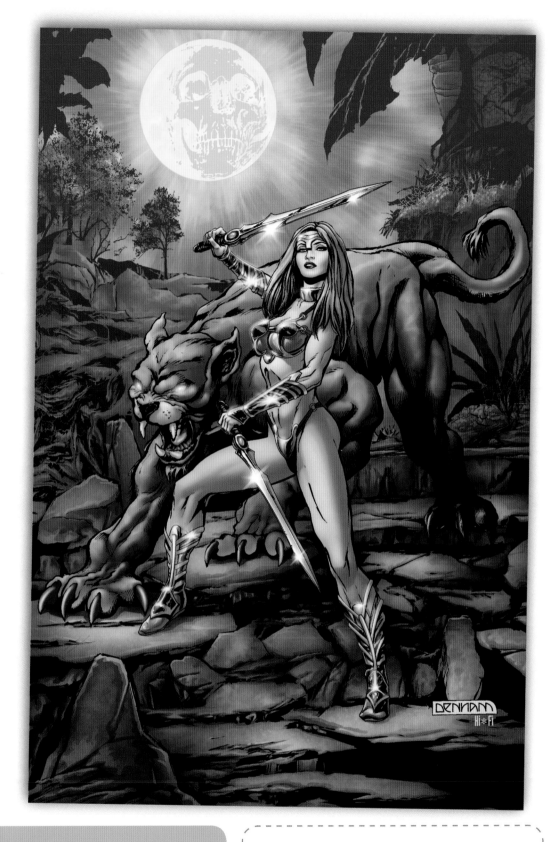

Create a Background

In this section, you colored a big cat in Brian Denham's *Kell & Tora* illustration. Use that knowledge to color Jack, Hanna and a creature from the Xenozoic age. Mark Schultz provides some fantastic artwork for this challenge from his award-winning comic book *Xenozoic Tales*. Mark's artwork incorporates elements of science fiction, pulp fiction, pin-up art and cinema poster design to create modern vintage art full of life and action.

You may notice Mark chose not to draw in any background elements. Should the background remain white? Perhaps a blue sky, a sunset or something more adventurous? Use your imagination and any Hi-Fi Helpers you need to create the background you feel best suits the illustration.

When rendering the scene, follow the clues provided to you within the artwork. Hanna is grasping some coral and using it for leverage. You can see a starfish too. Ripples are indicated near the creature's tail and legs. Perhaps this action is occurring on the sea-front during low tide. What else can you infer from the artwork? Look for the clues to guide you to success.

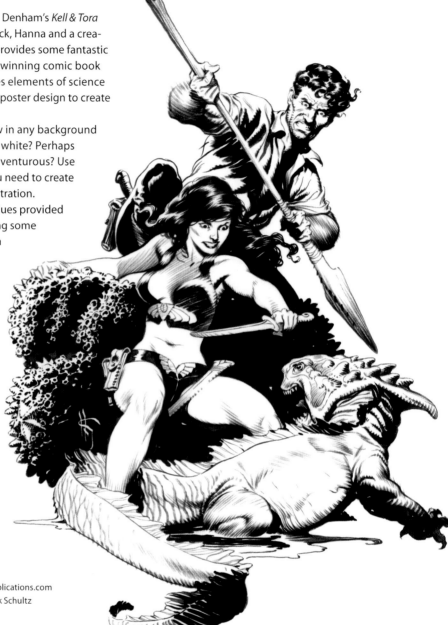

XENOZOIC TALES
Art by Mark Schultz
See more at www.fleskpublications.com
Xenozoic Tales © 2009 Mark Schultz

Bonus Disc: Homework Challenge Files

SciFi_Dino_400.tif

SciFi_Robot_600.tif

Share Your Results at HueDoo.com

Share your colored version of *Xenozoic Tales* and see how other *Master Digital Color* readers colored the image at HueDoo.com.

Use SCL (Setting, Color & Lighting)

When you think of science fiction, images of spaceships, aliens and robots may immediately come to mind. Shawn Pryor has provided you with Glory, a robot from *Exo-1 and the Rock Solid Steelbots* that happens to convert into a sportscar.

Your challenge is to determine setting, color breakdown and lighting, then clearly communicate your decisions to the viewer.

- **Setting:** You could imagine Glory was cruising down the highway when he rolled up on some danger, needed to take action and converted into robot form. Is Glory in a desert, alpine meadow, jungle or city? Do you think it's day or night? Is Glory in friendly territory or behind enemy lines? All of these decisions will affect your final image.

- **Color Breakdown:** The visible wheel and tire tips you off that Glory converts into a car. Surely there are some additional mechanical parts hidden and exposed. Decide what areas of Glory are painted car surfaces and what areas are auto parts, glass windows, headlights and exhaust pipes. Then decide what pieces of Glory are purely robot and would be hidden when Glory is in automobile form. These decisions will affect how you color each area when flatting.

- **Lighting:** Your decisions about setting will certainly affect your lighting. Once you have established the direction of the primary light source, you then need to think about the size and scale of Glory. Would one surface plane receive more light than another? Would Glory cast a shadow onto the ground if the light source were overhead? What if the setting is dark and the light is coming from an oncoming car? Do any parts of Glory illuminate? If so, how does that affect your decisions? Once you have made your lighting decisions, use the light source(s) to clearly define Glory's form.

Bonus
Use the techniques from Focus on Details: Rendering the Chrome Spheres (see page 108) and Rendering Reflective Metallic Surfaces (see page 49) to give Glory's paint job a super slick shiny look.

Share Your Results at HueDoo.com

Share your colored version of *Exo-1 and the Rock Solid Steelbots* and see how other *Master Digital Color* readers colored the image at HueDoo.com.

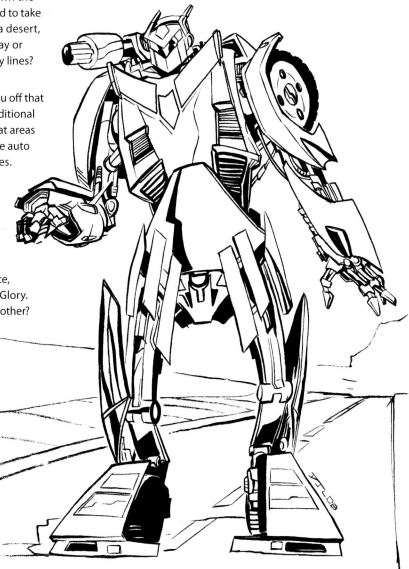

EXO-1 AND THE ROCK SOLID STEELBOTS
Art by Shawn Pryor
See more at www.pkdmedia.com
Exo-1 and the Rock Solid Steelbots © 2009 Shawn Pryor

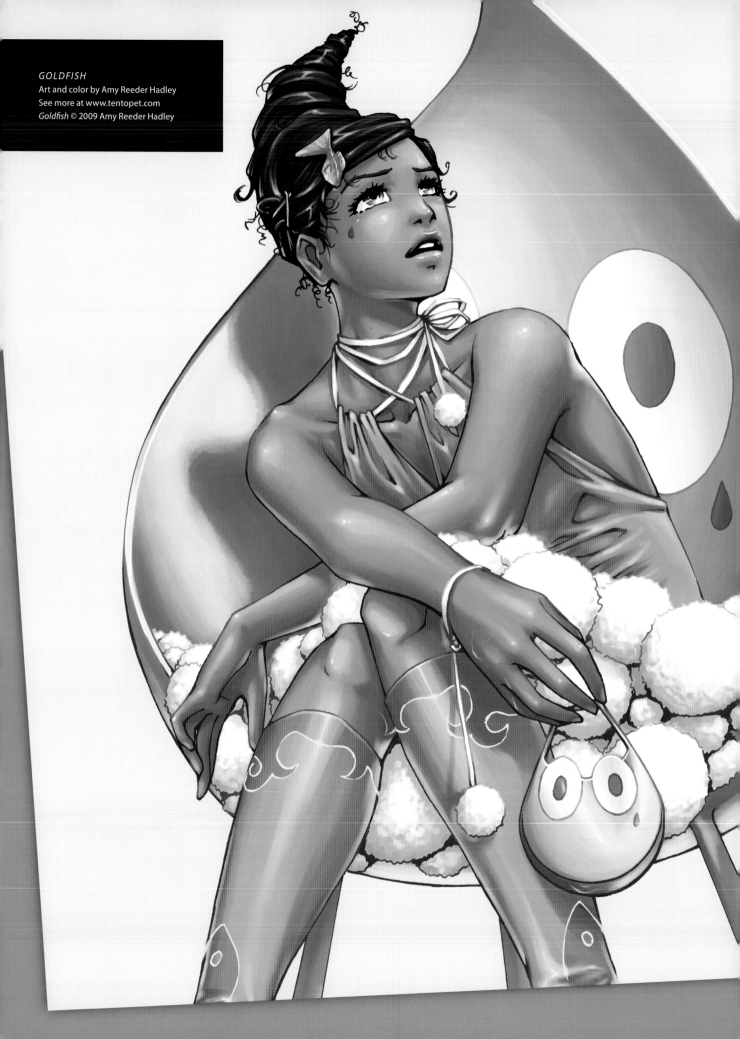

Manga Style

Sometimes it's hard enough to come up with an interesting and creative drawing, let alone deciding how to render it. Below, writer and artist Amy Reeder Hadley shares how she came up with the illustration for Goldfish.

"I dreamt up this drawing randomly in an effort to combine three design elements I love: raindrops, poofballs and goldfish.

"I try to use a logical mixture of hard and soft shading. The fingers have sharper transitions while her calves have smoother ones. I colored it in Photoshop, and I think the biggest trick to using the program is making sure the values stay vibrant. To increase this effect, I sometimes duplicate my colors on a new layer, set the layer to "color burn" and lower the opacity until I think it looks good, mixing with the old colors. It always looks much better afterward.

"I think it's important to draw with color, so the line work isn't doing all the work. For instance, I put a fold in her bag that was nonexistent in the inks. In keeping with the bubblegum, surreal look of the drawing, I went crazy on reflections, and made her skin look almost liquid. And finally, I color-held almost every outline to be slightly darker than the color it's surrounding, to give it a lighter feel."

NIGHTRUNNERS

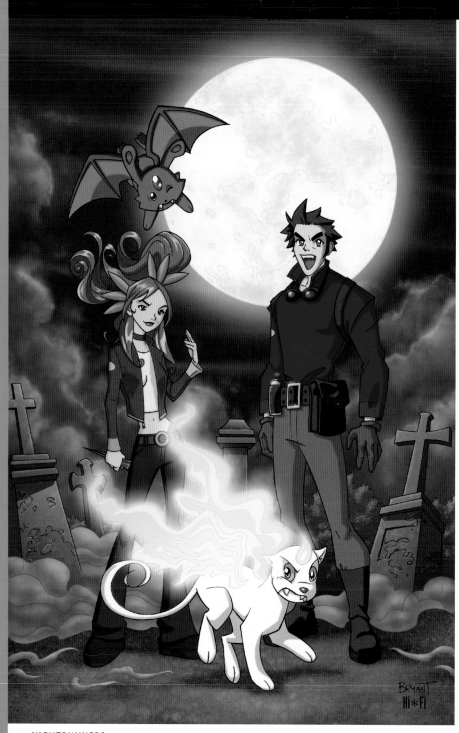

Dave Bryant's nocturnal *Nightrunners* blends traditional Japanese manga style with American pop culture for a comic like no other.

Clean and simple rendering is the key to this project. Traditional animators painted colors by hand on the back side of a piece of acetate called a cel. Due to the small size of each cel and the huge number of cels needed to create a television show or movie, the coloring was usually quite simple: one tone for shadows and another for highlights. That is the look you want to strive for as you color this *Nightrunners* image.

NIGHTRUNNERS
Art by Dave Bryant
Color by Hi-Fi
See more at www.davebryantgo.blogspot.com
Nightrunners © 2009 Bryant & Miller

Stage 1: Prepare the Line Art and Add Flat Color

Dave Bryant's artwork is open for color with very few areas of heavy shadow and no crosshatching or modeling in the line work.

HI-FI — STEP 1 SCRIPT

1 From the Bonus Disc, open the file Manga_Nightrunner_600.tif. From the Photoshop Menu bar, choose File > Scripts > Hi-Fi Step 1 to prepare the line art for coloring. Unhide the Line Art channel.

2 Use the Lasso tool and the Hi-Fi SPF method (see page 14) to add flat color fills to all areas of the artwork. Use cool, subdued colors for the background, since the scene takes place at night.

This time, before you move on, select the entire flatted background and copy it. Then open the Channels palette (Window > Channels) and click the Flats channel. This will deselect the RGB channels, and you will see only a black canvas because there is nothing in the Flats channel yet. Choose Edit > Paste, and your flats will be pasted into the Flats channel, giving you a gray-scale map that you will use in Stage 6.

Reselect the RGB channels before moving on.

SPF
Select Area
Pick Color
Fill Area

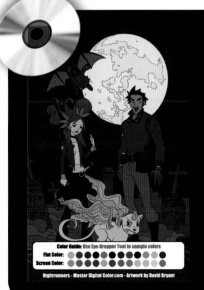

On the Disc: Color Guide

The Bonus Disc includes Color Guides for the projects in the book. Each Color Guide contains convenient swatches of the color pairs we used for flatting and rendering.

If you want to use our colors, just click each swatch with the Eyedropper tool to sample the color right into your Swatches palette.

Stage 2: Render the Background

Use the Hi-Fi 4 Step process (see page 14) to render each of the background areas. Remember to isolate each object for rendering and then merge its layer into the Background layer before moving on to the next object.

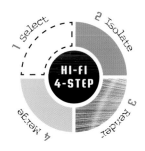

1 Create the moon's surface using the Hi-Fi texture brushes Spatter Brush 2 and Smoke-Scatter. Use the screen tone C50, M25, Y00, K00.

2 Use the Hi-Fi brush preset Brush & Shrub 02 to highlight the trees that lie beyond the gravestones. Imagine the moonlight is falling on them, creating small highlights that define their shape and form. Use the screen tone C90, M00, Y00, K60.

3 Render the gravestones using the Amphibian Texture Brush and the cut-and-grad technique. Use screen tone C75, M50, Y10, K10.

4 Create volume and depth in the fog on the ground using soft and fluffy strokes of the Smoke-Scatter brush. Try screen tone C90, M70, Y15, K10.

5 Use Spatter Brush 2 with a feathered edge to create loosely-defined shadows being cast by the figures and the fog wisps. Use the Gradient tool to bring a bit of moonlight onto the backmost part of the ground. Use warmer screen tones to create the primary highlight on the ground near the figures. For a cool screen tone, try C70, M50, Y15, K20. For a warm screen tone, use C00, M75, Y95, K00.

Stage 3: Render the Sky

You're going to paint your own cloudy night sky to use in this *Nightrunners* image.
Save your sky for use in future projects, too.

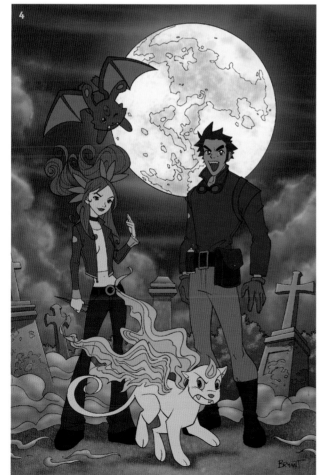

1 Create a new document, 400ppi at 6.875" × 10.438" (17cm × 27cm). Fill the canvas with C85, M65, Y15, K40. This will serve as the foundation for the sky.

2 Choose the Hi-Fi brush Clouds 01 (Screen mode, 75 percent opacity). Paint in some fluffy clouds using C80, M60, Y15, K15 as the screen tone. Remember, as you brush over an area, it will become lighter with each stroke.

Use the Gradient tool to bring some light up from the bottom of the image indicating a bit of atmosphere.

3 Use the Hi-Fi Default Soft Round brush to gently create a few wispy clouds. Save this sky to use again in future projects.

4 Select your painted sky and choose Edit > Copy. In the *Nightrunners* image, select the flatted sky, then choose Edit > Paste Into. Use Edit > Free Transform to scale and position your sky. Press Return (PC: Enter) to apply the transformation.

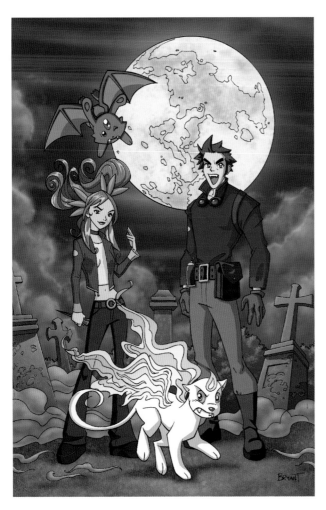

Stage 4: Color the Figures

When adding highlights to the figures, think about the lighting in this illustration. The moonlight is behind the figures and most likely not strong enough to create a believable light source for this scene. The fiery wings of the pet monster might cast a soft glow, but it too would be inadequate as the primary light source. So imagine that there's an ambient light source coming from in front of the figures to make them clearly visible.

Use the Lasso tool and the Hi-Fi 4-Step process to color the figures. Your goal is to create highlights that are simple and clean. Do not be tempted to zoom in more than 100 percent or to make overly detailed selections. When you're coloring in a basic manga or anime style, less is more.

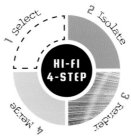

Focus on the Details: How to Render a Basic Manga Eye

1 Ensure that the flatted tones on the eye are the deepest values you want to use.

2 Isolate the iris and add the crescent-shaped highlight. Then isolate the pupil and the white of the eye and select the area of the white highlight, scribing an arc to indicate the roundness of the eye. Choose Edit > Fill and fill the selection with a highlight color.

3 Using the same technique as in Step 2, add the final highlight to the iris and a white highlight to the pupil.

Stage 5: Add Color Holds

Add color holds to push the background elements visually into the distance.

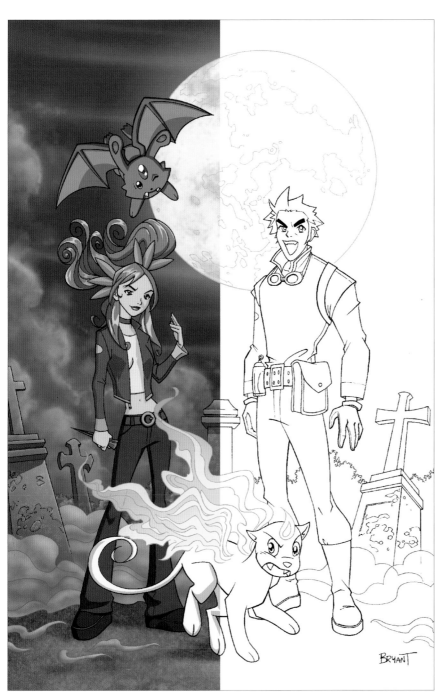

The color has been removed on the right side of the example allowing you to see clearly where the black line art has been changed to a color.

1 Use the Make Holds action (see page 26) to set up the file for color holds.

2 Use the Lasso tool to select the first area you want to color hold. Choose a color with the Color Picker, then choose Edit > Fill from the Photoshop Menu bar and fill the selection with the foreground color.

3 Repeat Step 2 to add the rest of your color holds.

4 When you are finished with your color holds, play the Finish Holds action (see page 26) before moving on.

Stage 6: Add Special Effects

Here, you will use the Elliptical Marquee to select a perfect circle and create a nice glow for the moon. Then you will learn how to use the Flats channel to "remove" the glow from the areas where it doesn't belong.

HI-FI STEP 2 SCRIPT

1 From the Photoshop Menu bar, choose File > Scripts > Hi-Fi Step 2 to set up the file for special effects.

Use the Elliptical Marquee tool with a Feather value of 30 pixels to create a selection on the Special Effects layer somewhat larger in diameter than the moon. Fill the selection with C70 M25 Y25 K15 to create a glow on the moon.

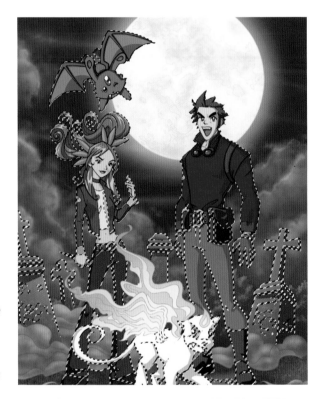

2 Next, remove the glow from the figures using the Flats channel (where you pasted your flats in Step 2 on page 127).

Open the Channels palette (Window > Channels), find the Flats Channel and click it. This will deselect all the other channels, and you'll see a gray-scale version of your flats.

Use the Magic Wand tool (with Hi-Fi's standard settings, Tolerance 0 and Anti-Aliasing off) to select the gray-scale moon and sky. From the Menu bar, choose Select > Inverse to invert the selection. You now have a selection that contains everything except the moon and sky.

Reselect the RGB channel to unhide it. Now go to the Layers palette and click the Special Effects layer to make it the active layer. Choose Edit > Fill and fill your selection with Black. This will mask out the Special Effects layer in the selected area, removing the moonglow from the figures.

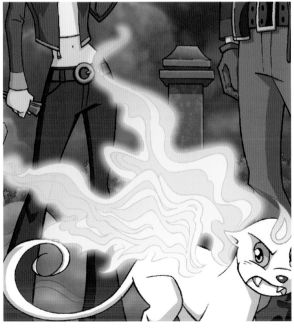

3 Return to the Channels palette and select the Flats channel again so that you see the gray-scale map of your flats. Use the Magic Wand tool to select the pet monster's wings.

From the Menu bar, choose Select > Modify > Expand, enter a value of 30 pixels, and click OK. Next, choose Select > Modify > Feather, enter a value of 25 pixels, and click OK.

Reselect the RGB channel to unhide it. Then go to the Layers palette and click the Special Effects layer to make it the active layer. Choose Edit > Fill and fill your selection with C00, M85, Y50, K00 to create a fiery glow.

Stage 7: Save a High-Res File

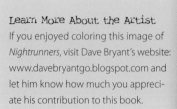 STEP 3
SCRIPT

When you have finished adding special effects, be sure to save your high-res .PSD file. If you want to make a final CMYK image ready to print, choose File > Scripts > Hi-Fi Step 3 from the Menu bar. Select "with Special Effects" and let the script run. Save your file as a CMYK TIFF, and be sure not to save over your RGB .PSD file.

Learn More About the Artist
If you enjoyed coloring this image of *Nightrunners*, visit Dave Bryant's website: www.davebryantgo.blogspot.com and let him know how much you appreciate his contribution to this book.

Share Your Results at HueDoo.com

To make a low-res version of a finished image for e-mail and online, use the Hi-Fi action "Save As JPG." Share your results in the Hi-Fi reader forum at HueDoo.com!

OLYMPIANS

Who can save Earth when demons and monsters from the past are unleashed in the present? *The Olympians* may be the planet's last hope.

This project introduces you to Click-A-Tone, Hi-Fi's gray-scale toning system for one-color comics. Find out how to download additional patterns and learn more tips and techniques at www.clickatone.com.

OLYMPIANS
Art by Dave Bryant
Color by Hi-Fi
See more at www.davebryantgo.blogspot.com
Olympians © 2009 Bryant & Miller

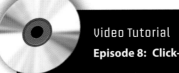

Video Tutorial

Episode 8: Click-A-Tone

Watch video tutorial episode 8 for rendering gray-scale images using Click- A-Tone.

Stage 1: Prepare the Line Art for Click-A-Tone

Overall, the artwork is open except on the skirt, where dark areas indicate the texture of thick fur.

Open a line-art file that is in Bitmap or Grayscale mode. For Click-A-Tone, suggested specifications are 600ppi at 100 percent of final size or larger. From the Bonus Disc, open the file: Manga_Olympians_600.tif.

If you are using Hi-Fi's Click-A-Tone for the first time:

- Make sure you have copied the Click-A-Tone actions and patterns to the appropriate folders in your Photoshop installation (see page 10, How to Install the Hi-Fi Helpers).

- From the Photoshop Menu bar, choose Edit > Preset Manager and load the Click-A-Tone patterns.

- Open the Actions palette (Window > Actions) and use its drop-down menu to load the Click-A-Tone action set.

Click the "Make Click-A-Tone" button in your Actions palette to prepare the file for toning.

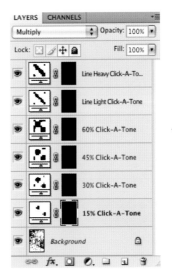

Layers Palette After the "Make Click-A-Tone" Action
The action creates six new layers, one for each of the six tones. Turn the page for full details on how Click-A-Tone works.

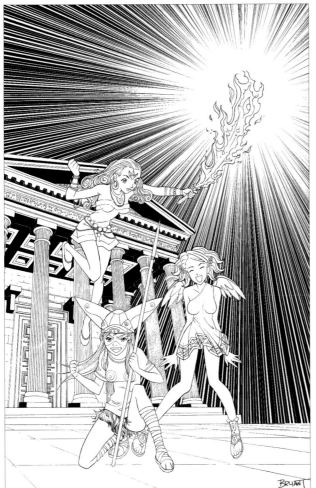

For Another Challenge

As an extra project, try coloring this image using Hi-Fi's color rendering tips, tricks and techniques. You could create an image in the style of an animation cel, with lightning effects radiating from the sword (above, left). Or maybe you would create a more painterly version with soft edges and a swirling energy effect (above, right). Whatever you decide to create, be sure to share your version with the online community at HueDoo.com!

How Click-A-Tone Works

Click-A-Tone uses Layer Masks in Photoshop to hide or reveal different halftone screens. On screen, these tones look like dots or diagonal lines, but these are true black-and-white halftone patterns. After you play the Finish Click-A-Tone action, the resulting file is suitable for printing from a home printer or for reproduction in a professionally produced newspaper, magazine or comic book. These tones tend to photocopy well, too, which makes them perfect for self-published comics.

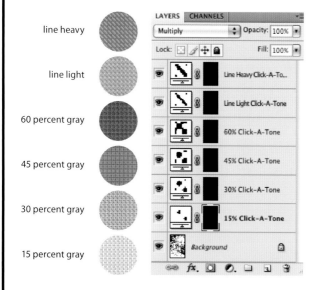

line heavy

line light

60 percent gray

45 percent gray

30 percent gray

15 percent gray

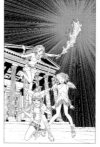

The composite image as viewed on screen. 15 percent Click-A-Tone is visible in the sky.

Hide the Line Art channel, and you can see that 15 percent Click-A-Tone fills the entire sky area.

Viewing the Layer Mask directly, you can see that white indicates the areas where the pattern is visible.

Steps for Using Click-A-Tone

Remember, the Bonus Disc includes a video tutorial for this process:

1 Open a line-art file that is in Bitmap or Grayscale mode. For Click-A-Tone, suggested specifications are 600ppi at 100 percent of the final size or larger.

2 Prepare the file for toning by playing the Make Click-A-Tone action.

3 Open the Layers palette and click the Layer Mask icon for the 15 percent Click-A-Tone layer to activate it.

4 Use the Lasso tool to select the area you want to fill with the tone, then choose Edit > Fill and fill the selection with white. (This part of the toning process is very similar to Hi-Fi's SPF method for flatting.)

5 Repeat Steps 2–4 for the remaining tone areas.

6 When toning is complete, play the Finish Click-A-Tone action to make the file ready for printing.

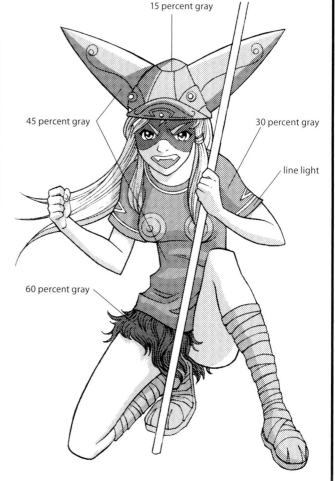

15 percent gray

45 percent gray

30 percent gray

line light

60 percent gray

Stage 2: Add Click-A-Tone Values to the figures

Read the facing page to understand how Click-A-Tone works, then use steps 3–6 on that page to add Click-A-Tone values to the figure of Calleos. Some tips:

- Use tonal contrast to distinguish clothing and accessories from flesh and hair.

- The *Olympians* are being illuminated by the sun and by a flaming sword (seen on the next page). As you tone the figures, think about how both light sources affect them.

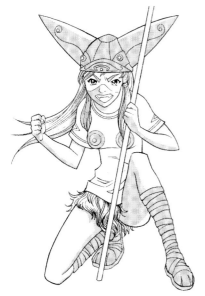 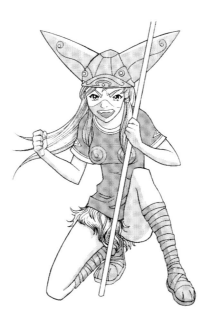 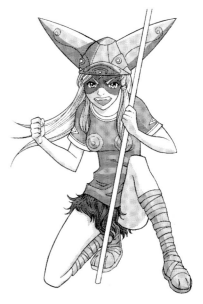

1 Determine which areas of the image will be the brightest ones, and leave those white.

Use the lightest tones to define the next-lightest areas: the basic shadows of Calleos's flesh, helmet and hair.

2 Use medium values to contrast her tunic from the rest of her figure and to create shadows on her boots, mouth and breastplate.

3 Reserve the darkest values for areas that should be in heavy shadow and for focal areas where you want high contrast. For example, you could use a dark value for Calleos's mask to distinguish it from her face.

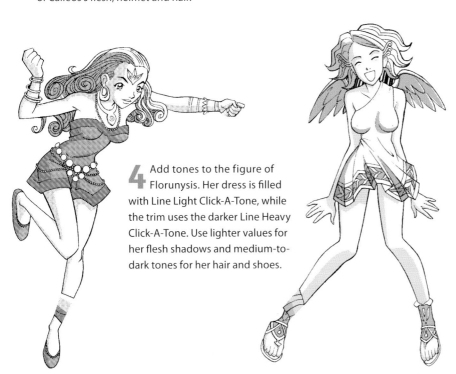

4 Add tones to the figure of Florunysis. Her dress is filled with Line Light Click-A-Tone, while the trim uses the darker Line Heavy Click-A-Tone. Use lighter values for her flesh shadows and medium-to-dark tones for her hair and shoes.

5 Add the tones for Erodytee. Her toga is white complemented with light-to-medium tones for the shadows. Use medium tones to distinguish her wings, sandals and hair from the darker tones in the background of the composition.

Stage 3: Tone the Background and Save

Florunysis holds the fiery Sword of Orion, which was given to Aphrodite and passed down to the Olympians to do battle on Earth. The flaming sword is a focal point for this image.

1 Use the Lasso tool to select the entire sky area. In the Layers palette, click the Layer Mask icon for the 15 percent Click-A-Tone layer to activate it. From the Photoshop Menu bar, choose Edit > Fill and fill the selection with White, exposing the 15 percent halftone pattern.

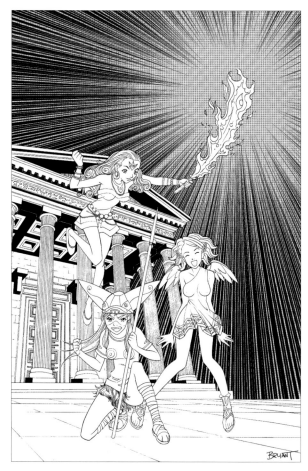

2 Use the same process as in Step 1 to fill the entire sky area with 45 percent Gray. Still working in the 45 percent Gray layer, use the Lasso tool to make a burst-shaped selection around the flaming sword, then fill the selection with Black. This will hide the 45 percent tone in the burst area, allowing the 15 percent value to come through for a brilliant lighting effect.

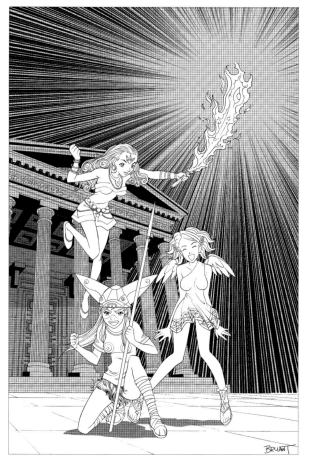

3 Tone the background elements, reserving 60 percent Gray for the darkest shadows.

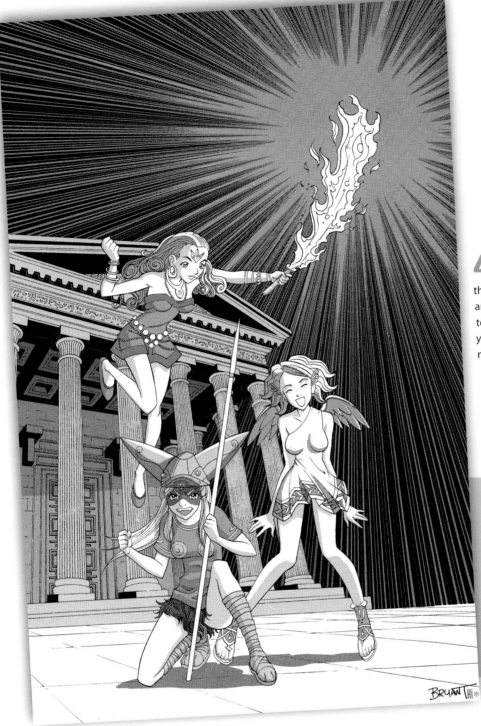

4 When you are done adding tones, save your working file. Then open the Actions palette (Window > Actions) and play the Finish Click-A-Tone action to make the file ready for printing. Save your finished file as a TIFF, and be sure not to save over your working .PSD file.

Learn More About the Artist
If you enjoyed coloring this illustration of *Olympians*, be sure to stop by artist Dave Bryant's website: www.davebryantgo.blogspot.com and let him know how much you appreciate his contribution to this book.

Share Your Results at HueDoo.com

We hope you'll share your Click-A-Tone and color results in the Hi-Fi reader forum at HueDoo.com! To make a low-res version of a finished Click-A-Tone image for e-mail and online:

1 Convert the image to Grayscale mode (Image > Mode > Grayscale).

2 Convert it to RGB mode (Image > Menu > RGB).

3 Then play the Hi-Fi action "Save As JPG" (Window > Actions).

MECHAFORCE 4

Mecha are walking vehicles controlled by a pilot—or, in the case of *MechaForce 4*, four pilots. Mecha robots appear in many futuristic science-fiction anime cartoons from Japan. Mecha can take many forms, from war machines to more ordinary vehicles like fire trucks and even jet aircraft that transform or assemble into giant walking robots.

The robot in *MechaForce 4* is a relic from an ancient civilization discovered in modern times. Piloted by four brave teens, *MechaForce 4* defends Earth from alien invaders and guards the galaxy to ensure evil never overcomes good. Go *MechaForce 4*!

MECHAFORCE 4
Art by Dave Bryant
Color by Hi-Fi
See more at www.davebryantgo.blogspot.com
MechaForce 4 © 2009 Bryant & Miller

Stage 1: Prepare the Line Art and Add Flat Color

Most of this illustration is drawn using monoweight lines. There are very few curves and few, if any, heavy black areas.

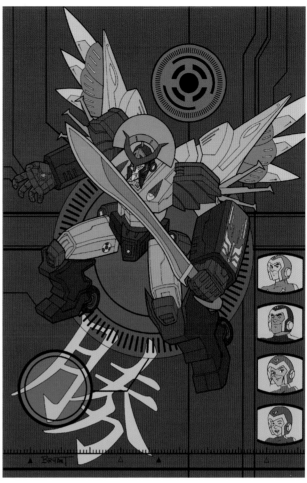

HI-FI
STEP 1
SCRIPT

1 From the Bonus Disc, open the file Manga_Mechaforce4_ 600.tif. From the Photoshop Menu bar, choose File > Scripts > Hi-Fi Step 1 to prepare the line art for coloring. Unhide the Line Art channel.

On the Disc: Color Guide

The Bonus Disc includes Color Guides for the projects in the book. Each Color Guide contains convenient swatches of the color pairs we used for flatting and rendering.

If you want to use our colors, just click each swatch with the Eyedropper tool to sample the color right into your Swatches palette.

2 Use the Lasso tool and the Hi-Fi SPF method (see page 14) to add flat color fills to all areas of the artwork. You can use colors similar to our example, or choose your own; a color scheme of two to four colors will ensure the visual cohesion of the form.

When you're done flatting, copy the flats and paste them into the Flats channel as directed on page 15.

SPF

Select Area
Pick Color
Fill Area

Focus on the Details: Rendering Mechanical Objects

1 Start by flatting the object with its darkest value. (This example is the mecha's shoulder.)

2 Fill the midtone and highlighted sides of the object with medium and light flat colors using the Hi-Fi 4-Step process and Edit > Fill. The highlight side faces the light source.

3 Use the cut-and-grad technique to add final highlights that indicate surface texture and/or reflectivity.

Stage 2: Add Midtones and Highlights

The line art for this image does not indicate the location of the light source, so it's your job to determine where the light is coming from and apply highlights that convince us of your decision.

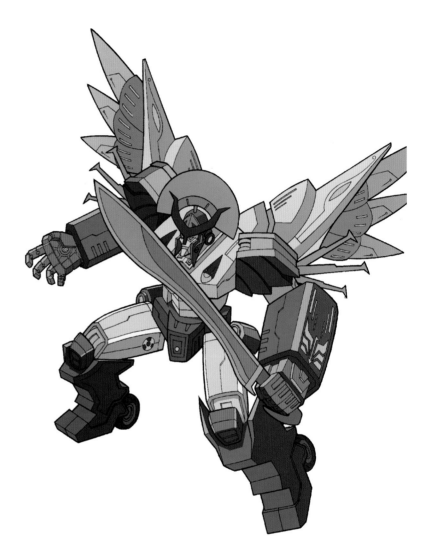

1 Decide where you want the light source to be. In our example, the light is coming from above, to the left of, and slightly in front of the robot, and the glowing sword is not used as a secondary source.

Based on the light direction you've chosen, identify which surfaces should receive the first (medium) level of highlights and which should receive the second (brightest) level of highlights. Then use the Hi-Fi 4-Step process (see page 14) and the Edit > Fill command to fill those areas with medium and brightest flat colors.

You may be more comfortable working all areas of one color at a time, or you might prefer to work the entire figure at once; either way is fine. Just make sure your tone placement is consistent across all parts of the mecha, indicating the same single light direction for the entire figure.

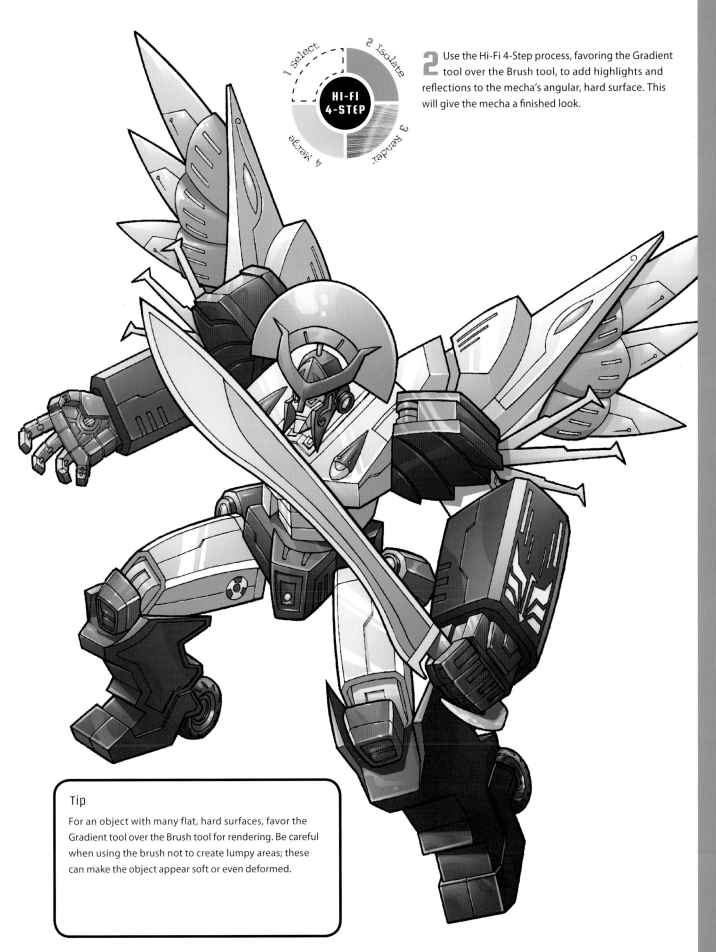

HI-FI
4-STEP

1 Select
2 Isolate
3 Render
4 Merge

2 Use the Hi-Fi 4-Step process, favoring the Gradient tool over the Brush tool, to add highlights and reflections to the mecha's angular, hard surface. This will give the mecha a finished look.

Tip

For an object with many flat, hard surfaces, favor the Gradient tool over the Brush tool for rendering. Be careful when using the brush not to create lumpy areas; these can make the object appear soft or even deformed.

Stage 3: Add Color Holds and Special Effects

Color holds on background elements will decrease the visual importance of the background, pushing the robot forward.

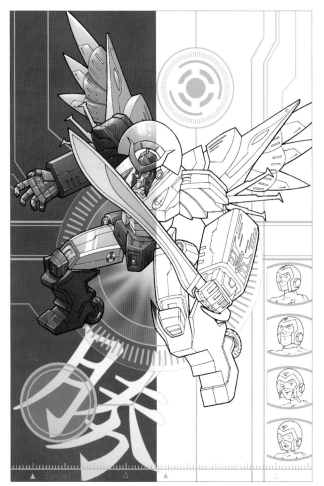

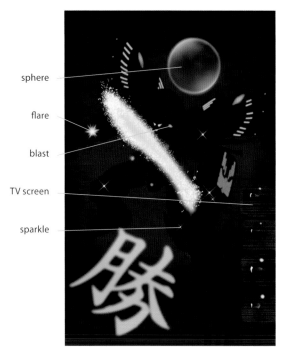

sphere

flare

blast

TV screen

sparkle

1 Play the Make Holds action (see page 26) to set up the file for color holds.

2 Use the Lasso tool to select the first area you want to color-hold. Choose a color with the Color Picker, then choose Edit menu > Fill and fill the selection with the foreground color.

3 Repeat Step 2 to add the rest of your color holds. To match the turquoise color around the robot in our example, use C55, M00, Y15, K00. When you are finished with your color holds, play the Finish Holds action (see page 26) before moving on.

HI-FI STEP 2 SCRIPT

4 From the Photoshop Menu bar, choose File > Scripts > Hi-Fi Step 2 to set up the file for special effects. Choose Window > Layers and select the Special Effects layer to make it the active layer.

5 Add the following effects to the Special Effects layer in this order:

- **Atmospheric glow:** Select the entire contents of the Special Effects layer (Select > All). Using the subtractive Lasso (Mac: Option-Lasso; PC: Alt-Lasso), select carefully along the mecha's outside edge, leaving only the background area selected. Brush in a subtle atmospheric glow. Brush: Hi-Fi Default Soft Round. Screen tone: C60, M40, Y40, K70.

- **Glow on kanji character:** Follow the instructions in step 3, page 132, except use a Feather value of 8 to 12 pixels and C60, M00, Y80, K00 for the screen tone.

- **Glows on sword and gold parts of robot:** No selection required. Brush: Hi-Fi Default Soft Round. Screen tone: C00, M25, Y80, K00.

- **Particle effects around sword:** No selection required. Brush: Spatter Brush 02. Screen tone: C00, M25, Y80, K00.

6 Paste the remaining effects into the Special Effects layer (complete steps for this process are on page 132). You can use the Hi-Fi Helpers in the *MechaForce 4* project folder on the Bonus Disc, or you can use effects you've created.

Stage 4: Save a High-Res File

HI-FI STEP 3 SCRIPT

When you have finished adding special effects, be sure to save your high-res .PSD file. If you want to make a final CMYK image ready to print, choose File > Scripts > Hi-Fi Step 3 from the Menu bar. Select "with Special Effects" and let the script run. Save your file as a CMYK TIFF, and be sure not to save over your RGB .PSD file.

Learn More About the Artist
If you enjoyed coloring this image of *MechaForce 4*, visit Dave Bryant's website: www.davebryantgo.blogspot.com and let him know how much you appreciate his contribution to this book.

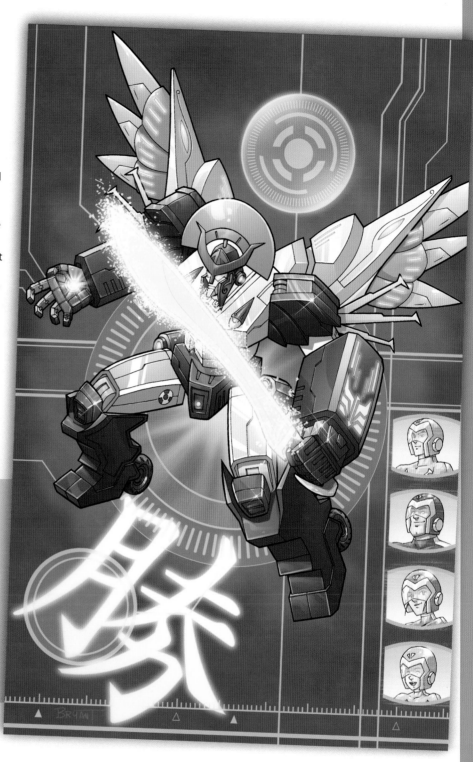

Bonus Video
Watch a bonus tutorial for adding special effects to the mecha robot, taken from Brian's new DVD, *Special Effects for Digital Coloring.*

Share Your Results at HueDoo.com
To make a low-res version of a finished image for e-mail and online, use the Hi-Fi action "Save As JPG." Share your results in the Hi-Fi reader forum at HueDoo.com!

Using Gray-Scale

Many manga books have bright covers, while interiors are all gray-scale. In this chapter, you learned how to add professional-quality gray-scale patterns to an illustration using Photoshop and Hi-Fi's Click-A-Tone system.

In this homework assignment, your challenge is to take what you have learned and incorporate gray-scale into an illustration on your own.

Technically, you can tone any line art illustration with half-tone patterns. Manga artists design their work specifically for gray-scale, so this Zapt! art from TOKYOPOP and Shannon Eric Denton is a perfect opportunity to practice your gray-scale skills.

Refer to page 135 if you need a refresher on how to set up a file for the Click-A-Tone process.

Before you start toning, ask yourself: Where is the light source? Where might I add the darkest shadow tones? Would any areas benefit from diagonal-line tones (such as Line Heavy and Line Light) over dot-pattern tones? Have fun shading this Zapt! art using Click-A-Tone.

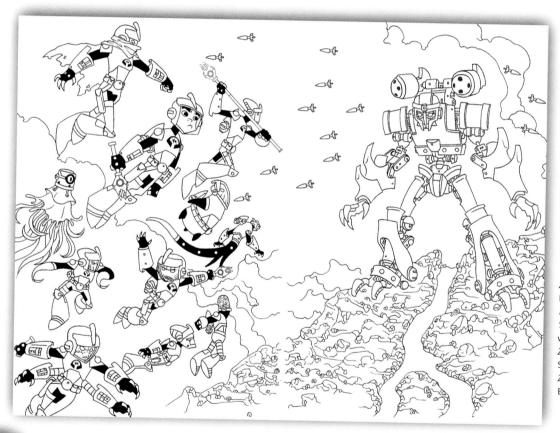

ZAPT!
Published by TOKYOPOP
Art by Armand Villavert Jr.
See more at
www.shannondenton.com
Zapt! © 2009
Shannon Eric Denton
Zapt! written by Shannon
Eric Denton and Keith Giffen

Bonus Disc: Homework Challenge File

Manga_zapt_04-05_600.tif

Share Your Results at HueDoo.com

Use the instructions on page 139 to save a low-res copy of your gray-scale version of *Zapt!*, then share your results at HueDoo.com.

"Three Objects" Technique

Amy Reeder Hadley gave you a great tip in the introduction for this chapter (see page 125). She said she likes to combine three favorite things to make one extraordinary image. For *Goldfish* (pictured), she used raindrops, poofballs and goldfish. You can see exactly where each element fits in and how they all come together to create a portrait of a fun-loving character with an outrageous personal style.

Your assignment: Use the "three objects" technique to get your creative juices flowing.

1 List three things you love (or love to draw), then combine them in one drawing. Your chosen objects could be in the background, or they could be more subtly incorporated as part of a character's costume, hair, makeup or tattoo.

2 Over the next few days, do several more drawings using different groupings of objects.

3 Pick your favorite drawing, scan it, and color it using a limited palette inspired by the objects in the drawing. Amy Reeder Hadley's *Goldfish* uses blue (water/rain), orange (goldfish) and white. Reducing the number of colors and values allows the viewer to focus on the content of your illustration.

Share your results and see what other *Master Digital Color* readers created at HueDoo.com!

GOLDFISH
Art and color by Amy Reeder Hadley
See more at www.tentopet.com
Goldfish © 2009 Amy Reeder Hadley

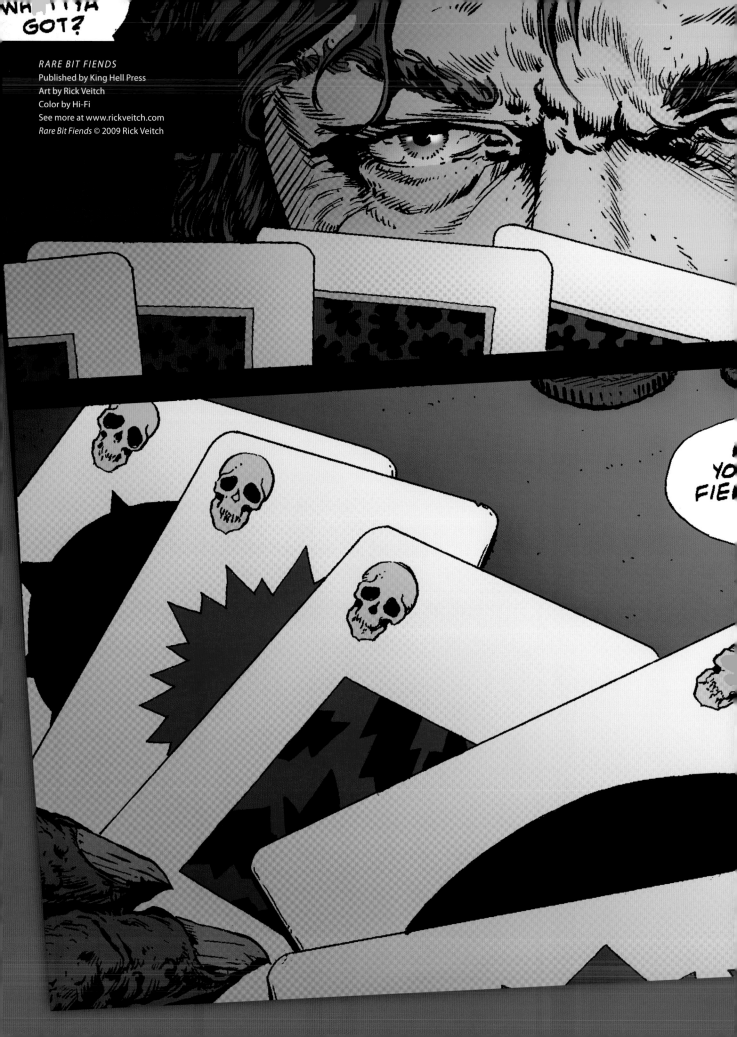

Alternative Comic Style

NDS ?!
AN'T PLAY
IN THIS
ME !!

What separates alternative comics from the mainstream? Is it the style of the art? The lack of superheroes? Is it the independent spirit of the creators? While the debate about what exactly makes a comic book "alternative" continues, one thing is certain, the writers, artists and colorists collaborating on these projects refuse to be labeled or categorized. They have stories to share, and no matter what you call them, these comic books are certainly ground-breaking.

Within the genre of alternative comics you will find horror comics, romance comics, realistic slice-of-life dramas, comics dealing with magic and the occult, and even counter-culture, anti-establishment comics. You can imagine the variety of exciting, cutting-edge stories that fall under the alternative comics umbrella. Would you believe several mainstream comic books like Teenage Mutant Ninja Turtles and The Tick started as independently published alternative comics? If you want to color a thrilling horror comic, a distressing damsel, or visit a magical boarding school, it would seem there are many surprises in store during a visit to the world of alternative comics.

Learn More About the Artist
Rick Veitch is one of the most prolific comic book writers and artists in the industry. With a career spanning three decades, Rick has worked on *Teenage Mutant Ninja Turtles* and *Swamp Thing*. His ground-breaking graphic novel, *Can't Get No*, was praised by *Publishers Weekly* as one of the "Best Books of 2006." His latest series from Vertigo, *Army@Love*, is a subversive, satirical look at war set five years in the future and features digital color by Hi-Fi.

CAMELOT PREP

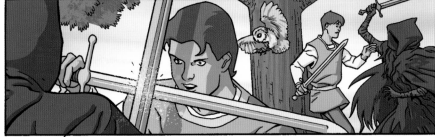

CAMELOT PREP
Art by David Hahn
Color by Hi-Fi
See more at www.hahndynasty.com
Camelot Prep © 2009 Jordan Gorfinkel

David Hahn's *Camelot Prep* brings us visions of Swordfighting 101, suits of armor and family crests proudly flown on the jousting fields. In addition to comics like *Camelot Prep* and *Private Beach*, Hahn is perhaps best known for his work illustrating the Vertigo comic book miniseries *Bite Club* and its sequel, *Bite Club: Vampire Crime Unit*.

David Hahn's art is open for color in the fashion of animated artwork. But while animation characters tend to be flatly colored, Hahn's figures inhabit three-dimensional space much like those found in traditional comic books. The key to coloring David's art successfully is to incorporate both of these thought processes into your coloring. Use bold highlights in this illustration to clearly define the forms of the figures and the space they occupy. You can add depth and weight by allowing props (such as the swords) to cast shadows onto the figures in the scene. Use lighting and color selection to enhance the mood and the action and to create a visual edit between panels three and four where the story moves from one location to the next.

Stage 1: Prepare the Line Art and Add Flat Color

David Hahn's line work is open with varying line weights to indicate an object's form and its position relative to other objects in the scene.

HI-FI STEP 1 SCRIPT

1 From the Bonus Disc, open the file Alt_CP_1_400.tif. From the Photoshop Menu bar, choose File > Scripts > Hi-Fi Step 1 to prepare the line art for coloring. Unhide the Line Art channel.

On the Disc: Color Guide

The Bonus Disc includes Color Guides for the projects in the book. Each Color Guide contains convenient swatches of the color pairs we used for flatting and rendering.

If you want to use our colors, just click each swatch with the Eyedropper tool to sample the color right into your Swatches palette.

2 Use the Lasso tool and the Hi-Fi SPF method (see page 14) to add flat color fills to all areas of the artwork. The flat colors should be the darkest values, the shadow tones. Be sure the costume and character colors are consistent from panel to panel.

When you're done flatting, copy the flats and paste them into the Flats channel as directed on page 15.

SPF

Select Area
Pick Color
Fill Area

Stage 2: Use Hi-Fi Helpers for the Skies

Choose a couple of different skies to paste into this image. They should be noticeably different from each other to reinforce the scene change that occurs between panels three and four.

You can use skies from the Bonus Disc, or any skies you've created, such as the one you made for the *Nightrunners* project (see page 129).

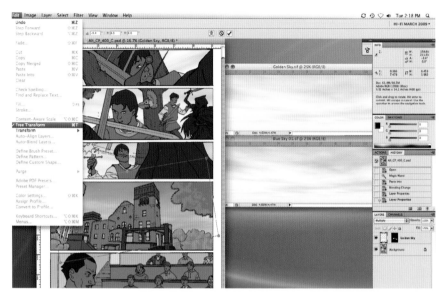

1 Open the Hi-Fi Helpers Golden Sky.tif and Blue Sky 01.tif from the Bonus Disc, or feel free to use any cloud or sky you have created.

2 Copy the Hi-Fi Helper image using Select > All, then Edit > Copy.

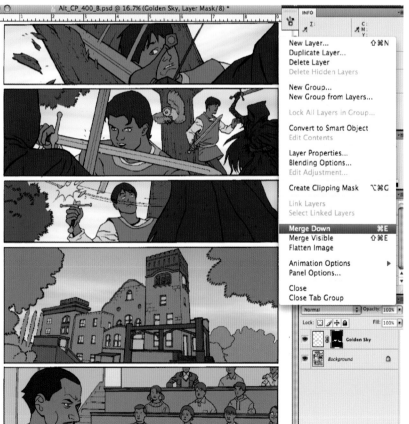

3 Use the Magic Wand tool to select all the flatted sky areas in the panel, then select Edit > Paste Into.

4 Choose Edit > Free Transform to scale, rotate and position the sky.

5 When the sky is where you want it, choose Merge Down from the drop-down menu in the Layers palette.

6 Repeat the Steps 2–5 on this page for each panel in the comic.

Stage 3: Color the Trees, Shrubs and Other Background Elements

The tree bark is an opportunity to try a very cool yet seldom-used Photoshop feature called Brush Rotation.

Also, did you know you can use Photoshop's Pencil tool with Brush presets? Unlike the Brush tool, the Pencil tool has no anti-aliasing, feathering, or fading, so it creates a hard-edged stroke that can work very well for rough textures.

Brush rotation: 113 degrees

Brush rotation: 95 degrees

1 For the tree bark:
Select the Pencil tool and set it to Screen mode and 65 percent opacity.

Open the Brushes palette (Window > Brushes). Open the drop-down menu and enable "Expanded View."

Select the Streaky Brush 01 preset. In the panel on the left side of the Brushes palette, click the words "Brush Tip Shape." Change the brush angle so that the wider axis of the brush tip shape is perpendicular to the tree trunk you are working on. (For the tree in panel one, use 113 degrees; for the tree in panel two, use 95 degrees.)

Choose C25, M75, Y100, K20 as the screen tone, then stroke the Pencil tool lengthwise along the tree trunk.

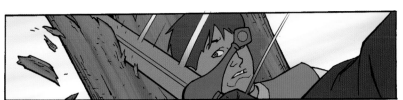

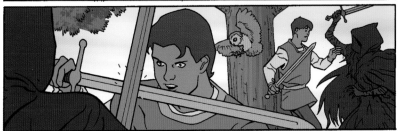

2 For the leafy parts of the trees:
Keep the same settings for the Pencil tool as in Step 1, except choose the brush preset Brush & Shrub or Brush & Shrub 02.

Select C25, M35, Y95, K10 for your screen tone (this tone will work for both of the flat tree colors).

Add highlights to the trees, leaving plenty of shadow areas to define the trees' volume and form.

3 Render the remaining background objects:
Stonework: Use the Lasso and Brush tools and the Hi-Fi 4-Step process (see page 14) to add subtle texture. Try the brush preset Stucco Brush 01 with the Pencil tool.

Glass and wood: Add simple, flat highlight areas by selecting and filling, as you did for the mecha on page 142.

153

Hi-Fi Hi-Lites

How Hi-Lites Work

Hi-Lites use Photoshop's Adjustment Layer feature. An adjustment layer holds color adjustment settings that affect the images in all layers beneath the adjustment layer. Initially, a Hi-Lites adjustment layer is hidden by a layer mask. Selecting an area of the mask and filling it with White reveals a Hi-Lite in that area.

Advantages of Hi-Lites

Because Hi-Lites are on an adjustment layer, they offer certain benefits:

- **Speed.** One selection can create a highlight across multiple colors.

- **Flexibility.** Hi-Fi Hi-Lites layers can be used singly or in multiples for a variety of rendering styles and techniques.

- **Consistency.** Hi-Lites are smooth and even across the entire image.

When to Use Hi-Lites

Hi-Lites are perfect for speed and consistency, such as group projects and daily web comics. In exchange for speed and consistency, you trade some of the fine-tuning that's possible only with the Brush and Gradient tools.

Experiment With the Many Ways of Using Hi-Lites

You can:

- Use Hi-Lites for all the rendering in an image.

- Use Hi-Lites for some areas, the Hi-Fi 4-Step process for others.

- Start rendering an area with the 4-Step process, then finish the area using Hi-Lites.

- Use one Hi-Lites layer, or use two or three for a look similar to that of three-stage rendering.

Steps for Using Hi-Lites

1 Load the Hi-Lites action set using the drop-down menu in the Actions palette. Play the Make Hi-Lites action, which creates a new layer called Hi-Lites.

2 Open the Layers palette and click the Layer Mask icon for the Hi-Lites layer to activate it.

3 Use the Lasso tool to select a highlight area, then choose Edit > Fill and fill the selection with White. The Hi-Lite is now visible.

4 Repeat Steps 2 and 3 to add more Hi-Lites. If you want to add another Hi-Lites layer, play the action Add New Hi-Lites Layer.

5 When you're done adding Hi-Lites (but before running the Finish Hi-Lites action), save your .PSD file.

6 Play the Finish Hi-Lites action to make the changes permanent, then save a new version of your image (be careful not to save over a previous version).

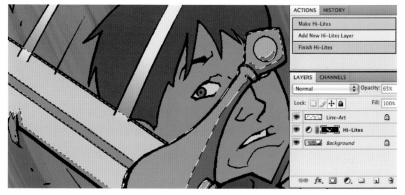

Define an Object's Form Quickly With One Hi-Lite
The highlights on this sword handle and blade were created with just one selection. The Hi-Lites layer applies its color adjustment consistently to all underlying hues, speeding up the process of rendering multicolored objects.

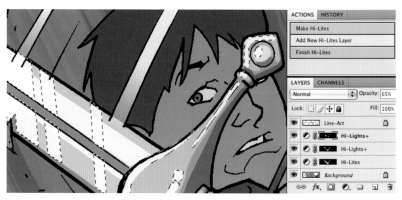

Add More Hi-Lite Layers For More Detail
Here, we've added two more Hi-Lites layers for multistage Hi-Lites. Imagine all the ways multiple Hi-Lites layers can define and refine forms.

Stage 4: Use Hi-Fi Hi-Lites for the Figures

To create depth and emphasize the main action, we're going to use a different rendering technique for the figures: Hi-Fi Hi-Lites.

Hi-Lites is a Hi-Fi tool that gives you another way to render. Read all about it on the facing page; take some time and experiment with it.

When you're comfortable with Hi-Lites, use them for all the rendering on the *Camelot Prep* figures. Use bold, relatively hard-edged selections to create depth and emphasize the dynamic action.

The scene in the last panel is inside a classroom. Continue to use Hi-Lites, but think about how you might change your rendering approach to give these quiet, seated figures a different look and feel from that of the battling warriors in the first three panels.

Video Tutorial

Episode 9: Hi-Fi Hi-Lites

See how Hi-Fi Hi-Lites are used! It's in video tutorial episode 9 on the Bonus Disc.

Stage 5: Create a Semi-Monochromatic Color Overlay Effect

When the background and figures are fully rendered, you are ready to add the color overlay effect.

Color overlays can be used to create a consistent look for a recurring setting. They can also be used to clarify action that alternates between locations or settings. Imagine an action film in which the editor has chosen to jump back and forth between a battle taking place high in the Alps and a love scene on a tropical island. Viewers will of course notice the natural differences in topography, but to emphasize and enhance the contrast between the two settings, the director might instruct the effects team to add a color overlay effect: perhaps a cool violet-blue overlay for the Alps and a warm golden one for the tropics. You can use color overlays to create the same dramatic effect in your comic illustrations.

Before the Overlay (right)

This is the fully rendered page, before the addition of any overlays.

1 Create a new layer called Color Overlay. Set this layer to Color mode and 65 percent opacity.

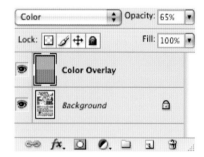

2 Using the Marquee tool, select the area you want to be affected by an overlay, then use Edit > Fill to fill the area with a color.

Here, the colors used in the overlay layer are shown on the right side of the illustration to help you visualize where to add the overlay colors. We've used an orange (C00, M50, Y75, K00) and a violet (C35, M65, Y00, K00).

To adjust the intensity of the effect, change the opacity of the Color Overlay layer. When the color overlays are complete:

- Save the file with the overlay layer so you can make changes later if needed.

- Merge the overlay layer down.

- Save a new version of the file, being careful not to save over previous versions.

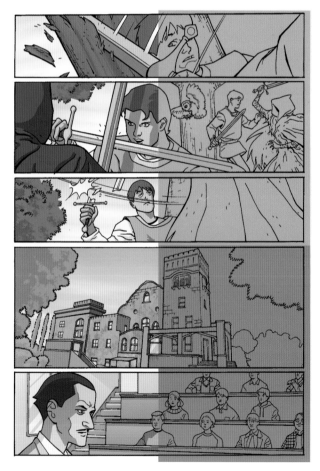

Stage 6: Add Special Effects and Save

Good job—you've combined the Hi-Fi 4-Step process and the Hi-Lites with a cinematic color overlay to create a page with a one-of-a-kind look. Use subtle special effects to add the finishing touches to this illustration.

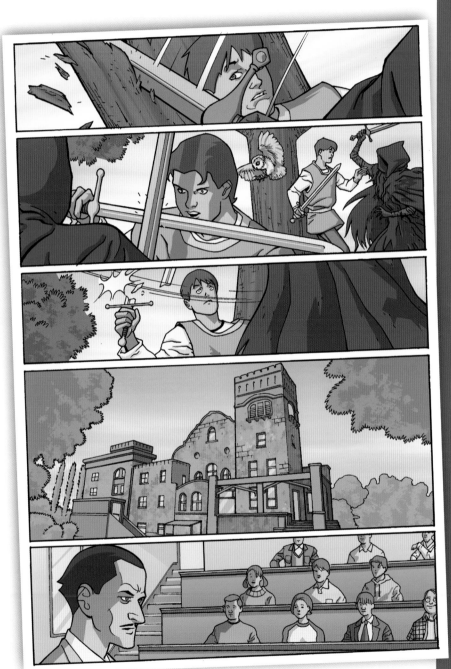

HI-FI STEP 2 SCRIPT

1 From the Photoshop Menu bar, choose File > Scripts > Hi-Fi Step 2 to set up the file for special effects. In the Layers palette, click the Special Effects layer to make sure it is the active layer.

Use the Brush tool with the brush preset Hi-Fi Default Soft Round to add glows to the sword whoosh in panels one and three and the sword impact in panel two.

Use the Hi-Fi brush preset Spatter Brush 02 to create the spark effects where the two swords collide.

HI-FI STEP 3 SCRIPT

2 Once you have completed your image be sure to save your high-res .PSD file. If you want to make a final CMYK image ready to print, choose File > Scripts > Hi-Fi Step 3 from the Menu bar. Select "with Special Effects" and let the script run. Save your file as a CMYK TIFF, and be sure not to save over your RGB .PSD file.

And of course, don't forget to share your work at HueDoo.com!

Learn More About the Artist
If you enjoyed coloring this image from David Hahn's Camelot Prep, visit David at www.hahndynasty.com and let him know how much you appreciate his contribution to this book.

STRANGERS IN PARADISE

Terry Moore is an amazingly talented comic book artist who chooses to print the majority of his comics in black and white. That fact is reflected in Terry's well executed, highly finished black-and-white illustrations.

Generally, only the cover of a Terry Moore book is in color. A colorist approaching the work of an artist as proficient as Terry must ask: Which areas need rendering, and how much detail do these areas need? Much of the contrast is already present in the inked artwork. In a case like this, less is more; too much rendering would throw off the finely tuned balance of the artwork.

STRANGERS IN PARADISE
Art by Terry Moore
Color by Hi-Fi
See more at www.abstractstudiocomics.com
Strangers in Paradise © 2009 Terry Moore

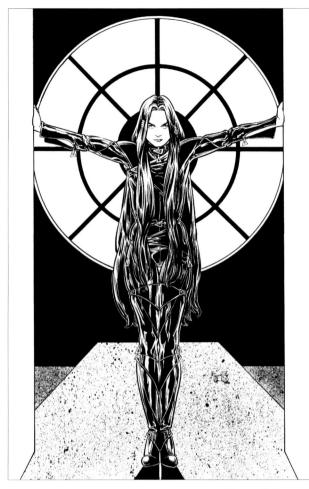

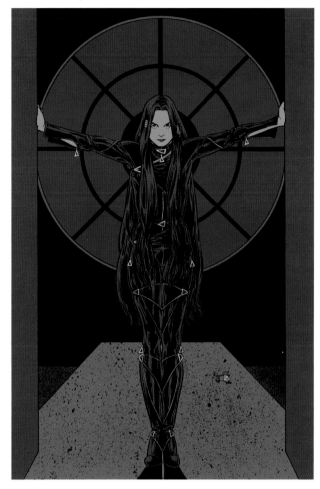

Stage 1: Prepare the Line Art and Add Flat Color

The artwork features an open and unmarked face framed by dark hair with stark highlights. The leather bodysuit is heavily inked with very few open areas for color.

HI-FI STEP 1 SCRIPT

1 From the Bonus Disc, open the file Alt_SiP31_600.tif. From the Photoshop Menu bar, choose File > Scripts > Hi-Fi Step 1 to prepare the line art for coloring. Unhide the Line Art channel.

2 Use the Lasso tool and the Hi-Fi SPF method (see page 14) to add flat color fills to all areas of the artwork. The flat colors should be the darkest values, the shadow tones. Keep these base values cooler and slightly darker than they would look under ambient light. Cooler flats will set the stage for a dramatic contrast when you add the warm rim lights later.

SPF
Select Area
Pick Color
Fill Area

On the Disc: Color Guide

The Bonus Disc includes Color Guides for the projects in the book. Each Color Guide contains convenient swatches of the color pairs we used for flatting and rendering.

If you want to use our colors, just click each swatch with the Eyedropper tool to sample the color right into your Swatches palette.

Color Guide: Use Eye-Dropper Tool to sample colors
Flat Color:
Screen Color:

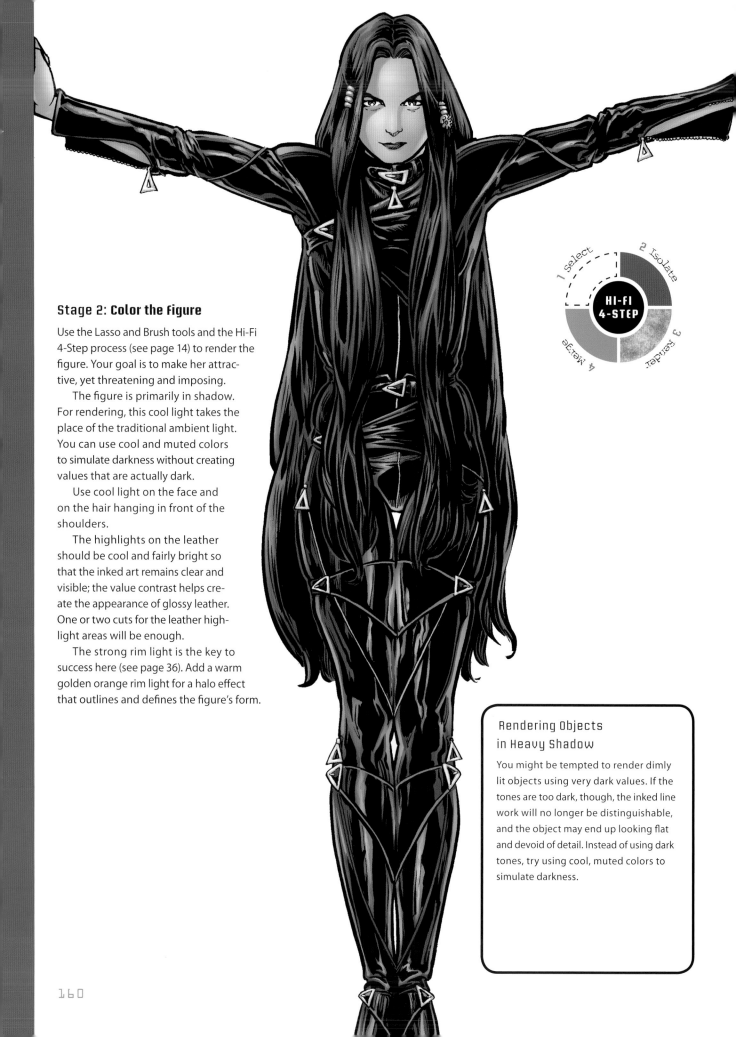

Stage 2: Color the Figure

Use the Lasso and Brush tools and the Hi-Fi 4-Step process (see page 14) to render the figure. Your goal is to make her attractive, yet threatening and imposing.

The figure is primarily in shadow. For rendering, this cool light takes the place of the traditional ambient light. You can use cool and muted colors to simulate darkness without creating values that are actually dark.

Use cool light on the face and on the hair hanging in front of the shoulders.

The highlights on the leather should be cool and fairly bright so that the inked art remains clear and visible; the value contrast helps create the appearance of glossy leather. One or two cuts for the leather highlight areas will be enough.

The strong rim light is the key to success here (see page 36). Add a warm golden orange rim light for a halo effect that outlines and defines the figure's form.

Rendering Objects in Heavy Shadow

You might be tempted to render dimly lit objects using very dark values. If the tones are too dark, though, the inked line work will no longer be distinguishable, and the object may end up looking flat and devoid of detail. Instead of using dark tones, try using cool, muted colors to simulate darkness.

HI-FI 4-STEP

1 Select 2 Isolate 3 Render 4 Merge

Stage 3: Color the Background

The idea of a swirling red vortex in the window adds tension to the image; that tension is heightened by the strong contrast of warm vs. cool colors.

1 Open the Hi-Fi Helper image Red Vortex.tif from the Bonus Disc, or feel free to use any warp or cloudy texture you have made. Select the vortex (Select > All), then choose Edit > Copy and close the Hi-Fi Helper file.

2 Use the Magic Wand tool to select the area in the *Strangers in Paradise* image where you want to insert the vortex. Choose Edit > Paste Into. The vortex will appear on a new layer above the Background layer.

3 From the Menu bar, choose Edit > Free Transform to rotate, scale and position the vortex. When you have it where you want it, choose the Merge Down command from the drop-down menu in the Layers palette.

4 Use the Lasso and Brush tools and the Hi-Fi 4-Step process to render the background elements.

For the floor, Terry Moore has created a very nice spatter effect with his inks, so there's no need to use texture brushes. Add two or three cuts of cool ambient light with a low to medium amount of contrast between cuts.

Use the Lasso or Elliptical Marquee tool to select an area for the pool of light on the floor. Add the orange light with two or three passes of the Gradient tool, fading the light toward the foreground.

The panels on either side of the figure receive window light that fades toward the foreground. The figure's arms cast shadows onto the panels. It will be easiest to render the panels one at a time. Select the first panel with the Magic Wand tool, then set the Lasso tool's Feather value to 6 pixels and use Option-Lasso (PC: Alt-Lasso) to subtract the arm shadow from the selection. Add warm light to the selection with the Gradient or Brush tool. When you have the panel well defined, drop the selection (Edit > Deselect) and blend a bit of light into the part of the cast shadow nearest the window. Render the other panel the same way.

When both panels are rendered, set the Feather value on the Lasso tool back to 0 pixels and render the white rose that has been dropped on the floor.

Stage 4: Add **Special Effects and Save**

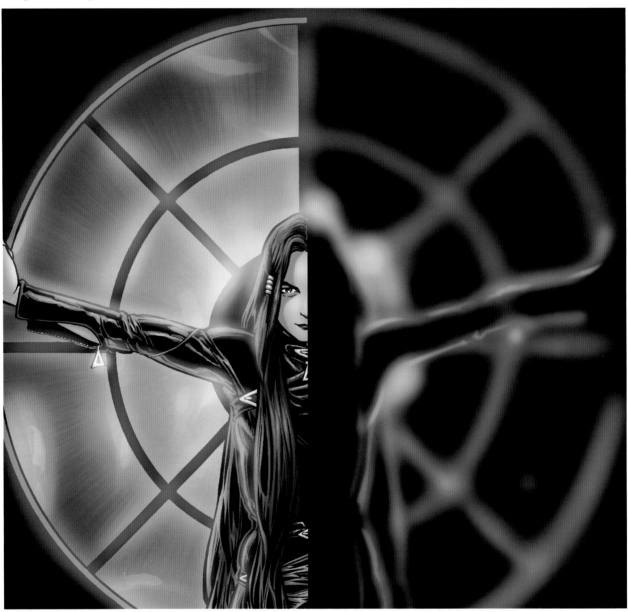

HI-FI STEP 2 SCRIPT

1 From the Photoshop Menu bar, choose File > Scripts > Hi-Fi Step 2 to set up the file for special effects. Choose Window > Layers and select the Special Effects layer to make it the active layer.

2 Use the Brush tool to paint strong golden-orange glows onto the Special Effects layer.

HI-FI STEP 3 SCRIPT

3 When you have finished adding glows, be sure to save your high-res .PSD file. If you want to make a final CMYK image ready to print, choose File > Scripts > Hi-Fi Step 3 from the Menu bar. Select "with Special Effects" and let the script run. Save your file as a CMYK TIFF, and be sure not to save over your RGB .PSD file.

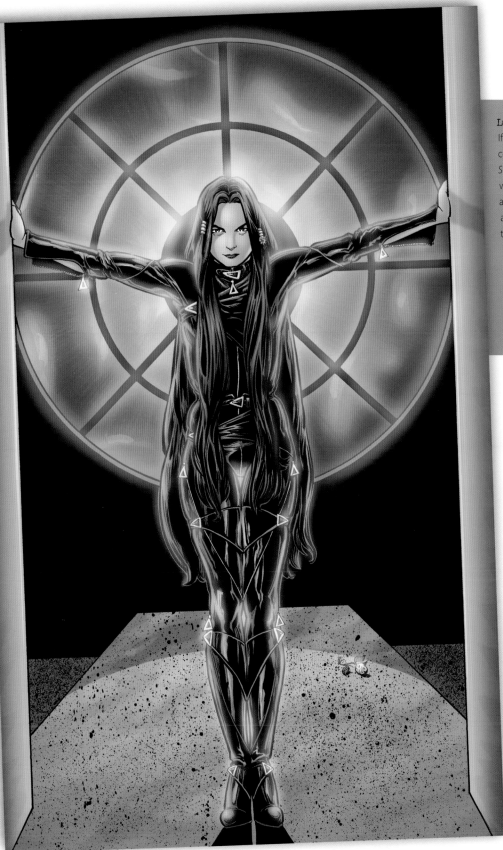

Share Your Results at HueDoo.com

To make a low-res version of a finished image for e-mail and online, use the Hi-Fi action "Save As JPG." Share your results in the Hi-Fi reader forum at HueDoo.com!

LONDON HORROR COMIC

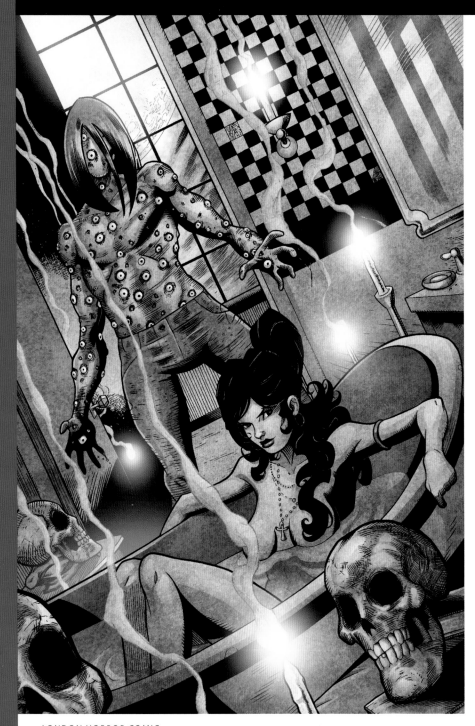

Alternative comics have their own unique visual style. Tone, mood and ambiance are more important than super-detailed rendering.

In horror comics, mood and ambiance are paramount. The rendering does not need to be highly detailed; less-detailed rendering adds to the mystery and suspense of an image by leaving much to the viewer's imagination. Let the inked shadows work for you to create a creepy vibe.

LONDON HORROR COMIC
Art by Lee Ferguson
Color by Hi-Fi
See more at www.londonhorrorcomic.com
London Horror Comic © 2009 John-Paul Kamath

Stage 1: Prepare the Line Art and Add Flat Color

This artwork uses a balance of inked areas, hatching and open areas to give you all the information you need about the light sources and the forms.

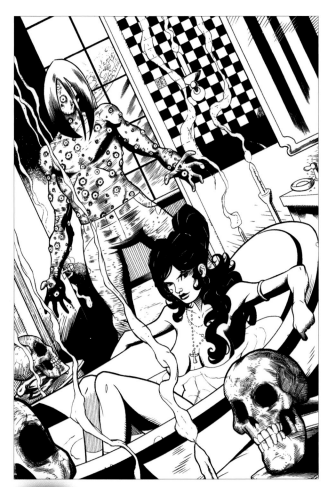

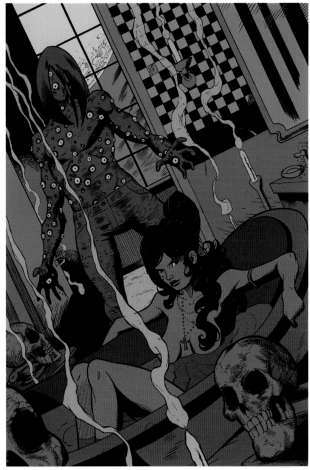

H I-F I STEP 1 SCRIPT

1 From the Bonus Disc, open the file Alt_ London-HorrorComic_600.tif. From the Photoshop Menu bar, choose File > Scripts > Hi-Fi Step 1 to prepare the line art for coloring. Unhide the Line Art channel.

On the Disc: Color Guide

The Bonus Disc includes Color Guides for the projects in the book. Each Color Guide contains convenient swatches of the color pairs we used for flatting and rendering.

If you want to use our colors, just click each swatch with the Eyedropper tool to sample the color right into your Swatches palette.

2 Use the Lasso tool and the Hi-Fi SPF method (see page 14) to add flat color fills to all areas of the artwork. The flat colors should be the darkest values, the shadow tones. Use cool, dark blues for the background, but use warmer tones for the tub and the female figure to create contrast. Use cool, muted tones for the creeper to add depth and create visual tension.

When you're done flatting, copy the flats and paste them into the Flats channel as directed on page 15.

SPF

Select Area
Pick Color
Fill Area

Stage 2: Color the Background

Start with the cool-toned background elements.

1 For the first level of highlights in the background, use the Lasso tool, the Hi-Fi Default Soft Round brush, and the Hi-Fi 4-Step process (see page 14).

For the mostly blue background elements, use the screen tone C40, M10, Y20, K00.

This is also a good time to add some warmer highlights to the candles, candlesticks, smoke and faucet handles. Use the screen tone C00, M35, Y60, K00. The warm/cool contrast will help these elements stand out against the background.

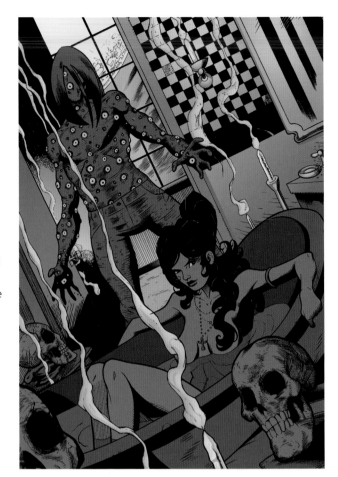

2 Add a second level of highlights to the background elements to bring out details.

For the window casing, mirror, frame and vanity, use the Hi-Fi Default Soft Round brush preset and C40, M10, Y20, K00 as the screen color.

For the moon and sky, use the Hi-Fi brush preset "Smoke-Thick N Chunky" and C30, M00, Y10, K00.

For the candles, candlesticks and smoke, use the Hi-Fi Default Soft Round brush preset and C00, M35, Y60, K00.

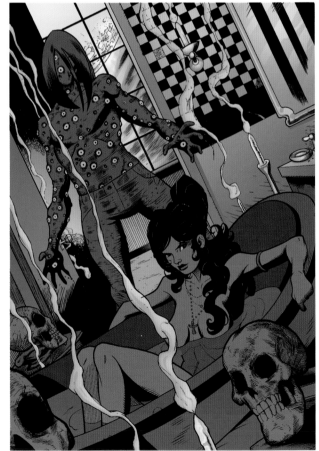

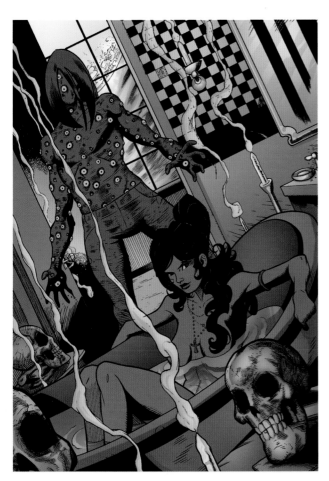

Stage 3: Render the Middle Ground and Foreground Objects

Move forward in the image and begin to address the objects around the figures.

1 Add a first level of highlights to the middle ground and foreground objects using the cut-and-brush technique and the Hi-Fi Default Soft Round brush.

For the old-fashioned bathtub, keep the lighting on the tub subtle so as not to create too shiny a surface. Use screen tone C00, M60, Y52, K00.

For the tables and the book cover use screen tone C00, M50, Y45, K00.

To add the golden candlelight to the skulls and the pages of the books, use screen tone C00, M35, Y60, K00.

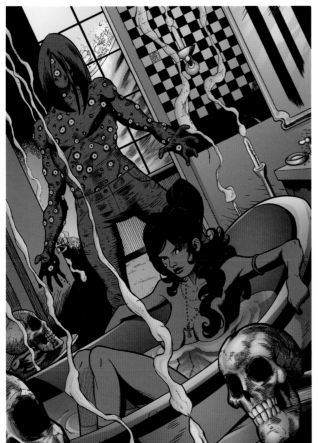

2 Continue using the cut-and-brush technique with the Hi-Fi Default Soft Round brush preset for all the highlights in this step.

Add more light on the part of the bathtub that is closest to the candles using screen tone C00, M60, Y52, K00.

Add final details to the tables and book cover using C00, M50, Y45, K00.

Add finishing highlights and details to the skulls and book pages using C00, M35, Y60, K00.

> ### Tip
>
> Need help rendering the skulls? See Focus on the Details: Foreground Skulls on page 169.

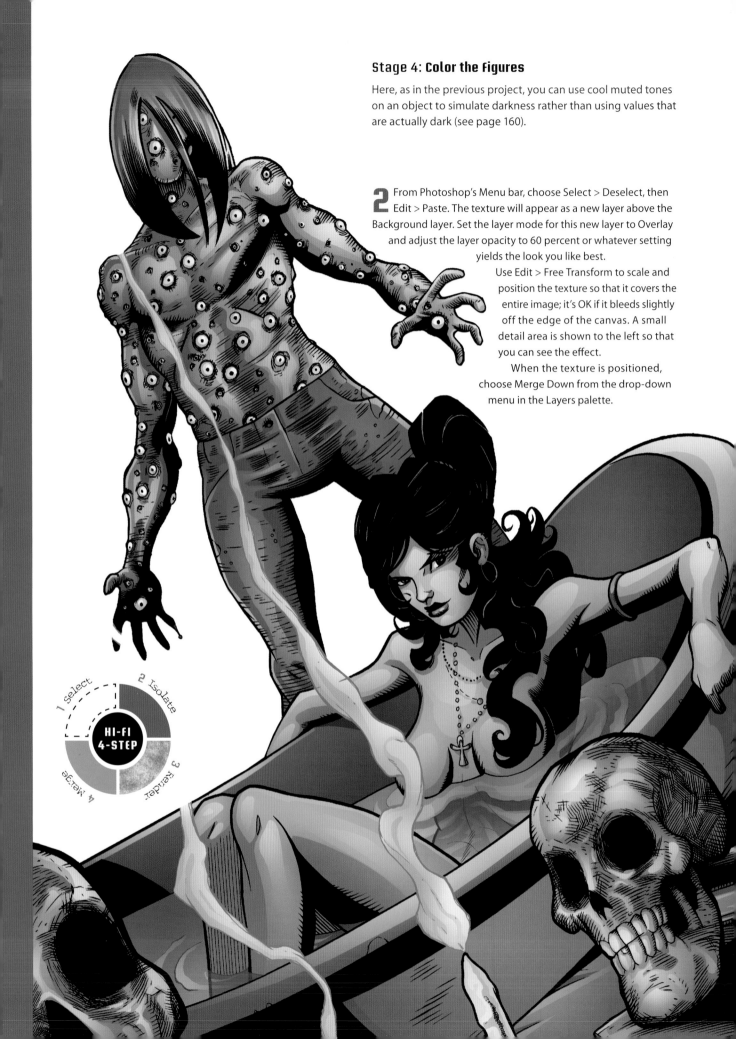

Stage 4: Color the Figures

Here, as in the previous project, you can use cool muted tones on an object to simulate darkness rather than using values that are actually dark (see page 160).

2 From Photoshop's Menu bar, choose Select > Deselect, then Edit > Paste. The texture will appear as a new layer above the Background layer. Set the layer mode for this new layer to Overlay and adjust the layer opacity to 60 percent or whatever setting yields the look you like best.

Use Edit > Free Transform to scale and position the texture so that it covers the entire image; it's OK if it bleeds slightly off the edge of the canvas. A small detail area is shown to the left so that you can see the effect.

When the texture is positioned, choose Merge Down from the drop-down menu in the Layers palette.

HI-FI 4-STEP
1 Select
2 Isolate
3 Render
4 Merge

Stage 5: Add a Texture Overlay to the Entire Image

Adding a texture overlay to the entire image will enhance the gritty, nervous mood of this illustration.

1 Open the Hi-Fi Helper file Flake Texture.tif, or feel free to use a texture you've made. From the Photoshop Menu bar, choose Select > All, then Edit > Copy. Close the texture file.

Before texture overlay

After texture overlay

2 From Photoshop's Menu bar, choose Select > Deselect, then Edit > Paste. The texture will appear as a new layer above the Background layer. Set the layer mode for this new layer to Overlay and adjust the layer opacity to 60 percent or whatever setting yields the look you like best.

Use Edit > Free Transform to scale and position the texture so that it covers the entire image; it's OK if it bleeds slightly off the edge of the canvas. A small detail area is shown to the left so that you can see the effect.

When the texture is positioned, choose Merge Down from the drop-down menu in the Layers palette.

Focus on Details: Foreground Skulls

1 Use the first level of highlights to define the skull's overall shape, while hinting at the rim light from the candle on the left.

2 Add detail and definition to the skull's form with the second level of highlights, creating a clear division between illuminated surfaces and those remaining in shadow.

3 Applying the texture overlay will create the illusion of more detail to the surface rendering while adding a rough and weathered look.

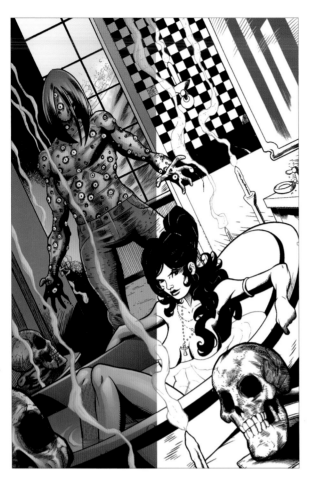

Stage 6: Add Color Holds and Special Effects

1 Play the Make Holds action (see page 26) to set up the file for color holds.

2 The color holds in this piece are on the moon, the smoke, the mirror, and the water in the bathtub.
Use the Lasso tool to select the first area you want to color-hold. Choose a color with the Color Picker, then choose Edit > Fill from the Photoshop Menu bar and fill the selection with the foreground color.

3 Repeat Step 2 to add the rest of your color holds.

4 When you are finished with your color holds, play the Finish Holds action (see page 26) before moving on.

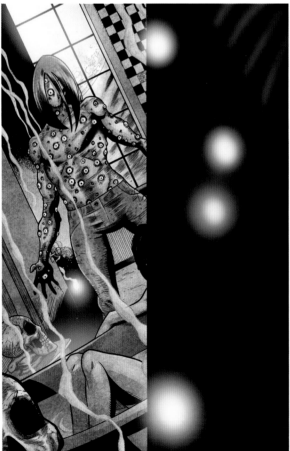

HI-FI STEP 2 SCRIPT

5 From the Photoshop Menu bar, choose File > Scripts > Hi-Fi Step 2 to set up the file for special effects. Choose Window > Layers and select the Special Effects layer to make it the active layer.

6 Use the Brush tool to paint warm glows for the candles. Add a soft blue glow coming from the window. Add glows to suggest reflections on the mirror.

Stage 7: Save a High-Res File

 STEP 3 SCRIPT

When you have finished adding glows, be sure to save your high-res .PSD file. If you want to make a final CMYK image ready to print, choose File > Scripts > Hi-Fi Step 3 from the Menu bar. Select "with Special Effects" and let the script run. Save your file as a CMYK TIFF, and be sure not to save over your RGB .PSD file. Remember to share your results at HueDoo.com!

Learn More About the Creator
If you enjoyed coloring this cover image from John-Paul Kamath's *London Horror Comic*, visit www.londonhorrorcomic.com and let him know how much you appreciate his contributions to this book.

Tell the Story With Color

Alternative comics start with a great story. The artist then uses his or her interpretation of that story to create the black-and-white illustrations. Your challenge is to continue telling the story with color. The color choices you make and style of rendering you use affects how the reader perceives the story.

What is the setting? What type of people are the characters? What is the mood? What sort of lighting did the artist infer? Ask yourself these questions and then one more: What does this artwork ask of me? You may find you are a better storyteller than you know.

In the *Camelot Prep* tutorial, you used a color overlay to separate the two scenes of the story. How can you use this technique to help enhance the story in another comic?

Shannon Eric Denton has provided you with three pages of artwork from *Graveslinger*. These pages span from day to night and you may find story breaks within the pages.

Using what you learned about color choices and color overlays, render these three pages and create visual edits with color overlays where you see fit. Be as creative as you want, but keep the story in mind as you color.

GRAVESLINGER
Art by Nima Sorat
See more at www.shannondenton.com
Graveslinger © 2009 Shannon Eric Denton
Graveslinger created by Shannon Eric Denton
and Jeff Mariotte

Bonus Disc: Homework Challenge Files

Alt_Graveslinger_PG1_600.tif
Alt_Graveslinger_PG2_600.tif
Alt_Graveslinger_PG3_600.tif

Share Your Results at HueDoo.com

Share your colored version of *Graveslinger* and see how other *Master Digital Color* readers colored the pages at HueDoo.com.

Let Color Define the Genre

Within the realm of alternative comics you will find art and stories from many genres. Science fiction, western, adventure, and even superhero tales can be interpreted through the alternative lens.

There is a razor-thin line between super-hero and alternative comics. The main differences can be boiled down to the storytelling and the way the art and color are approached. A man running around the city with a cape and the symbol of a bat on his chest is perceived as a cartoon-ish superhero. The same character filtered through the fabric of alternative storytelling is a dark knight.

Jim Hanna has provided you with another page from his comic, *Code Zero* (see pages 64–69).

Use what you have learned about telling a story in color and apply it to this *Code Zero* art. What choices will you make in your color selection? Will you use a texture effect to enhance the look? Remember to alter the look and feel of your rendering. Alternative comics seldom feature bright, primary colors. You may want to establish a moodier palette. Your challenge is to transform this team of superheroes into something edgier and hardcore. Are you up to the challenge?

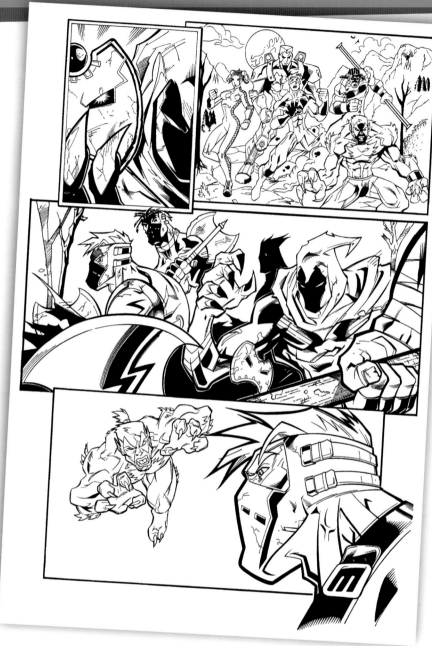

CODE ZERO
Art by Jim Hanna
See more at www.realjimhanna.blogspot.com
Code Zero © 2009 Jim Hanna

Bonus Disc: Homework Challenge File
Alt_CodeZero02_600.tif

Share Your Results at HueDoo.com

Share your colored version of *Code Zero* and see how other *Master Digital Color* readers colored the page at HueDoo.com.

Index

Master Comic Art with These Great Titles
from IMPACT!

This is THE definitive book on digital coloring for amateurs and professionals alike—from comic book fans and Photoshop whizzes who want to color for the fun of it, to colorists looking to perfect their skills, to graphic arts professionals in seach of something new to offer their clients.

ISBN-13: 978-1-58180-992-3
ISBN-10: 1-58180-992-1
Paperback, 160 pages, #Z0939

Learn the top tips, tricks and techniques for coloring digitally. Expert colorist Brian Miller will teach you how to break down an image into flat color, and then show you how to add light. The artwork used in the video is included on the DVD, so you can follow along as you learn to color the Hi-Fi way.

ISBN-13: 978-1-60061-855-0
ISBN-10: 1-60061-855-3
DVD, 80 minutes, #Z5423

Discover the inside secrets behind eye-popping visual effects for your artwork. Colorist Brian Miller shows you how to create energy glows, sparkles, warp effects and much more. Plus learn how to make special "Hi-Fi Helper" effects you can use again and again. The artwork used in the video is included on the DVD, so you can follow along as you learn to create stunning special effects.

ISBN-13: 978-1-60061-859-8
ISBN-10: 1-60061-859-6
DVD, 50 minutes, #Z5427

These and other fine IMPACT books and DVDs are available at your local art & craft retailer, bookstore or online supplier. Visit our website at www.impact-books.com

IMPACT-BOOKS.COM

- Connect with other artists
- Get the latest in comic, fantasy, and sci-fi art
- Special deals on your favorite artists